PROTECTING

SANIBEL

AND

CAPTIVA

ISLANDS

PROTECTING
SANIBEL
AND
CAPTIVA
ISLANDS

THE CONSERVATION STORY

BETTY ANHOLT
& CHARLES LeBUFF

THE
History
PRESS

Published by The History Press
Charleston, SC
www.historypress.com

Front cover, top: The brilliant colors of the roseate spoonbill, along with the bird's unique bill, are a tourist highlight. *Terry Baldwin.*
Back cover, bottom: Sea oats overlook the Gulf of Mexico at sunset on Sanibel Island. *Cameron Anholt.*

First published 2018

ISBN 9781540237088

Library of Congress Control Number: 2018952985

Notice: The information in this book is true and complete to the best of our knowledge. It is offered without guarantee on the part of the authors or The History Press. The authors and The History Press disclaim all liability in connection with the use of this book.

To the islands' families—past, present, and especially future.

CONTENTS

ACKNOWLEDGMENTS

For us, writing this book about our home has been a labor of love. To do so has brought memories flooding back and returned us to times when Sanibel and Captiva Islands were islands in every sense of the word. In those earlier days, we islanders shared an independent, self-sufficient and socially interconnected lifestyle. Neighbors helped neighbors, and we fiercely protected our unique islands. We especially want to acknowledge the role earlier islanders played in conserving this fragile place and in their teaching of newcomers the value of so doing.

In any history or scientific endeavor, so much that has been previously done to arrive at the present can never be adequately acknowledged. So many people have become anonymous with time, whether they wielded a pen, a shovel or a camera. We thank them all for their unheralded contributions.

Cameron (CJ) Anholt and Theresa (Terry) Baldwin have each contributed several of their finest photographs to this project, and their work has helped make this book much better. Terry has been a year-round resident of Sanibel for the past twenty years and has been a visitor to the area for more than thirty-one years. During this period, her love for capturing the beauty of the area's birds, animals and reptiles through her photographs has blossomed. She has been very fortunate in gaining local, state, national and international award recognition for her work. CJ loves the natural world around him, whether exploring by land, kayak or RV. Becoming an islander at the age of two, he has lived or worked here ever since. He has enjoyed growing up on Sanibel and continues to spread his fascination of the barrier islands through his photography of the nature around us all.

ACKNOWLEDGMENTS

Others have given permission for us to incorporate their art to depict the time before the development of photography. Institutions and several individuals have graciously given us permission to include their photographs, old and new, in our book. Images from the Sanibel Public Library helped put historical aspects of the early years of Sanibel and Captiva Islands into perspective. The donor of each image follows the caption of that illustration.

Wildlife Refuge Manager Paul Tritaik of J.N. "Ding" Darling National Wildlife Refuge Complex granted us the use of U.S. Fish and Wildlife Service photographs and provided periodic important updates on wildlife use and distribution on the refuge and Sanibel and Captiva Islands in general. Additionally, Kristie Seaman Anders, Chelle Koster Walton, Phyllis Gresham, Jim Griffith, Linda Estep, Joyce Matthys, Linda Edinburg and Holly Milbrandt kindly provided their perceptive accounts on some of our leading conservation organizations.

We also want to thank The History Press for their attention to our layout and design, and particularly, thanks to Abigail Fleming, Adam Ferrell and Amanda Irle, who have answered many questions as we have laid out our text and photography.

We each are grateful for the considerate support we received from our spouses. Jim and Jean gave us the time and space it took to meet the required effort necessary to create and finalize this project. Without them, our island lives would be incomplete.

INTRODUCTION

anibel and Captiva Islands are two popular coastal barrier islands in
Southwest Florida's Lee County. They are truly ecological marvels when
one compares them to most of Florida's other grossly overcrowded
and over-built barrier islands. Their special nature lies in the powerful
conservation ethic that is present and a sense of place that has been vibrantly
viable for well over one hundred years.

So how did it happen that the residents of these islands pursued the ethic
of conservation when many Floridians, whether on islands or mainland,
were damaging or destroying the very essence of what drew tourists and
residents to our shores in the first place? Why were these communities willing
to halt or slow the development flood that inundated the state? And how
did they manage it? The early years of Sanibel and Captiva's history did
not provide a clue to these questions. Development pressures on the islands
were as dramatic as in the rest of the state and began much earlier. Was it
simply luck? Determination? An awareness of the importance of nature? A
sense of community that had a common goal? A desire to save what seemed
unique and valuable? All of these things?

The word *conservation* connotes many things, from nearly complete
preservation to ethical use. To preserve a resource is to maintain it in an
original or an existing state, which cannot always be done or is even desirable.
On Sanibel and Captiva Islands, conservation efforts have developed in
multiple ways. Conservation safeguards the natural environment and its
ecosystems, such as flora and fauna. It also relates to human resources such

as architecture, human history and artifacts, museums, libraries and even the internet. Conservation is a balance between preservation and depletion gained through supervision and knowledgeable handling of resources to prevent deterioration, exploitation and wasteful use. It minimizes loss and implies wise usage, allowing some consumption without enabling depletion, including repair and restoration when needed. It implies a prudent and flexible approach to both natural and cultural resources.

When an ethical attribute is coupled with conservation, a moral principle develops and is applied by individuals and groups who affirm the need and the public's desire to apply conservation methodologies. The conservation ethic is a strong and powerful attribute of most residents of Sanibel and Captiva Islands. And many are generous to the extent that conservation programs will be funded and safeguarded into the future.

The history of conservation efforts on Sanibel and Captiva Islands involves a unique, long-established mindset of a parade of conservationists. These are persons, some unknown, others renowned, who were fortunate enough to visit or—like us—live permanently on Sanibel and Captiva Islands for an extended period of time. We both knew and interacted with many of those personalities and followed in their footsteps to serve the good work they had started. Those early conservationists contributed their time and treasure to ensure that the islands that they too once loved were properly nurtured into the future. For the most part, that concept has worked, proving their investments were wise and that a strong sense of environmental stewardship is alive and well on these islands. Many of these individuals provided the impetus for the conservation organizations on the islands, and these extend their reach and influence beyond our physical shoreline.

An important result of this conservationist outlook is that because islanders demonstrated how much they cared about their environment and other qualities of life such as the rate of growth and building densities, many mainlanders grew to consider residents of Sanibel and Captiva to be wealthy elitists. After all, the conservation ethic ruled here. This is a drastic change from the economic hierarchy that existed prior to 1963 in this region. If you lived permanently on Sanibel or Captiva before 1963, the residents of mainland Lee County considered you to be a second-class citizen because of the differences in the living standards between the barrier islands and the county's lone city at the time, Fort Myers. This attitude would diminish after Sanibel's connection to Punta Rassa by the first bridge in 1963. A decade later, privately owned subdivisions and other developed residential and multifamily lands resulted in Sanibel and Captiva

Islands being considered upscale bedroom and resort communities. The tables had turned.

Long before such social attitudes were manifested, these islands were remote, hostile and populated by only the hardiest elements of humanity. Following the first two episodes of European contact with the aboriginal inhabitants of the islands, the region's change was initially inconsequential. Three centuries would pass before humans would materially affect and change the region. We will discuss each era in a timeline format in the pages ahead.

There have been several historically oriented books written about Sanibel and Captiva Islands, among them works we have both contributed to and written. Ours and the works of others are listed in our bibliography section for your further reading. This is the first to examine and consolidate the historic struggles of individuals and groups united in a common cause to form a longstanding conservation ethic that has thrived and continues to expand into the twenty-first century.

To write this book, we have relied on over one hundred years of combined experiences. With our families, we have lived and worked as permanent year-round residents on Sanibel Island, and for much of that time, we shared common events. Independently, we are students of the biology, natural ecosystems, archaeology and human history of Sanibel and Captiva Islands. We each have contributed our time and talents to the conservation ethic of these islands. Please enjoy our historical compilation and do your part to hold the course and help nurture the conservation ethic you have discovered here.

—Betty Anholt and Charles LeBuff

1
ABOUT THE ISLANDS

T he geology of the islands is fundamental to their story.

Sanibel and Captiva Islands are located a few miles off the Florida mainland in the Gulf of Mexico—about 16.7 miles, as the crow flies, from central Fort Myers, the Lee County seat. Both islands are among an erratically arranged coast-paralleling chain of barrier islands. These extend south from Tampa Bay's Manatee County to reach Cape Romano and the upper Ten Thousand Islands near Marco Island in Collier County. This chain of mostly narrow islands is approximately 131 miles long.

Two major estuaries have important roles in the immediate region. One of them, the Charlotte Harbor Estuary, is situated at the north end of eighteen-mile-long Pine Island Sound. The other, the Caloosahatchee Estuary, is positioned at the south end of the sound and abuts Sanibel Island. The marine waters of the Gulf and the estuarine waters of Pine Island Sound mix, surrounding Sanibel and Captiva Islands with a complex and productive marine ecosystem.

Along the span of the chain of barrier islands, the broad entrance of San Carlos Bay separates the islands from the mainland for the greatest distance. There are 2.9 miles of open water from Sanibel's easternmost point, Point Ybel, to the northernmost point of Estero Island (Fort Myers Beach), known as Bowditch Point. Sanibel Island is atypical for a barrier island. Along the Florida Peninsula, most barrier islands are aligned north–south, roughly parallel to the mainland, but Sanibel is geologically positioned in an east–west orientation. Its westerly shoreline begins a sweeping bend to the

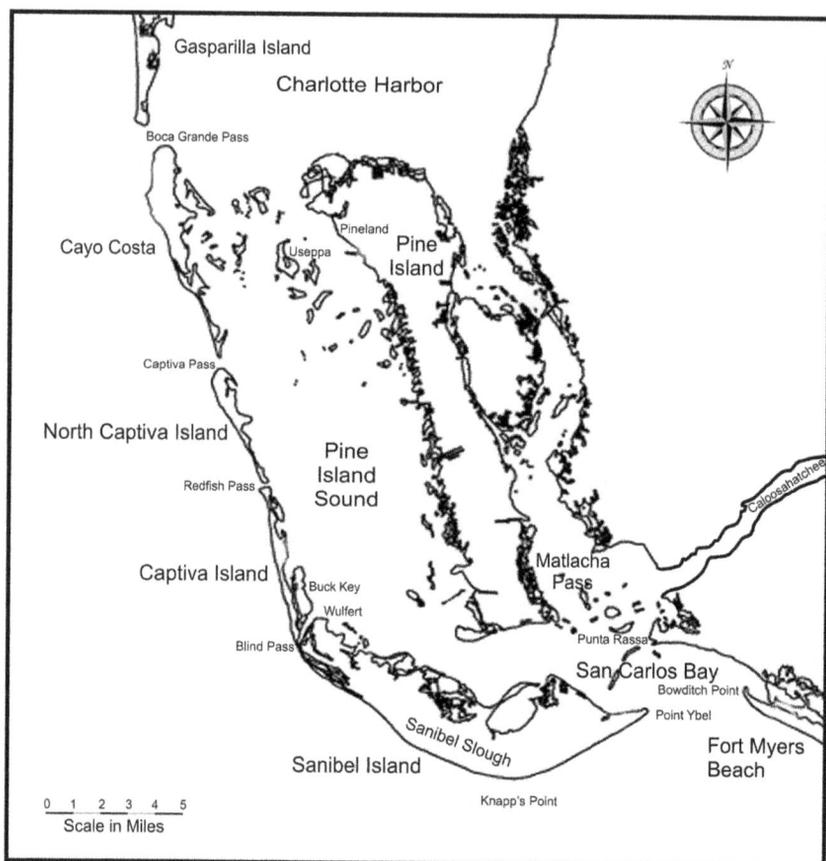

Map showing relevant sites in the Pine Island Sound vicinity of Southwest Florida. *Charles LeBuff.*

north at Knapp's Point (see map above). The position of this "point" is the southernmost projection of Sanibel Island. Knapp's Point is actually located some 10.4 miles farther seaward than any barrier island positioned south of San Carlos Bay.

The southern end of Captiva Island reaches considerably farther seaward. Using similar straight-line measurements, Captiva's tip is positioned 17.1 miles west of Bowditch Point on Estero Island and is 6.7 miles farther out in the Gulf of Mexico than Knapp's Point. We will return later to this unusual offset configuration and discuss how this oddity relates to important historical events and the biological diversity of our subject islands.

Voters on Sanibel Island supported a popular movement to incorporate, and the City of Sanibel was born in 1974. The city's corporate limits comprise 11,600 acres of uplands and wetlands. Much of this acreage includes unspoiled wilderness mangrove forest and tidal bay bottoms.

Along its vulnerable west-facing Gulf of Mexico shoreline, unincorporated Captiva Island has been constantly eroding since Redfish Pass opened nearly a century ago. More powerful wave dynamics are in play here. They are much stronger than those of moderate-to-low energy that influence much of neighboring Sanibel Island's Gulf shoreline. Because of its curvature, the oceanic wave energy striking eastern Sanibel Island is diminished. The energy generated by sea swell produces waves that continue to pummel Captiva and dislodge beach soils. Periodically, millions of dollars are expended to renourish its beach and parts of northern Sanibel's. Anecdotal information tells us that about 1,500 feet of Captiva's width have eroded—disappeared—since 1903. That is equivalent to an approximate loss of 910 acres of land in 115 years.

The Gulf's littoral current transports the loosened suspended solids to the south, where they may accrete to Sanibel or continue to flow to reach more southerly positioned members of the barrier island chain. Today, 5-mile-long Captiva Island contains approximately 760 acres of land that is mostly developed as residential or resort multifamily properties. Pristine Buck Key is tucked behind Captiva. One family was still in residence there until at least 1960, and the island has since been ditched by the Lee County Mosquito Control District for mosquito abatement. Sanibel Island is 10.6 miles long (straight line from Point Ybel to the foot of the Blind Pass Bridge), and at its widest extremity, the island is approximately 3 miles across. Because of the curvature of the island, its beautiful Gulf-front beach is 12 miles long.

Sanibel Island is the largest land mass in the barrier island chain of Southwest Florida. Nearby and almost totally beachless is mangrove-bordered Pine Island, not a barrier island. It is positioned five miles across Pine Island Sound from Captiva, where it hugs the mainland. At the closest point, Sanibel Island is nearly two miles from Pine Island. Pine Island is the largest island in the state of Florida.

A series of inlets, or *passes*, as they are known on the Gulf Coast, separate the islands from one another and allow tidal interchange. Ever-changing and sometimes closed, Blind Pass separates Sanibel from Captiva. Because of southerly sand drift eroding Captiva, the two islands can be connected by continuous beach as they were at times in the past, between 1967 and 1972, and for shorter periods of time since.

Redfish Pass has separated Captiva from North Captiva (formerly called Upper Captiva) since a major hurricane breached a narrow section of Captiva and formed the two island entities in 1921. Hurricanes were not named in those days. The water that passes through Redfish Pass during the ebb and flow of the tide moves with great velocity because of a Venturi effect. When the pass was scoured out by the 1921 hurricane's surf energy and storm surge, it reached its depth and width so quickly that natural accretion of sand was unable to plug the opening.

With Redfish Pass functioning so well, the value of Blind Pass for water interchange has diminished since 1921. Blind Pass's periodic closing and shifting of its Gulf-side opening is testimony to its lack of importance to the natural hydrology of Pine Island Sound. Blind Pass is an old name—in the 1500s, the Spanish named it Boca Seca, which translates to Dry or Blind Mouth. The pass has always been marginal.

Sanibel and Captiva Islands are within the Northern Hemisphere's subtropical zone. Annually, island air temperatures average 74° Fahrenheit (F). The annual precipitation in the form of rain falling on Sanibel Island averages 55.93 inches. Daily rain records kept by one author for more than thirty-five years show annual variations from a low of 32.75 inches in 1988 to a high of 106.48 inches in 1995. Ice has briefly formed on the islands in outside water containers, and short-lived snowfall occurred as recently as 1989. The temperature on Sanibel reached a record low 22°F in December 1962.

The terrain of Sanibel Island averages four feet above mean sea level, and the highest natural elevation on the island is thirteen feet. Some ancient Calusa Indian middens scattered about the island may have been higher originally, but they have been diminished in height because of both long-term weathering and leveling by homesteaders around the beginning of the twentieth century, when the islands flourished with an agricultural- and fishery-based economy.

EARLY SPANISH INFLUENCE

outhwest Florida's geology has always played a major role in the lives of its inhabitants, ever since natives were first known to inhabit the peninsula, twelve thousand and no doubt more years ago. Its flat topography, tidal influences, storms and sea level variations have defined how and where buildings and towns have been placed—and much more.

Sea level is never actually level, or stable. The obvious changes of the tide are clear, but winter and summer temperature, wind and its fetch, currents, gravitational pull of the moon and sun, rainfall and storms all contribute to changes, both short- and long-term. From a distance, the melting or freezing of glaciers and continental ice affects southern shorelines. The Florida Indians that we call the Calusa were well aware of the characteristics of their waterways. In large part, they lived their lives around their interpretation of it. While they, like us, built and lived close to the shoreline, they were more flexible in moving their houses and belongings than we can be. Normal shoreline changes have morphed into beach erosion for us, as we cannot withdraw as easily from our immobile structures.

Long before Sanibel and Captiva, as well as many other of the barrier and estuary islands, existed, the natives on a much wider and drier Florida peninsula gathered around sinkholes, or cenotes, that offered access to fresh water. Just to our north, Little Salt Spring and Warm Mineral Springs have provided substantial evidence of human residence from thousands of years ago. At that time, the coastline was far west of our current beaches. These natives of some ten to twelve thousand years ago left tools since found in the springs,

such as the famous example of an extinct land tortoise that had been killed with a spear or stake. Many other artifacts have been found and dated over the years, including human remains. These natives would have been hunter-gatherers, often traveling to find resident and migratory animals and plants. The dry savanna of twelve thousand years ago emphasized the importance of the occasional springs, where a thinner portion of the karst or limestone cap allowed water to reach the surface. This water could be fresh, brackish or nearly the salinity of sea water, and it usually was both warm and differing in chemistry from Gulf waters, as it traveled through the sponge-like rock of the Floridan aquifer, increasing calcium and decreasing magnesium levels.

Our local islands would have been nearly in the center of Florida's peninsula at that time. A spring named the "Mudhole" that is now about eleven miles offshore from Sanibel's beach at latitude 26°15.837 north and longitude 82° 01.047 west was likely another habitation site for the early Indian groups living here. Now submerged at about fifteen feet, this submarine spring (defined by Shihadah M. Saleem as "a spring that discharges below sea level in a coastal salt-water environment") and a half-dozen others nearby continue to flow from the continental shelf. According to geologists, these are associated with many land springs, including Warm Mineral Springs. Across the grasses of a much wider Florida peninsula, the springs were an obvious draw for hunting wildlife as well and became a source of food and water for humans.

Sea level rose, and on our west coast, the flat land was quickly overrun by the sea. It's probable that significant native populations lived on the shore at that time, but the evidence of their lives is now underwater at the edge of the continental shelf, as much as one hundred miles off the current beach. Perhaps underwater archaeology will progress to a point that information from that area can be gathered. Is it possible that natives living at the Gulf of Mexico's edge ten thousand years ago were ancestors of the Calusa of one thousand years ago and moved easterly as the sea level rose?

Once sea levels stabilized some five thousand years ago, longshore currents gradually shaped barrier islands like Cayo Costa, Captiva and Sanibel, and their slow emergence and growth from sandbar to island allowed the formation of shallow estuary waters between them and the mainland. The mix of salt water with the fresh water from creeks and rivers and rainfall produced a less saline environment that encouraged nurseries for marine creatures from fish to plants and attracted birds and mammals to patrol there for their meals. Native Floridians were quick to adapt to the bounty that the estuary offered.

Today, we can see evidence of some of the mounds and middens built by the Calusa in the last several hundred years, although many such sites have been dismantled or destroyed. For many years, the Indian history of Southwest Florida was overlooked, and the few archaeologists who visited the area weren't well heard, despite the fact that much of Florida's history with Europeans originated here more than five hundred years ago.

In the last thirty or forty years, we have learned quite a bit about the Calusa from scientific archaeological study. In addition, the examination and discovery of more historical documents have given insights from the point of view of the Spanish explorers, priests and government. Both of these avenues are irreplaceable, but they mirror and interpret the Calusa and in a sometimes distorted way. It is unfortunate that we will never be able to hear directly from the natives themselves, as they are extinct and left no written record other than that of the ground and water they once lived upon.

Documents from the Spanish give their viewpoint of the Calusa from 1513 to the natives' final exodus from Florida in 1763.

Juan Ponce de León y Figueroa "discovered" what he considered to be the "island" of Florida in the spring of 1513, sailing from Puerto Rico through the Bahamas to land first along the upper east coast of the current state. He then traveled south in exploration of the coast. His expedition consisted of three ships, the *Santiago*, the *Santa Maria de la Consolación* and the *San Cristóbal*, with an estimated total of sixty to seventy people, including one woman. During his trip—while trying to stay far enough offshore for the safety of his ships—in the vicinity of current West Palm Beach, he found that he could not make any headway because the current flowing north was too strong. It averages about five miles per hour flowing north. He had to hug the shoreline to sail south. He had discovered the Gulf Stream, a significant bonus for Spanish treasure ships returning to Spain in later years.

Ponce made stops along the way for water and exploration. One stop was near the Miami River, where the Tequesta, one of several native groups subservient to the Calusa, lived. They cruised along the Florida Keys, the "Martyrs," and turned north. In all probability, the explorers entered San Carlos Bay in late May. As they coasted along the western shore, they encountered Sanibel as it reached out into the open Gulf. Ponce described the island, with its unusual barrier island configuration, as "islands that make out to the sea," a surprising and definitive landmark coming from the south for the mariner.

It required them to sail farther out into the open water, and they traveled to what many historians think is the mouth of Charlotte Harbor, Boca

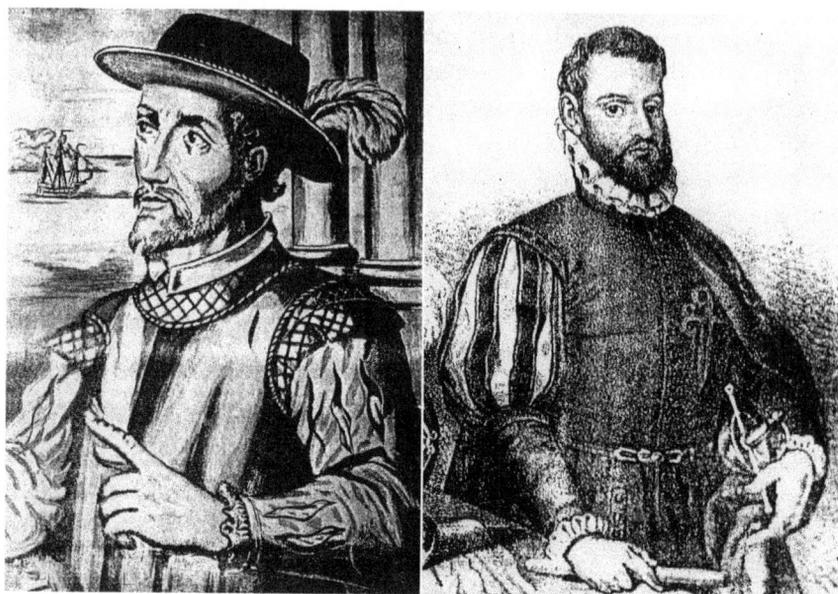

Juan Ponce de León (*left*) and Pedro Menéndez de Avilés, Florida adelantados in the sixteenth century. *Sanibel Public Library*.

Grande Pass, before turning south and entering the much wider bay opening between Sanibel and Estero Islands. In the few weeks the expedition spent here, the Spanish and the Calusa encountered each other with suspicion. Although this was supposedly the first time Europeans found Florida, the reality is that slaving raids on the peninsula and other islands were well known by the tribes here, and natives had been transported to Puerto Rico and other islands to work the fields and pan for gold and other minerals. The Calusa controlled much of the southern peninsula of Florida at the time the Spanish arrived, and their communication system, from the Keys to Lake Okeechobee to the Miami River and north, worked efficiently. In fact, the chief, or cacique, of the Calusa, Senquene, had allowed a number of refugees from Cuba—when the island was overrun by the Spanish in 1511—to settle within his domain. The conquest of Cuba by Diego Velázquez de Cuéllar and his cohort Pánfilo de Narváez was brutal. The natives were well familiar with what the ships on their horizon meant, and they did not welcome them.

By this time, after some months at sea in tropical waters, Ponce needed to clean the hull of the *San Cristóbal* of the barnacles and seaweed that had grown during the long spring trip. The shallow, protected waters of the bay allowed the Spanish to careen the ship to scrape and recaulk the wooden

hull. Notably, an Indian sent by the Calusan cacique to interact with the Spanish and determine the reason for their presence during this process understood enough Spanish to communicate with Ponce. He may have been a refugee from Cuba. The pretended welcome from the Indians was followed by attacks from war canoes in an effort to chase off the intruders. Nevertheless, Ponce and his crew, including pilot Antón de Alaminos, were able to absorb a good deal about the location. In particular, the freshwater interior of Sanibel was noted as a good watering place. It is probable that Alaminos and Ponce had discussed the possible benefits of the area's location as a stopping place for potential trade routes. Once the ships were repaired, the expedition headed back to Puerto Rico by way of the Tortugas, where they took on nearly two hundred sea turtles and more than a dozen West Indian monk seals (now extinct).

Although Ponce didn't return to Florida's west coast for eight years, he was named *adelantado*, or governor, of Florida and Bimini for his discoveries, and he was granted permission to settle a colony there. A governor of a region implies a settled or "pacified" area, while the term *adelantado* indicates a region not in total control, a frontier. In that interim, he was knighted and received a personal coat of arms. Ponce was a farmer, running a profitable enterprise on Española—the island now called Hispaniola, which contains the nations of Haiti and the Dominican Republic—on land awarded him in 1502 for his services to the king. He founded the town of Salvaleón in Higüey Province, the easternmost province of what is now the Dominican Republic. He supplied foodstuffs to ships outfitting to explore or to return to Spain, and he also supplied his explorations from his farming operation.

Several other discovery voyages by other Spanish occurred, particularly after Havana was established in about 1515, allowing a closer starting point for expeditions. Some explorers who passed or stopped along the Calusan coast included Diego Miruelo in 1516, Francisco Hernández de Córdova in 1517 and Alonzo Álvarez de Pineda in 1519. Ponce's pilot, Alaminos, became pilot for Hernández on a slaving expedition to the Yucatan. They were attacked at two locations there, and in fleeing back to Cuba, they were desperate for fresh water. Alaminos suggested they return via Florida, as he knew how to find "Ponce's watering place"—presumably Sanibel Island. Hernández had been wounded ten times with arrows, and Alaminos, on the flagship, was essentially the fleet commander. When they landed and went for water, the Calusa attacked both the landing party of twenty Spaniards and a ship. Alaminos and Bernal Diaz in the landing party were wounded, but the party drove off the Indians and freed the ship that the Calusa had

captured and were towing upstream by that time. Diaz later wrote that more than twenty Indians were killed and the only man not wounded during the Yucatan battles was captured by the Calusa. They managed to get water aboard the ships and hurried back to Cuba, although the flagship grounded in the Florida Keys en route. A few days after reaching Havana, Hernández died of his wounds, likely from infection.

Alaminos had a long and storied career as a pilot. He sailed on Christopher Columbus's fourth voyage as an apprentice pilot in 1502, and in addition to his voyages with Ponce and Hernández, he piloted Juan de Grijalva to Vera Cruz, Mexico, later using it for the Cortés landing site and becoming the chief pilot for Cortés during his conquest of Mexico. He also recognized that the Gulf Stream current originated in the Florida Straits, which made the infant city of Havana central to Spanish shipping.

Although encounters between the Spanish and Calusa were few, the natives knew the time when such skirmishes would become larger encounters was inevitably drawing nearer. That cloud over their heads would continue to disturb their way of life.

Ponce returned to San Carlos Bay in February 1521 with two ships full of colonists, their farming supplies, animals and possessions, most of which came from his farm on Española. He understood that an expedition, or an army, did travel on its stomach. Supplies were essential to success, a reality on which many other expeditions fell short. His mission was to establish a colony and explore the region. It is likely the colony attempt would have been on the mainland near the mouth of the Caloosahatchee. The Calusa were not happy to see the Spanish return, and tensions were high. Shortly after the ships' arrival, the natives attacked and routed the colonists in a fierce battle, likely in June. Ponce de León was shot by an arrow in the thigh or buttocks during the fight. His ship retreated to Havana, while the other ship sailed to Mexico to join Cortés and reported the collapse of the attempted settlement. Ponce died of his wound ten days later, in the same manner as Hernández did four years earlier.

Although other explorers, notably Narváez and Hernando de Soto, passed by the Calusa domain, the natives were left alone due to their reputation for fierceness and danger. From 1521 until the arrival of Pedro Menéndez de Avilés in 1566, the only Spanish to arrive in Southwest Florida were unwilling ones—either captives or refugees from shipwrecks in the Florida Keys or east coast, sent to the cacique as tribute. Most died or were killed, due to extreme conditions of living, sacrifice by the Calusa to their gods or fighting with their captors. Some captives adapted to Indian life, even

marrying, raising children and refusing to leave the tribe when rescue was at hand. Notable of these captives were two young boys, Juan Ortiz and Hernando d'Escalante Fontaneda. Ortiz and three others were accidently left behind by a ship searching for the lost Narváez expedition and held captive for ten years, until the Hernando de Soto expedition arrived in the Tampa Bay region in 1539. He served as an interpreter for de Soto until his death in Arkansas in 1541. Fontaneda, a thirteen-year-old from Colombia, after seventeen years of imprisonment with the Calusa, was rescued in 1566, used by Menéndez as an interpreter and then went to Spain, where he wrote a valuable account of his years with the Calusa.

In addition, we have letters and commentary from Menéndez's efforts with the Calusa and letters from his party's Jesuit leader, Father Juan Rogel, who spent time with the soldiers and the Calusa on Mound Key, the head town of the tribe, and interpreted what he saw through his Catholic point of view.

As might be imagined, there was never any trust or comfortable feelings between the natives and the Spanish. The Calusa were seen as sly, devious, dangerous and unwilling to bend to the will of the Spanish, and the Spanish tried to force Catholicism on the natives' belief system in addition to breaking perceived promises and failing to provide protection, or provisions, to the Indians. With little or no understanding of each other, an inevitable tragedy lurked.

The Calusa society had reached a peak in the sixteenth century. These were not a primitive people. They could be considered wealthy in that they were powerful and received tribute from all areas of the southern peninsula. Their military force was formidable and elite. The royals practiced sibling marriage. They had developed fishing technologies that fed their towns without having to work incessantly and turned spare time into artistic endeavors. They built infrastructure, canal systems, water courts and permanent town centers, middens and mounds. Their population was stratified, broken into a number of social levels, with the ruling leaders thought to be able to control the weather and skies. Dynamic weather changes and storms were a significant threat to the well-being of the tribe, and controlling the heavens was essential.

Their religion involved an afterlife and offerings to their ancestors. The leader of the kingdom, one of three of the greatest importance, was accompanied by his war leader and his shaman, or religious leader. Their combined power was absolute. They held control over as many as seventy towns, requiring obedience. Apart from these noblemen and their staff

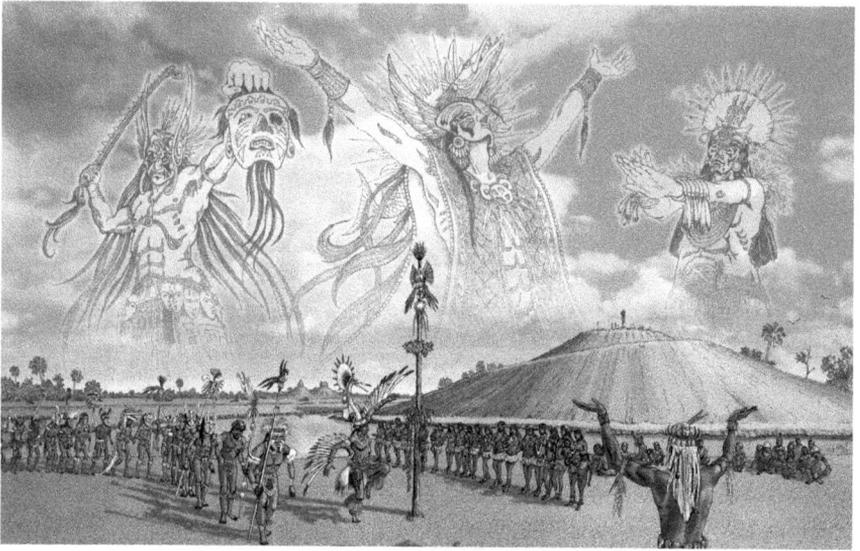

Depiction of a spiritual ceremony of the Calusa as envisioned by illustrator Merald Clark. *Art by Merald Clark, courtesy Florida Museum of Natural History.*

and protectors, all related by birth, were the artisans who created religious objects and war objects, through carving, painting and working with shell. They made netting, fish traps, pottery and shell tools. They swam, dove in passes to spear fish, built canoes, catamarans and large assembly buildings and played games. They traded over long distances. They gambled, hunted, sang, worshipped, told stories and raised their children in loving ways.

The Calusa were not farmers, and they rejected the concept of tilling crops when the Spanish tried to introduce them to it. Undoubtedly, they had food plants growing near their houses, but such growths were occasional or accidental. They did gather plants, foraging in season. After all, they had the bounty of the sea and knew how to both conserve and use it.

The consequences of the early arrivals of the Spanish disturbed what may have been, at least for parts of the Calusa domain, an idyllic life. Even though they were avoided for nearly fifty years between Ponce's ill-fated colonization attempt and Menéndez's appearance in 1566, tremors from other parts of the peninsula affected the politics of the people and led to dissension and contention regarding how to deal with the invaders.

Pedro Menéndez de Avilés arrived in Southwest Florida in 1566. He had been appointed adelantado of Florida as had Ponce de León years earlier. In

September 1565, Menéndez ousted the French from Northeast Florida in a series of religious battles, Spanish Catholicism versus French Protestantism, that left a lasting stain on his reputation. He massacred all vanquished French, who were deemed heretics. Florida had been saved for Catholic Spain. Menéndez had several objectives. He had heard that the Calusa had a number of European captives, largely from foundered ships. His only son, Juan, was captaining a treasure fleet in 1563 when it disappeared somewhere near Florida in a storm. Menéndez was hoping to find him.

Another objective was finding or making a passageway across Florida that avoided the dangerous, particularly in the storm season, Florida Straits. The many treasure ships, like the one helmed by his son, faced uncertain weather conditions in that narrow strait leading to the Gulf Stream and the boost of its current toward Spain. If there was a connection on the west coast leading to the abundant waters of the St. Johns River, much of the danger and loss of the treasure ships coming out of Mexico would be alleviated.

Yet another objective was bringing the true religion to the natives. While the French Huguenots were heretics who refused the true faith of Catholicism, Indians were merely heathens. They had not been shown the one true way. Their religion was only some pagan ritual. Menéndez would bring Jesuits, and later Franciscan priests, to the tribes, to bring more souls to the Catholic Church.

Carlos, the cacique of the Calusa, was already planning to deceive the Spanish when Menéndez hove into view. The Spanish adelantado had much the same idea. Menéndez asked for any Calusan captives to be brought to him. Carlos doled out some and tried to tempt Menéndez into a trap onshore. Failing that, he invited the Spanish to a large assembly with food, dancing and singing. Menéndez and his troops came, and Carlos decided to get the Spanish on his side by presenting his elder sister

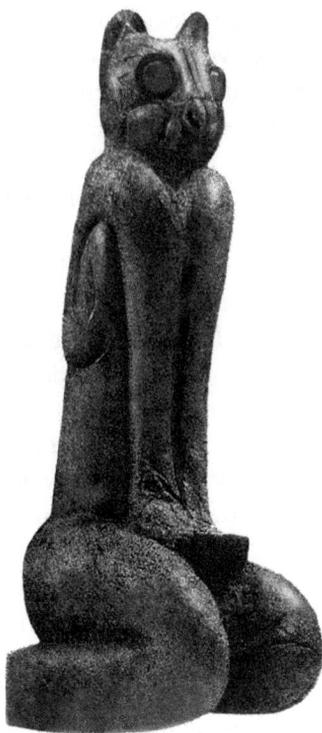

The Key Marco Cat, reproduced by artist Warren Boutchia. *Warren Boutchia.*

to Menéndez in marriage. The one-upmanship continued until both sides thought they had come out on top.

Carlos wanted the Spanish to help him defeat the Tocobaga around today's Tampa Bay. The Tocobaga had been encroaching on Calusa territories, picking off towns that had been paying tribute to Carlos. Menéndez wanted to see if there was a route from one of Tampa Bay's rivers that would reach to the St. Johns River, something that might be known by the Tocobaga. When the two sailed north to confront/conference with the tribe, Carlos felt betrayed when Menéndez refused to attack them and he became abusive. It was only one of many sparring matches.

Carlos was the supreme leader of the Calusa, but his ascendency to the position was flawed. The man who was his second in command, named by the Spanish as Felipe, had actually been in line for the throne but had been eased out in a political move by his uncle, Carlos's father. Carlos was fighting a battle on several fronts. He was trying to consolidate his right to his head cacique position, dealing with the Spanish and their demands, fighting with the Tocobaga as they smelled dissension in the Calusa regime and wary of moves by his cousin, Felipe. He was forced to accept a contingent of soldiers to be stationed at his Mound Key head town, and a fort was built under the leadership of Captain Francisco Reinoso. The fort was described thusly in *Missions to the Calusa*: "The year of (15)66 the adelantado Pedro Menéndez put a settlement in the Bay of Carlos on an islet that is in the middle (of it), with thirty-six houses encircled with brushwood faggots and lumber."

Later, Menéndez brought in Father Juan Rogel to catechize and baptize the Indians. The priest demanded that the Calusa give up their worship, which meant for Carlos that he would no longer be a legitimate leader. It was untenable. Before long, Carlos erupted and Captain Reinoso killed him, installing Felipe as the new head of the tribe.

Felipe was in the same position Carlos had been. He could not disavow his religion, which the priest and Menéndez required. He postponed and did his best to delay and deter the Spanish, while more Calusa towns lost faith in his leadership. Soon he attacked his own advisory group and the lesser chiefs of the recalcitrant towns and danced with the decapitated heads of some fifteen of his enemies. The collapse frightened the soldiers in the fort, and soon Felipe was also killed. By this point, the residents of the town burned their houses and fled. Without the Indians, Fort San Antón could no longer function, and the Calusa were left alone for decades to repair their society.

The society did not fully recover. More incursions occurred, as the Spanish, and later the English, continued to covet the area. Cuban fishermen began coming to South Florida in winter for mullet, salting or drying the fish to sell in Cuba. Sailing vessels also arrived for a variety of live fish stored in live wells onboard ship. Trade, and smuggling, increased. By 1763, the English had obtained Florida from the Spanish in a trade for the city of Havana. The Calusa had been overcome and preferred to stay with the Spanish rather than the English with their Creek Indians armed with guns. They quickly fled to the Keys and Cuba.

The value of the written history from the contact period cannot be measured. Despite the insights being one-sided—those of the Spanish— from a perspective of five hundred years, more or less, we glimpse some of the day-by-day activities of the Indians as perceived by the Europeans, whether soldiers, priests or captives. Nevertheless, it is a photograph of a moment in time, and it is not clear how their society got to that point. When multiple disciplines of science also come to bear, additional answers and questions emerge. Examination of soils, climate, bones, wood fragments, shell, charcoal, decorative items, pottery and so much more gradually tells a story. Archaeology, by its nature, is a science of multiple parts—botany, zoology, geology, engineering and even art—that furthers our knowledge of the past. It can look deeply into time and track movement, expansion and destruction of groups of people and the way they lived.

The first archaeologists visiting the Sanibel environs saw significant evidence of the Calusa, but in the late 1800s, few people who were homesteading in the region had interest. The mysterious shell mounds were treated as reservoirs of building material for roads and tabby buildings. Frank Hamilton Cushing passed through Charlotte Harbor and the Pine Island Sound on his way to examine Marco Island finds on the Pepper-Hearst Expedition. A forerunner in his field, Cushing was a controversial man who was in and out of favor, but he was strongly supported by John Wesley Powell, director of the U.S. Geological Survey and the Bureau of Ethnology at the Smithsonian.

Due in part to a hurricane and a winter freeze that had stripped the landscape of concealing vegetation, Cushing had a clear look at the many mounds in the estuary as he sailed south. He estimated that between Charlotte Harbor and Sanibel there were more than seventy-five mounds, with over forty "gigantic" ones. He said that there were no doubt many others, "but the amount of work represented even by the number I have already named is so enormous and astounding, that it cannot be realized or appreciated."

Frank Hamilton Cushing, archaeologist. Cushing explored the islands of Southwest Florida, uncovering the invaluable site at Key Marco, and worked and lived with the Zuni in Arizona. *Public domain.*

Cushing stopped at Sanybel, at Ellis (now Tarpon) Bay, to examine and take with him some skulls found there by homesteader Captain Samuel Ellis, who was "whole-souled," courteous and helpful to him. The Anglicized place name Sanybel is believed by some scholars to have corrupted that

which appeared on early Spanish charts, originally Puerto S. Nivel, which translates to "South Level Port." Various spellings such as Sanybel, Sinnabel, Sanybal, Sannibal and so forth have evolved in recent years to a standard spelling of Sanibel. Pronunciation continues to be disputed. Both en route to Marco and on his return, Cushing visited the Ellises and the Barnes homestead at the Sisters on the Gulf (now Casa Ybel). Cushing's finds at Marco Island put Southwest Florida on the archaeological map.

Others quickly followed up once the news spread. Clarence B. Moore spent time digging in various spots throughout San Carlos Bay and Pine Island Sound at the start of the twentieth century. A prolific amateur archaeologist, Moore was hoping to best Cushing's discoveries, which he did not manage, but he did document a considerable amount of material from our area. Several others visited and even listed sites for Florida's Master Site File, but it would be decades before systematic investigations began.

AMERICA REACHES SOUTHWEST FLORIDA

Within twelve years of the United States' acquisition of Florida as a territory, the islands of Sanybel and Captiva, as well as some of the mainland, were under the development gun. Although the area had not yet been seen by the potential developers and no real concept of what might be produced or existed was available, the controlling factor was the rush to be first on the scene.

The story began long before. From the time it was first claimed by Europeans in 1513, Florida was controlled by Spain. Frequently at war with other nations, and never entirely comfortable with the huge territory—by the mid-1700s, it stretched to the Mississippi River—during the French and Indian War, Spain lost the city of Havana to the British. In consequence, in the 1763 Treaty of Paris, Spain traded its territory of Florida for the Cuban city. It was a logical move, as the Caribbean was where Spain dominated, and the English controlled what would become shortly thereafter the United States of America. Both countries benefitted—or thought they did.

As the British began to populate (mostly) northern Florida—around the St. Johns River and the northern Gulf Coast—aboriginal Florida Indians, or the few remnants remaining, left the area, largely for Cuba. They were accustomed to the Spanish and to Catholicism, and the English, who were not interested in sharing the land or its bounty, brought with them Creek Indians from Georgia and Alabama. The English armed the Creek with weapons and made slave raids on the native Florida tribes. Soon, few, if any, native Indians were left in Florida.

Things didn't go smoothly for the English. Florida, big and empty, was a different animal than much of the rest of their America. Crops flourished and failed, rich soil turned barren, drought was followed by unceasing rain and storms. Even more, the colonies to the north were restless, and before long, the English found themselves in another war, the American Revolutionary War. They eventually discovered themselves on the losing end, and the second Treaty of Paris, ending the American Revolution in 1783, had England giving up Florida, returning it to Spain. Their twenty-year experiment was finished.

Although Spain now possessed Florida again, it wasn't in a better position than it had been previously. The Spanish had lost most of the native Indians, while other southeastern groups had begun moving into the empty lands, many running cattle in the Alachua (Gainesville) area and others fanning out through the upper part of the peninsula. In time, these groups would loosely coalesce into the Seminole and Miccosukee tribes. And now Spanish Florida had an expanding new country on its border, flush with success and ready to explore and inhabit new country. It was an inevitable clash.

Raids began from the north, over the border, some famously led by Andrew Jackson. It didn't take long. Spain was in debt to the United States for some $5 million, and the Adams-Onís Treaty, worked out from 1819 to 1822, resulted in the United States acquiring the territory of Florida from Spain in forgiveness of those debts.

But King Ferdinand VII of Spain, had, he thought, one ace up his sleeve. As the treaty was being worked out, he made a series of land grants to his friends and petitioners, including the Duke of Allagon. The Allagon Grant covered much of the western peninsula of Florida, several million acres. This included a deal by the duke with the Madrid, Spain consul—Richard S. Hackley of Richmond, Virginia—for half of the grant. Hackley was a New York merchant and highly placed in the government. The grants were questionable and eventually declared invalid, but legal arguments as to their validity continued into the twentieth century. In 1905, the claims of ownership by both Richard Hackley and the Florida Land Company were finally invalidated in court. It's hard to imagine the consequences had the ruling gone in the opposite direction.

In 1828, Key West incorporated, becoming the most important Florida port and town due to its strategic location along the Florida Straits. Hackley's two sons were sent to Florida: William R. Hackley to Key West, where he became a town councilman, and Robert to Tampa. Richard Hackley was positioning himself and his family to be developmental tycoons. The following year, Dr. Benjamin Beard Strobel also came to Key West.

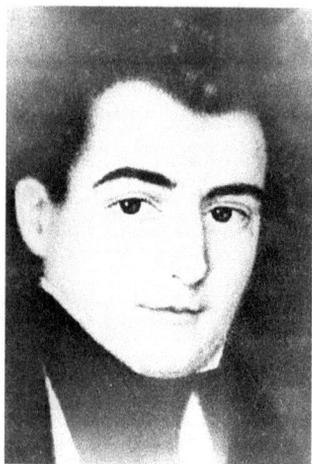

Dr. Benjamin Beard Strobel: naturalist, adventurer and physician. Strobel first explored Sanibel and Captiva Islands in 1833. *Florida Historical Society.*

He made quite an impression.

Strobel was a young man, born in 1803 in Charleston, South Carolina, another major port in the United States' early history. Always intrigued by the natural world, he soon became a naturalist. He became friends with the Reverend John Bachman of Charleston's Lutheran St. John's Church. Bachman was a social reformer, and decades before the Civil War, his church was integrated, despite being in the heart of slave country. Bachman, also a well-known naturalist and birder, and Strobel spent many hours exploring the wilds near their town. Perhaps as a consequence of this naturalist bent, Strobel became interested in anatomy and, in 1826, obtained a medical degree. He was described as "outspoken and frequently 'on his feet'" by colleagues, evidently never afraid to express his opinion.

When Strobel arrived in Key West in September 1829, a yellow fever epidemic was raging. He pitched in immediately, quickly becoming well known and appreciated. In the following two and a half years, he worked with the town's population as a medical doctor and became post surgeon to the military and the health and quarantine officer. In addition, he established and published the *Key West Gazette* and became a town councilman, along with William Hackley. As integral to the town as he became, Strobel had ambivalent feelings about Key West. He was not willing to see it as an "unblemished paradise." His outspokenness and ability to editorialize in his newspaper led to occasional clashes, particularly with a fellow Key West councilman named David Coffin Pinkham.

Meanwhile, Strobel's friend the Reverend Bachman discovered a small warbler with a black bib in the South Carolina canebrakes. Thinking it a possible new species, he sent the bird's skins to John James Audubon for identification. After a time, Audubon named the warbler after its discoverer, the Bachman's warbler. The communications between the two prominent birders led to a friendship and eventually even marriage between their children. Bachman suggested Audubon look up his friend Strobel when he made his planned 1832 trip through the Florida Keys to the island of Key West on the revenue cutter *Marion*. Strobel guided

Audubon to a number of birding sites in the lower Keys, including those of the roseate spoonbills.

Consul Richard Hackley forged ahead with plans for the land grant. After all, he knew many influential people. His wife, Harriet Randolph Hackley, was one of several children of Thomas Mann Randolph, sister to Governor Thomas Mann Randolph Jr. He had called Thomas Jefferson and James Madison friends. He was sure the somewhat shady grants would eventually resolve in his favor. He had placed his sons in logical places to control local politics, and in 1831, the Florida Land Company was formed in New York. Hackley sold an option on a part portion of the clouded title to the land company.

In June 1832, Richard Hackley met in Key West with his son William; the marshal of Key West, P.B. Prior; and a representative of the land company, a Colonel (or Major, or Judge) George A. (or W.) Murray. Murray had had a rather checkered career in the Keys and had been accused of incompetency, reneging on land sales of the island of Key West and Cape Florida property and more. He seemed to be an early example of the shady side of real estate dealings in Florida. A plan for profiting from the king of Spain's gift of a wide swath of Florida land was set into motion.

William R. Hackley, Marshal Prior and Murray set off to explore the disputed land grant area. They hired Captain William Bunce of the sloop *Associate* and his five-man crew. Bunce was a customs inspector and well-known and respected operator of fishing ranchos along the Southwest Florida coast up to Tampa Bay. He was a good choice, as he was very familiar with the Southwest Florida coast. They explored for three months, until September, examining Charlotte Harbor, Myakka River, the Peace River, Pine Island Sound, the Ten Thousand Islands and the Caloosahatchee nearly to Lake Okeechobee. They commented on the abundance of waterfowl, the cultivated islands in "Sanybal Sound" tended by the men of the fishing ranchos and their families, the shallow water depths and the grassy prairie of the countryside.

The island of Sanybel was decided upon as the most promising, as it had a fine harbor and protected water. It was designated the town location, with fifty lots delineated on the island, and with each of the fifty shares including 1,800 acres of mainland for farming, to be chosen between Tampa Bay and Cape Romaine (Romano). The shares cost $500 each. These 90,000 acres would net $25,000 for the entrepreneurs.

Five palmetto houses were built by Bunce's rancho staff at the designated "town center" on the easternmost point of the island. A farming operation

was projected along the lower Caloosahatchee. Then the *Associate* and its passengers returned to Key West.

That same month, Dr. Strobel announced that he planned to leave Key West, and he became involved with the land company agents. In the fall, he went to Charleston and New York, evidently looking for people ready to invest in shares and travel south, people planning to settle on Sanybel Island with the Florida Land Company. Strobel's overarching concept was that he would become doctor to the colony and eventually run a sanatorium on the island.

By January 1833, the expedition was ready to return to Sanybel. Strobel and the group of investors traveled from Key West to the island on two ships: Bunce's sloop the *Associate* and a larger vessel, the *Olynthus*. In stormy weather, probably a winter cold front passing through, the larger *Olynthus* managed to hit and ground on a sandbar a few miles south of Sanybel. The *Associate* made it to the island and the waiting palmetto huts and then shuttled more people to land from the stranded *Olynthus*. The next day, the *Olynthus* freed itself from the sandbar and continued to Sanybel.

Dr. Strobel kept a journal and later published his impressions and thoughts. They are a valuable resource in describing Sanybel in an undeveloped state. Although he was probably the island's first publicist and promoter, he had no qualms about pointing out the island's shortcomings: "On landing we were assailed by immense swarms of flees [*sic*] whose company we could well have dispensed with."

He laid blame for the hordes of mosquitoes and sandflies on the Spaniards and Indians of the ranchos. He described mosquitoes while aboard the ship:

> *We were surrounded with smoke pans, and enveloped in smoke, but still found it necessary to keep our hands and feet in active motion to avoid the assaults of the enemy. After supper I went on board of our sloop—our beds were brought on deck, and our mosquito nets spread, and we ensconced beneath them. But, alas, it was fruitless labor. The enemy stormed and assailed us in every direction. One of the sailors swore that they had divided into two gangs, and that one hoisted the net, whilst the other got under and fed, and I verily do believe there were enough of them to have done it.*

He also critiqued the construction of the palmetto huts. During the storm, with about twenty people in one of the huts, he reported:

> *In building our houses, the Indians had neglected to raise the floor above the surrounding grounds; in consequence of which, thirty or forty beautiful*

little streams of water, came rushing through our lodging, with a delightful murmuring noise. In a few minute we were all afloat, our bed room being converted into a complete lake.

Despite his complaints, Strobel was clearly taken with the island's wildlife and explored on foot all the way up to what is now North Captiva. He waded up the Sanibel Slough, or River, hunting for teal, and brought back eighteen blue-wing, retrieving them himself as he shot them. Then,

The last time I went in, I happened to get on top of an old Alligator which was lying on the bottom, he flirted, floundered, and cleared himself. From that day, I gave up playing my own dog, particularly in fresh water, and where I was likely to meet with Alligators.

In several articles, he described the soil, harbor, climate, wild hogs and other islands. Dr. Strobel visited a fishing rancho by the mouth of the Caloosahatchee, stayed overnight and enjoyed a good dinner and smoking Cuban cigars. The fishery put on a ball in honor of his visit; Indian women danced, providing a rhythm with turtle shells half-filled with seeds strapped to their ankles.

About Sanybel he said, "The plain is so level that you may stand in a given spot and see for miles, there being nothing to interrupt the vision, except the cabbage palmetto trees, which are scattered at wide intervals throughout the prarie [*sic*]." And he described the potential establishment of "a large hotel, expressly for the accommodation of sick and transient persons. It will be provided with a skilful physician."

As the colony worked to build permanent housing and establish itself on the island, the Florida Land Company was busy. On February 17, 1833, a territorial Florida act incorporated two towns on the island, Sanybel on the eastern end (the town center) and Murray to the west in the Wulfert Point (present-day) vicinity. Richard Hackley had political pull. March saw the colony purchasing cattle, and by July 1833, Tampa and "Sarrazota" Bays had been explored for settlement opportunities as well.

By March, Dr. Strobel had returned to Key West, where his rival on the town council, David Pinkham, immediately called him out to a duel. The grounds were that Strobel had complained that Pinkham, the deputy collector of customs, had exceeded his authority in interfering with one of Strobel's military patients, discharging him without Strobel's knowledge or permission. Strobel had never been shy with criticism, although this

The prairie-like interior of Sanibel was due in part to the extreme wet/dry seasons, wildfires and hurricanes. *Linda and George Toft.*

sounds like a legitimate complaint on his part. They dueled on March 23, and Pinkham was wounded. At first, he appeared to be in recovery, but he relapsed and died on April 11. Meanwhile, Strobel had gone north to file his reports on the island's developmental progress and potential to the land company.

The duel and Pinkham's death ended Strobel's connection to the land company. He did not return to Key West but began teaching at the medical college in Charleston. Eventually, he returned to Florida during the Second Seminole War as a regimental surgeon in 1836. In an 1839 yellow fever epidemic in St. Augustine, Strobel would point out the significance of rain and mosquitoes relating to the disease. His was an early understanding of the evolution of yellow fever. Later, he would consult with a Dr. Weedon about the health of the Indian war captain Osceola shortly before Osceola's death, when he was being held prisoner at Fort Moultrie in 1838. Strobel died in March 1849, leaving a wife and two children.

In June 1833, Edward Armstrong finished the beautiful survey and development map of Sanybel Island, complete with fifty equally divided sections, one for each share, north to south, Gulf to bay, along its length, and a town center with roadways on the eastern tip. Even today, it is recognized as quite accurate geographically. In December of that year, thirteen Sanybel residents petitioned the federal government for a lighthouse at the island's

eastern end. Had the numbers of the colony already shrunk, or did not everyone sign the petition? Either way, they were still looking forward to a viable settlement.

At any rate, in 1835, an intense hurricane hit Key West and Florida's west coast, and then word arrived of the Dade massacre in late December. The Second Seminole War had begun, and settlers in the isolated regions of South Florida, including Sanybel, fled to Key West. By February 1836, the town's newspaper reported an estimated two hundred refugees had arrived in only four or five days. In 1836, Henry Crews, a U.S. customs inspector for Charlotte Harbor, was murdered near Useppa, and Southwest Florida's barrier islands and estuaries, isolated and lonely, were effectively abandoned. While Crews's death was blamed on marauding Indians, he was roundly disliked for his policies and hatred of the Cuban ranchos—particularly the long-established one only a quarter of a mile from his quarters on Useppa Island run by ninety-year-old José Caldez. Suspicion still remains that blame may have been misplaced. In 1837, a traveler sailing past Sanybel reported that at least one elegant wooden two-story building, and several other smaller ones, were standing abandoned on the island. Sanybel's first full-scale development scheme had collapsed.

The Calusa had been gone from Southwest Florida since the 1760s. Although the Cuban fishing ranchos employed a number of Native Americans, often called Spanish Indians, their connection to Florida natives is murky. There may have been some Calusan refugees in these ranchos or Cubans of Indian heritage. Some historians believe that to be the case, as both groups had experience with saltwater fishing, unlike the later groups from the north. The ranchos had fished in Calusan waters long before the Spanish turned Florida over to the United States.

The Indians coming down the peninsula from northern Florida were recent immigrants, coalescing into two tribes, the Seminole and the Miccosukee. They spoke different languages and considered the Calusa "bad Indians." They did not have the water-based skills that the ranchos prized. They were hunters who originated in the hills and mountains of Georgia and Alabama, often from Creek tribes. Several of their bands incorporated black slaves fleeing slave hunters, as the Seminoles treated them much more humanely. Some became leaders within their tribal bands as the Second Seminole War wore on.

Both the Second and the Third Seminole Wars were fought in the peninsula, but the Second Seminole War (1835–42) was by far the longest and most bitterly fought. The United States made an attempt to rid the

This Florida Land Company map created in 1833 depicts the town center and shareholders' lots, and its geographical detail is quite impressive. *Sanibel Public Library.*

territory of Indians in order to accommodate the growing influx of settlers. Even though the aboriginal Indians—the Calusa, Tocobaga, Tequesta and others—had fled to the island of Cuba or to the Bahamas, the Creek and other tribes who had immigrated into the empty territory along with the English only seven or eight decades earlier were well settled. Many had become prosperous cattle ranchers in the vicinity of Gainesville on the Alachua Prairie. Americans were eyeing the fertile new lands to their south and, seeing that prosperity, wanted to expand and prosper as well. Congress passed the Indian Removal Act in 1830 after fierce debate, and President Andrew Jackson, who precipitated the First Seminole War, quickly signed it. It was essentially an attempt at a land grab. The forced removal of all Indians to the west side of the Mississippi River, into Oklahoma—a land so completely the antithesis of Florida—was violently opposed by the natives.

Treaties were broken by the U.S. Army and captures made under a white flag. In retaliation, Indians surprised a company of soldiers going from Fort Brooke to Fort King (Tampa to Ocala), killing 108 of the 110 men (Dade massacre), and war was declared. As the war wore on, the Indians were forced south into the Everglades, starved and killed. Ships laden with captured Seminoles were loaded and carried from the Caloosahatchee to New Orleans. Some went peacefully, seeing no other recourse. Others continued to fight. Eventually, the United States' patience ran out, the action ended and an estimated three hundred Seminoles remained hidden in the Everglades. Despite a flare-up and more removals during the Third Seminole War, eventually, the Indians were left huddled in their unique Everglades environment, where they adapted and flourished. They claim they never surrendered to the United States.

During the war, in 1838, Fort Dulaney was established at Punta Rassa, about where the fishing rancho that Dr. Strobel visited may have been built. The numerous raids by the Indians necessitated both army and navy patrols

in the barrier islands, and supplies for the patrols had to be provided. The fort was destroyed in an 1841 hurricane that inundated the area, and Fort Harvie (later to become Fort Myers) was then built in a more secure spot upriver. Fort Dulaney was later rebuilt and used during the Civil War. It became the site of a hotel and telegraph station.

The abundant estuaries of Southwest Florida that allowed the Calusa to prosper were recognized by Cubans as a food resource. Cuban fishing ranchos had likely been established in Southwest Florida waters by the late 1600s, and the fish camps, or *pescadores ranchos*, were timed to mullet runs in the fall and winter. Over the years, some of the camps grew into year-round communities, with multiple houses, storage buildings and drying racks for fish and nets. Generations of the same families, or town members, ran the ranchos, scattered from Tampa Bay south. Several were in Charlotte Harbor and San Carlos Bay, including the establishment at Punta Rassa visited by Dr. Strobel in 1833. He stated it had been used for some twenty-five to thirty years at that time.

While a variety of fish was caught and processed for sale, mullet was the main product. The winter mullet run was the busy season. Fish were netted and dried on racks or salted in barrels. Mullet roe was prized. It was first soaked in salty water, then partly dried and pressed between boards before being placed on racks in a smokehouse to cure. At slower times of the year, net repair and other building and planting occurred.

Each rancho was supplied by a ship that carried the fish, fish oil, turtles, cardinals (called redbirds) and other trade items south to market and returned with salt (which was required to be purchased in Cuba, not produced locally), food needs and other supplies, as well as tobacco and *aguadiente* (an alcoholic drink). The rancho on Useppa Island run by José Caldez operated two schooners, and the rancho grew numerous fruit trees and had ten acres in cultivation of beans, melons and other food plants for the twenty or so houses on the island. That community was more than fifty years old, started by the industrious and successful Caldez in the 1780s, likely shortly after Spain regained Florida. Caldez had three other local fishing camps under his command as well. In such longstanding communities, the mix of Cuban men and Indian residents inevitably led to intermarriage. Children were sent to Havana for baptism and education.

As events changed around them, the rancho residents continued their trade connections with Cuba. When the United States acquired the territory in 1821, those residing there automatically became American citizens, but as Americans moved into the area, establishing Key West and exploring, the

Spanish-speaking residents were viewed with distrust. Disputes arose about citizenship, and in 1825, Colonel George Brooke requested permission to "break up this intercourse existing between *foreigners at heart* and Indians." It was commonly believed the ships from the ranchos were actively engaged in smuggling aguadiente and other spirits, doubtless with good reason. The ranchos were suspect on a number of levels, and if they could be removed, the land and resources of Southwest Florida would be available to "real" Americans. The ranchos continued their lives as they had always done, but they were slow to recognize and adapt to their new political landscape. Although they paid their taxes and were citizens, they were redefined as squatters taking resources not theirs.

Key West has always been essentially a port town, attracting watermen from all over. New England fishermen arrived and quickly recognized the value of the area, adding to pressures against the ranchos. When the Indian Removal Act was passed in 1830, one result was the forced removal of family members of the ranchos, particularly women and mixed children. By late 1836, Lieutenant Powell reported, "All the old ranchos were visited, but they had been abandoned, and for the most part, destroyed, during the last season."

When Henry Crews was killed, the ranchos were burned by soldiers who feared they were used by Indian sympathizers. The fishing rancho life had been devastated. The American acquisition of the territory and the Second Seminole War had emptied the local waters of a longstanding folkway.

Once the war ended, some Cubans returned to fish, but suspicion and resentment dominated in direct proportion to the number of settlers starting to homestead in Southwest Florida. The last of the fishing ranchos established on Sanibel, that of the Tarivo Padilla family, remained until the late 1800s. They remained on Cayo Costa until after the turn of the twentieth century, the last of an old tradition.

4

DEVELOPMENT BEGINS WITH THE SANIBEL ISLAND LIGHT STATION

F or nearly fifty years, petitions and pleas went unheeded in Congress each time individuals and groups in South Florida tried to convince that body—along with the Lighthouse Board representing the U.S. Lighthouse Establishment—to install a light station near the Port of Punta Rassa. The Florida Land Company had championed the necessity for a light station and had so noted a future location for a lighthouse on the 1833 plat map for its Sanybel Island real estate development. This idea was later put into action when a group of people in Key West, some associated with the Florida Land Company, submitted the first petition to Washington, D.C., in hopes of monies being appropriated for construction of a lighthouse. This appeal was denied but noted.

The two lighthouses along the lower Florida Gulf Coast had no real value for the small communities along the mainland coast between them. The Loggerhead Key Lighthouse in the Dry Tortugas was erected in 1858, and the Egmont Key Light Station at the entrance of Tampa Bay was built in 1848. Separated by 106 miles of open and dark seas, these would remain the only major aids to navigation along the Southwest Florida coast for many years. Hamlets and villages along the Southwest Florida coast were growing and coastal trade increasing, yet the Lighthouse Board stood fast and would not agree that a landfall lighthouse near Punta Rassa was needed.

Over time, and many years before the railroads reached Southwest Florida, the increase of commercial vessel traffic brought an element of

justification to the constant requests that a lighthouse be erected near Port Punta Rassa.

In March 1872, former Florida lieutenant governor W.H. Gleason, submitted a "Memorial" to the U.S. Congress in support of a lighthouse on Sanibel Island. This memorial was another name for a petition, and it contained some pertinent facts:

To the Congress of the United States:

...The precise location for the light would be determined by the Light-House Board, as also the advantages to the country in the advent of war, and the safety of vessels and commerce of this coast; but I more especially wish to call attention to the rapidly increasing commerce of this harbor.

The following statistics from January 1, 1871, to January 1, 1872, are procured from the collector of customs at Key West: Number of trips made by vessels in and out of Punta Rassa, 260; number of cattle shipped, 15,450; value of cattle shipped, $231,750. [In 2018 dollars, this would be approximately $4,400,000.]

This statement does not include those shipped to the port of Key West or other domestic ports coastwise, only those shipped to Cuba.

In consideration of the above facts, I would request most respectfully and urgently that a light be erected on the southern and eastern end of Sanibel Island.

The Island of Sanibel belongs to the Government; is well watered, well timbered, and has plenty of good land for cultivation. It is the theory of the pilots, and I am informed also of the Coast Survey, that the light should be on this island.

W.H. Gleason

This memorial had some impact. At the time, W.H. Gleason served in what was then known as the Florida House of Representatives, and his words may have had some clout with Florida's congressional delegation. It certainly added high-level support for those who were lobbying Congress to fund a lighthouse on Sanibel Island. There was one major inaccuracy in Gleason's petition that would later become an obstacle.

With a growing interest in establishing a landfall lighthouse for the entrance of Port Punta Rassa, and that of the Caloosahatchee beyond it, the Lighthouse Board finally consented to the proposition and conducted a land

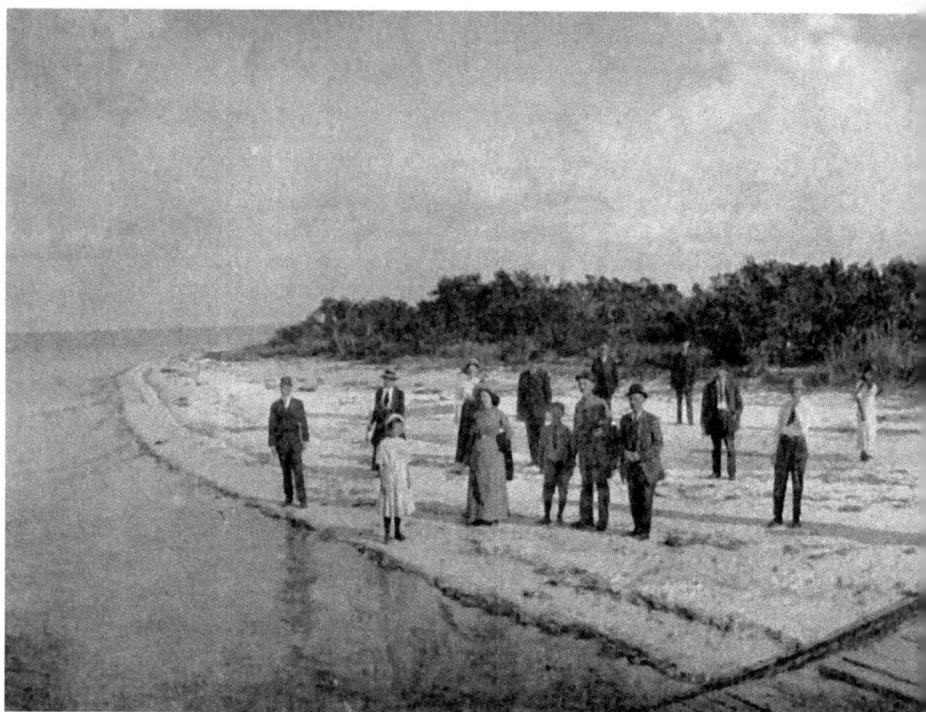

Islanders gathered by the lighthouse dock on San Carlos Bay to watch an anticipated arrival or departure. *Sanibel Public Library*.

survey in 1877. This resulted in the establishment of two local lighthouse reservations: one at Bowditch Point at the north end of Estero Island, and the other at East Point (now known by the place name Point Ybel) on Sanibel Island. The decision on a final specific location would be left to the engineers of the Lighthouse Board in association with the harbor pilots who served Port Punta Rassa. In the end, the Sanibel site was selected, because a light tower positioned there would be farther west than one on Bowditch Point. Therefore, its beacon would be visible farther seaward from Port Punta Rassa; that is the reason Sanibel Island made the final cut.

In 1883, Congress finally appropriated funds, in the amount of $50,000, and authorized construction of the Sanibel Island Light Station. At this point, the Lighthouse Board ran into the unforeseen obstacle that W.H. Gleason and other lighthouse advocates had missed. There was little upland on Sanibel Island that remained part of any public domain lands; therefore, the lighthouse site was not owned by the federal government, as stated in

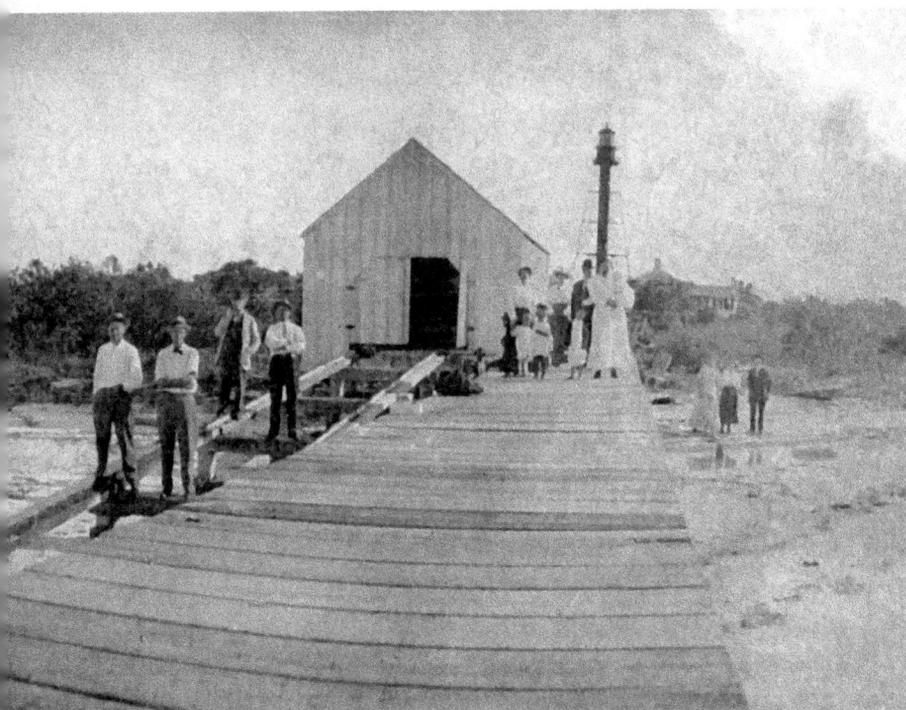

Gleason's 1872 memorial. Not long after Florida entered the Union as a state in 1845, Congress passed the Swamp Land Act of 1850. In essence, this act had transferred ownership of most land on Sanibel Island to the State of Florida.

The Lighthouse Board and the State of Florida negotiated, and acting on behalf of the general public good and welfare, Governor William D. Bloxham and his cabinet relinquished the state's claim to the designated property. On December 19, 1883, Sanibel Island was withdrawn from the public domain by an executive order, and all of Sanibel Island became a lighthouse reservation.

The tower and other metal parts for the Sanibel project were manufactured by the Phoenix Iron Company of Phoenixville, Pennsylvania. This firm, located near Valley Forge, was founded in 1812 and specialized in manufacturing prefabricated iron components for lighthouses, bridges and railroad track—it even made cannons during the Civil War. Near the end of the nineteenth century, the Phoenix Iron Company began to produce steel. The company shut down operations in 1984 as the American steel-manufacturing industry collapsed.

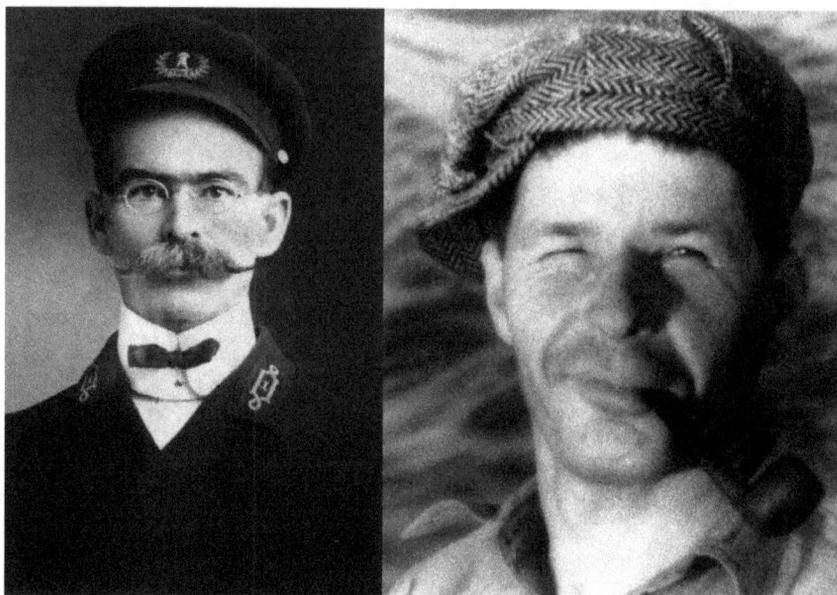

Assistant lighthouse keepers. Charles Henry Williams, in full uniform, served from 1910 to 1923 (*left*) and Roscoe "Mac" McLane in 1934. *Sanibel Public Library.*

Now that the construction process was set in motion, things started to happen. A shipment containing the wrought-iron components for two lighthouses was loaded aboard the 207-ton schooner *Martha M. Heath*. Its destination was, first, Sanibel Island to drop off the parts for its new light station. A large wharf had been built at Sanibel by an advance construction team to receive the shipment. After the Sanibel Island delivery, the *Martha M. Heath* was scheduled to sail north to Cape San Blas on the Florida panhandle and deliver similar parts for the Cape San Blas Light Station's replacement tower. It was a sister structure to that eventually unloaded on Sanibel. They were nearly exact duplicates of each other. Three earlier lighthouses at Cape San Blas, beginning with the first, a brick lighthouse erected in 1857, had been lost to erosion.

As the *Martha M. Heath* approached Sanibel Island on May 5, 1884, when the schooner reached a point about two and a half miles southeast of the island's eastern point, it went hard aground. It foundered on a huge sand shoal that still extends offshore of Point Ybel. The sailing vessel soon broke apart—a total loss. Most of the components of both lighthouse structures fell into the Gulf of Mexico.

Two lighthouse tenders that were stationed in Key West soon arrived on the scene of the calamity. The recovery team included a hard-hat diver, and the tenders were fitted with cranes, so in the shallow water, the retrieval went relatively quickly. It wasn't long before all parts, except two small gallery fittings for the Sanibel Island tower, were recovered. Due to the unexpected seawater bath, the tower assembly arrived on Sanibel Island behind schedule, but actual progress on the station was not affected. The light tower's concrete footing had already been completed, so assembly work could begin right away. New balcony railing parts were ordered from a foundry in New Orleans, and in the meantime, erection of the tower and installation of the quarters' support pilings got underway. The light tower was completely assembled, both quarters were finished, the water system filled and operational and the Sanibel Island Light Station was completed by mid-August 1884. Its light went into permanent operation on August 20, 1884. The lighthouse staff consisted of a primary lighthouse keeper and an assistant lighthouse keeper and their families. These men and women and their children became the first permanent residents of Sanibel Island.

Sixty-five years after its bright light first flashed in some distant offshore seaman's line of sight, the Sanibel Island Lighthouse would make a longstanding contribution to the conservation ethic on Sanibel and Captiva Islands. That aspect will be covered in a later chapter.

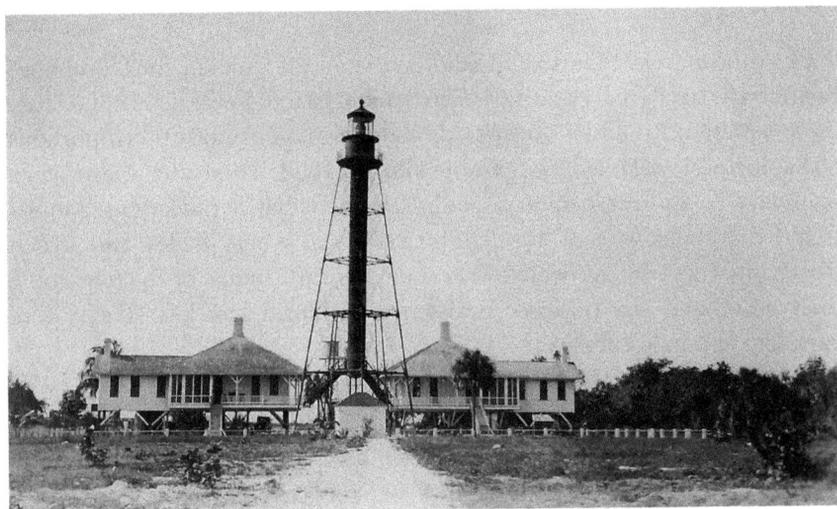

Sanibel Island Light Station in the early 1920s. Note the stairs to the quarters' porches, cleared spaces to protect against wildfire, rail fence and probable chicken coop. *Jerry Lauer.*

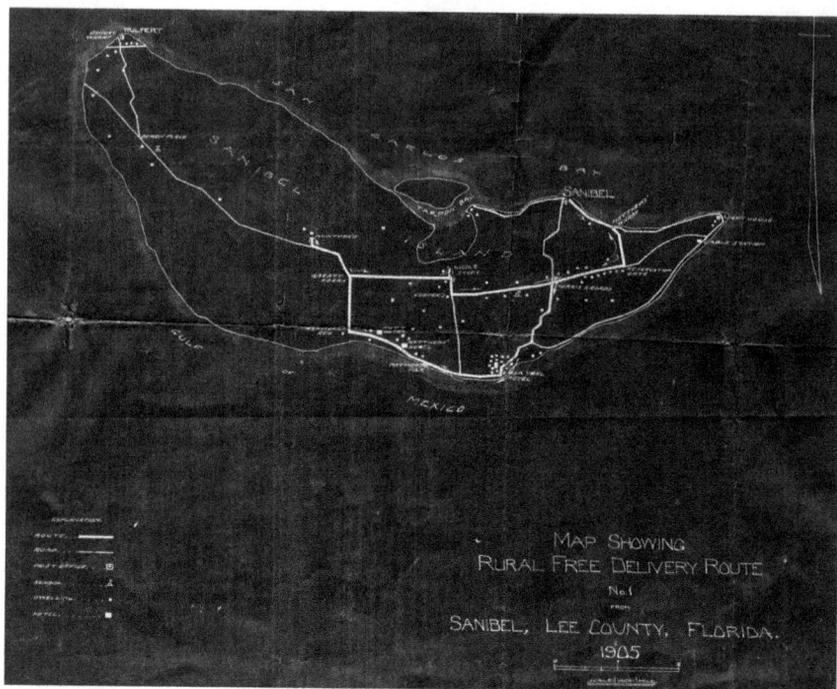

Sanibel Rural Free Delivery Route in 1905. Most roads exist today, although the "Gulf Drives" were on the beach. *Sanibel Public Library.*

Once the Sanibel Island Light Station became operational, the Lighthouse Board reviewed its real estate needs on Sanibel Island. It was determined that the reservation would be downsized, and the middle and western portions of Sanibel were released for homesteading in 1888. Thereafter, the western boundary of the reservation was aligned such that it ran across Sanibel Island two miles west of the lighthouse, about where Bailey and Beach Roads intersect with Periwinkle Way today. In 1902, much of the remaining reservation land was surveyed into ten- and fifteen-acre lots. These were later sold at public auction.

On October 31, 1923, the present boundary was approved by W.W. Himeritt, superintendent of lighthouses for the Seventh District, in Key West. The land contained in the remaining Sanibel Island Lighthouse Reservation now extends from the water's edge at Sanibel's eastern tip westward to the Gulf-to-bay north–south boundary. The tract's legal description places the property line one thousand feet to the west of the center of the lighthouse tower.

SPECIFICATIONS, SANIBEL ISLAND LIGHTHOUSE:

YEAR CONSTRUCTED: 1884. It became operational on August 20, 1884.

CONSTRUCTION MATERIAL: Wrought iron

CONSTRUCTION STYLE: Pyramidal skeletal tower

FOUNDATION: Reinforced concrete

NUMBER OF INTERIOR STEPS: 105 interior spiral steps

BASE LEVEL OF STAIRWAY TUBE: Twenty-five feet above mean sea level

DAYMARK COLOR: Originally metallic brown below watch room, watch room and above, black. Current daymark color is uniformly brown.

AUTOMATED AND UNATTENDED: 1949

LIGHTING APPARATUS: The original Fresnel-designed lens was in place 1884–1923. This was a third-order catadioptic lens that was clockwork-driven and revolved on small chariot wheels around a matching inner kerosene wick lamp. In 1912, the wick lamp was replaced with an incandescent oil vapor lamp. In 1923, an acetylene-burning flasher unit replaced the oil vapor lamp, and another Fresnel third-order non-rotating fixed lens with a 360° focal plane replaced the original lens. In 1962, a third lens, a Swedish-made 500-millimeter drum lens, formerly fitted to an obsolete lightship, replaced the second third-order lens. This drum lens is on display in the Burnap Cottage at the Sanibel Historical Village and Museum. In 1962, the light was electrified, and a timed series of 250-watt incandescent bulbs provided illumination. In 1982, a plastic-lensed 300-millimeter airport beacon was fitted in the lantern room.

FOCAL PLANE: Ninety-eight feet above mean sea level

CHARACTERISTIC: Original (1884)—white flash every two minutes (FFlev.120sec98ftvis16M). Modern—group of two white flashes every six seconds (FL(2)6s98ft13M).

ACCESS TO LIGHT TOWER: Access was originally from adjacent inside corners on the north porch of each quarters via staircases. As these continually deteriorated, they were replaced by a ground-level ladder that reached the entrance platform in 1951.

NATIONAL REGISTER LISTING: On October 1, 1974, all original structures (light tower, the two elevated quarters and the ground-level brick oil house) were officially listed in the National Register of Historic Places.

PUBLIC ACCESS: The light tower and the quarters are not open to the public. The adjacent land and beach comprise public parkland owned and operated by the City of Sanibel.

5
EXPANDING HORIZONS

nce Florida was admitted into the Union on March 3, 1845, as the twenty-seventh state, the status of the Seminoles and the Cubans involved with their ranchos became even more tenuous. The Second Seminole War was over, and more conflict was to come. The population of the entire state was between sixty and seventy thousand, about one-tenth of the 2010 population of Lee County alone according to the U.S. Census Bureau. Most residents lived in North Florida.

But with peace, more people were coming. And they were bringing changes and development ideas with them. Army general William Harney wrote in 1848 that the Everglades was "a waste of waters fit only for the resort of reptiles." He was quite familiar with Southwest Florida, having survived an attack on his camp on the north bank of the Caloosahatchee on July 23, 1839. The general was later involved in a number of forays for remnant Indian bands into the Everglades. He captured and hanged Chekika, a leader of several Indian attacks, in the Everglades in December 1840. It was Chekika who led the attack on Harney and his camp and afterward led the massacre on Indian Key in the Florida Keys in which Henry Perrine and several others died on August 7, 1840. Later, the Harney River—emptying from the Everglades to Florida Bay—was named for the general.

Harney's comment reflected the widely held belief that the Everglades, if it could only be drained, would be magnificent agricultural and residential land. It was also the last resort of the Seminoles. In 1855, an army surveying group was sent into the western Big Cypress to check on Indian

communities and crops. Billy Bowlegs's camp was growing banana plants that the troops destroyed, despite having been ordered not to damage or disturb the Indians. Retaliation was swift. Under Bowlegs's command, the Indians began raiding and killed four soldiers in the offending army camp. Some historians believe the provocation was deliberate, to justify military intervention and Indian removal. After three years of skirmishes, the U.S. government paid Bowlegs and his 164 followers to board ship for Oklahoma. Nevertheless, several other bands refused to go, and remained hidden in the deep glades, a total of about 200 people.

The Indians were forgotten, if not defeated. That threat had been neutralized. Development, drainage and connections to the rest of the United States would be underway. In January 1855, the Florida Internal Improvement Fund Act granted railroad builders a two-hundred-foot right-of-way across state land to build railroads, and the state guaranteed interest on the bonds for thirty-five years. That transport would open the state to economic prosperity, as crops would be shipped north and new residents would come south. Trains carried more cargo, and they didn't sink. The insecurities of travel by ship through the always difficult Florida Straits would be minimized. That guarantee would nearly bankrupt the state.

By 1861, yet another war loomed. In January, Florida seceded from the Union it had joined only sixteen years earlier, the third southern state to do so, and well before the start of hostilities. Although the state, and Southwest Florida, saw little direct conflict during the four years of the Civil War, or War Between the States, both were greatly affected. There was an immediate Union naval blockade of the state, and in short order, four blockading squadrons were formed. The East Gulf Blockading Squadron patrolled Southwest Florida to control contraband being ferried to Confederate troops throughout the war. The need for Florida beef for Rebel troops was overwhelming, and in 1863, the Florida Cow Cavalry was formed to guard and supply the need. Blockade runners slipped through secret passageways in the mangrove channels to the delight of Rebels and disgust of the Union navy. In response, the Union secured and occupied Fort Myers, controlling the Caloosahatchee and executing attacks on cattle shipping and saltworks. In 1863, some thirty thousand cattle were delivered to the Rebels, but by the next year, the number had slipped to twenty thousand. By February 1865, in frustration, a force of Rebels attacked Fort Myers, but the group was repelled by the garrison within. Few casualties resulted, and the clash is thought to be the southernmost land battle during the conflict, which ended two months later.

Civil War communications emphasized the benefits of telegraph service. The ability to send information quickly over many miles proved advantageous, and in 1866, the first successful submarine cable from Europe to America was connected. Southwest Florida's link to Cuba, from the early 1500s, was even more important in the time after the Civil War. In 1866, the International Ocean Telegraph Company (IOTC) was formed in Newark, New Jersey. It was awarded a contract to lay submarine telegraph cable from the mainland to Cuba, but first, the near four hundred miles between Florida's northern and southern borders had to be connected. The telegraph system and its many companies expanded quickly after the Civil War, and competition was strong. Success wasn't assured, and speed was important. The IOTC hired George Renton Shultz (1843–1921), also of Newark, in 1866 to head a crew stringing telegraph wire from Lake City, Florida, to Punta Rassa.

Shultz's crew started in the spring of the year, arriving at the old Fort Dulaney at Punta Rassa. Their first successful transmission went out on May 29; the names of the Telegraph Swamp and Telegraph Creek are remnants of their passage.

They had to clear a maintenance path, sometimes called "the wire road," place poles and string wire as they moved south. The overland system needed to be in place before the submarine cable could be laid by sailing ship. Once Shultz arrived at the abandoned fort, he set up his telegraph station in one corner, surrounded by canvas walls, and sleeping quarters in another corner.

Similar to the government's cession of land to railroads, the abandoned fort—with its surrounding cattle pens and dock, first used to provision troops with scrub cattle—was ceded to the IOTC by Congress. Connecting the telegraph to Cuba meant the Caribbean and Europe would also be connected.

The cable ship *Narva*, built in 1866, was chartered for the job, fitted out in England and departed in June 1867. The young engineer in charge of the cable and its testing was Philip Crookes, a brother of Sir William Crookes, the chemist. When the *Narva* reached Havana in late July, the crew discovered an ongoing yellow fever epidemic and sailed on to Key West the next day.

They began laying shore-end cable on August 3 with the help of some shallow-draft boats and barges. There were several sizes of cable, measured by its weight per mile: four tons, two tons, down to a three-quarter ton per mile. The heavier cable was used in shallow and shore duty, lighter in deep water, as wave action is more intense in shallow water. The cable consisted of seven copper wires covered with three coats of India rubber, a hemp

George Renton Schultz, proprietor of the Schultz Hotel and telegraph operator at Punta Rassa for fifty-five years. The youngster is probably his granddaughter Lorraine Heitman. *Sanibel Public Library.*

covering and insulation of gutta-percha—a rubbery substance derived from Indian tree sap—then the outer wrapping.

The line from Havana to Key West was laid in one day on August 6—102 nautical miles. The line from Key West to Punta Rassa crossed the eastern tip of Sanibel and then went across San Carlos Bay, a total of 133 nautical miles from Key West to Punta Rassa. The telegraph line opened on September 10, 1867, and in 1873, Punta Rassa to Havana sent 51,899 messages. At that

point, Western Union took a controlling two-thirds interest in the company. The Punta Rassa cable was abandoned after World War II.

Once the Key West shore cable was laid, the ship returned to Chorrerra, Cuba, four miles west of Havana, for the Cuban shore end connecting to a cable hut there, and the Cubans hosted a celebration. On the following day, August 6, they paid out the main deep-water cable overnight but were pushed about twenty miles off course by the strong current, which required the use of some of the other cable. Once the cable was connected and tested, the crew returned to Havana to rest before the Key West–to– Punta Rassa run.

Philip Crookes, head of the cable crew, tested and repaired any flaws or faults in the cable as it was paid out. Since they were working during the Caribbean summer, the gutta-percha insulation around the core lines sometimes became too warm, allowing the interior wire to ooze through to the outside of the cable. It did, however, crystallize when cold, perfect for ocean depths. Testing the line involved frequent communication over it to the crew members stationed on shore.

The *Narva* arrived off Punta Rassa on August 24 and enlisted the help of a little cattle steamer, the *Emily*, to lay the shore cable in the shallow water. Due to a rain squall, they waited a day to work and slept ashore in the telegraph house, "the only building within 30 miles." Crookes described that night in the barracks:

> *a log house built on piles, and loopholes arranged in the walls for firing at the Indians, who used to be very troublesome about there, but are now pretty nearly exterminated. The mosquitoes and sand-flies are so bad that the operators there have had a little canvas room built in the house, where they keep the instruments and sleep; by keeping it shut all night they manage to circumvent the brutes....[T]he sand-flies came in clouds, and prevented any of us from sleeping a wink....[In] the canvas house...[I] saw a small space vacant, between the legs of one individual and the head of another, where I coiled myself and contrived to get a couple of hours' sleep.*

They left for the *Emily*, paid out the shore cable and found that on board the *Narva*, one man had died, another was dying and a third soon followed. All three were buried ashore. At Key West and Chorrerra, others also succumbed to yellow fever. Crookes noted the odd fact that of the twenty cable men, half died, while no sailors did. He suspected a miasma in the cable hold, as the sailors slept elsewhere in the ship. The cable hold collected

One of the two Sanibel cable huts bringing the submarine telegraph cable over the island, later used as housing. *Betty Anholt.*

water, which aided in keeping the cable's insulation cool but would certainly breed mosquitoes.

The cable crossed Sanibel's eastern tip via a cable hut at both the Gulf and bay sides, en route to Punta Rassa. One hut disappeared early, perhaps in a storm. The second Sanibel cable hut was moved and used as housing on property that later became part of the refuge. Destroyed in a prescribed burn in 1992, the building had great historical significance as the earliest surviving structure on the island.

In 1868, the start of the Ten Years' War, Cubans began fighting for independence from Spain. Thousands of refugees came to Florida, establishing cigar factories from Key West to Tampa. The cattle industry, which in many cases warded off starvation for the Cuban people, helped Florida recover economically. Florida returned to the Union in 1868 as well.

Only two people were on "Sinnabel Island" in the June 1870 Monroe County Census—William S. Allen, age forty-seven, and his son, George W., age sixteen. Monroe County encompassed all of what is South Florida from the Atlantic to the Gulf on a line above Charlotte Harbor at that time. William was the census taker for the islands and listed himself on the census as assistant marshal and farmer, George as a farm laborer. The Allens

farmed poisonous castor beans for their oil, which was used extensively during and after the Civil War as a medical treatment for yellow fever and for other needs. When the massive 1873 hurricane hit the islands, the Allens moved to Immokalee and later to Key West. Castor bean plants gone wild are occasionally seen on the island today.

Across the bay, the IOTC was profiting from the cattle docks at the telegraph station. It charged fifteen cents per head to load cattle at Punta Rassa. Captain Francis A. Hendry, a Confederate scout and major cattleman who participated in the attack on Fort Myers in the last months of the war, paid the IOTC the fee. But it rankled. The IOTC was flying the Stars and Stripes over the barracks, and he was a staunch Confederate. So he built his own pens and a dock nearby, charged ten cents a head and soon had the IOTC out of the cattle business. He then sold the property to Florida cattle baron Jake Summerlin.

By the 1880s, development pressure moving south had increased. More than 2,000 miles of railroad had been built in Florida, and Henry Plant's Florida Southern Railway's acquired 2.58 million acres in land grants. Plant's railroad was formed from the Gainesville, Ocala and Charlotte Harbor Railroad, and in 1886, he opened a line from Bartow to Trabue (Punta Gorda). From Punta Gorda, Plant ran a number of ships to Fort Myers, shipping goods and transporting visitors.

Many railroads failed during and after the Civil War, and the state had guaranteed bond interest on them back in 1855. Florida was pinched for money to cover the debt. For $1 million cash, Hamilton Disston, an heir to a saw manufacturing company in Philadelphia, bought four million acres of land in South Florida from the state, alleviating the danger of Florida declaring bankruptcy. Additionally, Disston promised to drain the area for agriculture, dredging a canal from Lake Okeechobee to the Caloosahatchee and also the St. Lucie River. His company, the Atlantic, Gulf Coast and Okeechobee Land Company, dug more than eighty miles of canals as it attempted to reclaim lake bottom and marsh lands and lower lake levels. Disston's actions would have long-term consequences for the estuaries and islands downstream.

The Menge brothers were hired to dredge the canals and first used a dredge designed by their father, Anton Menge. It cut 250 linear feet, 24 feet wide and 6 feet deep, through soft muck in ten hours. The dredge was a wood-burner and used up to one and a half cords daily. Built in about 1882, the dredge was worn out and abandoned in 1887. The Disston Company built another dredge, but it was lost in a storm while being towed to Kissimmee and was never relocated. Although the rivers-turned-canals drained some of

the lake, they never managed to drop it the four feet promised, and in some seasons, the water would actually run backward, into Lake Okeechobee. In May 1905, the Everglades Drainage District was formed, and efforts to drain the swamp have been one of Florida's frustrating follies over many years. A significant part of the reason is that the Everglades land is largely peat, and draining water from peat causes it to dry out and shrink. Thus, the land subsides, and the water runs back into the lowered areas. Another consequence is increased fires, as the vegetative peat burns easily, often through lightning strikes. The Everglades District was 60 miles wide and 150 miles long, totaling 4.3 million acres.

When the Sanibel light was first activated on August 20, 1884, no one else lived on the island. The first lighthouse keeper, Dudley Richardson, and his assistant keeper, John Johnson, were isolated. Richardson remained as lighthouse keeper until 1892, when Henry Shanahan, his assistant at that time, took over the job. By then, most of the island had been opened to homesteading, and some people lived on the island.

In 1885, Thomas Edison stopped at the Shultz place, the former Fort Dulaney, which had been transformed into a telegraph station and hotel. The two telegraph operators with Newark connections hit it off, resulting in a long-term friendship. Edison later became a shareholder in Shultz's hotel. Shultz recommended Edison explore upriver to Fort Myers, and Edison soon settled there and established his winter quarters and laboratory. Among Edison's other interests, the uses of tropical vegetation intrigued him, and he frequently traveled to Sanibel and Captiva while in Florida each winter. One homesteader he often met with was Oliver Bowen, a former Mississippi riverboat pilot and later a ship captain. Bowen homesteaded on Wulfert Point with his wife and brought agave plants—a plant Edison experimented with—to Sanibel from her native Trinidad.

Also in 1885, W.H. Wood caught a tarpon in Ellis (now Tarpon) Bay on rod and reel, starting a fishing and tourism boom that Shultz and others benefitted from. Tourists began to flock to San Carlos Bay for the world-class sport fish, the "Silver King," in winter and spring. The sport was exciting and could be dangerous. In a 1906 account, Charles Frederick Holder related the consequences when an angler brought a tarpon—a virtual living steel spring of tremendous power—into the skiff:

The result was definite and certain; a fountain of chairs, oars, men, gaffs, rods, and bailing tins seemed to shoot into the air, in the centre of which was the tarpon rampant. It swept the decks, and every time its tail or

The dry-loving agave was brought to Sanibel from Trinidad in the 1890s by Oliver Bowen, a Wulfert homesteader and former sea captain. *Linda and George Toft.*

head touched anything, something gave way. It was the most exciting and interesting example of ground and lofty tumbling of man, fish, and appurtenances, I had ever witnessed.

Homesteading the islands finally began in 1888. The U.S. Homestead Act of 1862 offered 160 acres of land to those who improved and lived on the property for five years. Since the island had been held as government reservation, it opened late to the process, but once open, many families arrived. The first Sanibel homesteader was Samuel Woodring, a Pennsylvanian who had initially seen the islands during Union service in the Civil War. He returned to Pine Island across the bay in 1885, when the San Carlos Hotel at St. James City advertised for an ironworker. He chose his eventual homestead on the northern point soon named for him. He ordered lumber for his home from Key West before the island opened for homesteading on July 3 and moved in shortly thereafter. In the years to come, his son Sam Junior would marry Esperanza Almas. The son of the first homesteader wed the granddaughter of the last fishing rancho owner, Tarivo Padilla.

Descendants of the Woodring family continue to live on Sanibel Island, and they have always been drawn to fishing and work on the water. Most new homesteaders were farmers from southern states, largely Kentucky, Georgia and Virginia. Crops were shipped by the Plant Line and smaller boats, often hitting the markets early because of excellent growing conditions. Because Sanibel's freshwater slough traversed much of the lower island, water was available in the dry winter season. Tomatoes and peppers were major crops, and soon other truck farming appeared as well. On Captiva and Wulfert, grove trees of limes, grapefruit and oranges predominated, as surface water was less accessible.

Early residents discovered they could rent rooms to visitors in winter to earn extra funds. Some homesteaders, like the Barnes family on the Gulf, quickly morphed into hoteliers. By the time homesteading stopped in the mid-1890s, advertisements for several Sanibel and Captiva hotels were appearing in the Fort Myers newspaper. It was easy to pitch the beauty of the palms, beaches, shells and birds and quiet of the islands.

All was not ideal though. The threat of hurricanes was real, and a number of storms blew through in the 1890s. In 1894 a hurricane arrived in September, followed by an intense freeze in December, destroying citrus through much of the state. Then, only six weeks later, another bad freeze hit. As a consequence, many new residents moved to the islands, where the cold had been somewhat less damaging. Among the new arrivals were the Bailey

Esperanza and Sam Woodring share a moment. Legend is that Sam was a rumrunner and under the box was some hidden contraband. *Sanibel Public Library*.

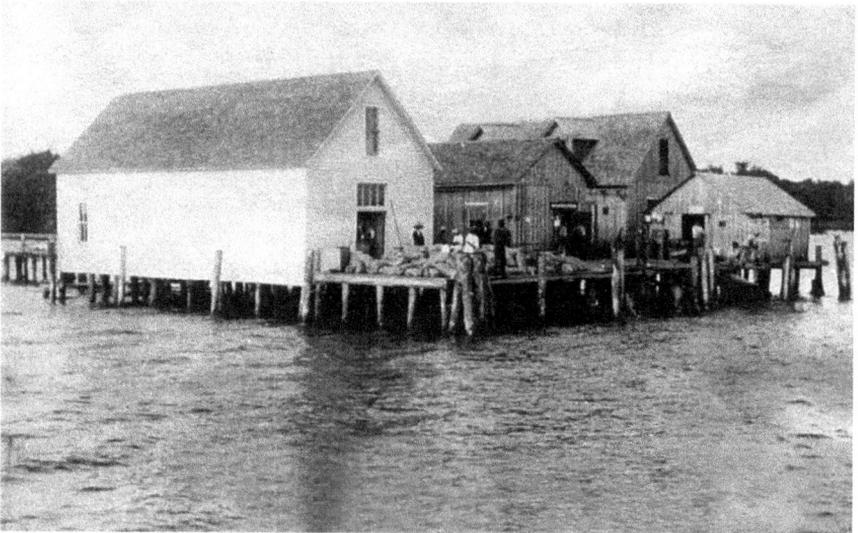

The Sanibel Packing Company dock was the main arrival and departure point for commercial goods and travelers in the early twentieth century. *Sanibel Public Library*.

family, who had been tobacco farmers in Kentucky and continued farming here, soon opening a packing company and general store that has continued in business for nearly 125 years under the family's direction.

On February 15, 1898, the first word of the sinking of the *Maine* in Havana Harbor was sent by telegraph submarine cable to George Shultz at the Punta Rassa telegraph office. The station became the War Department's most important communication center—all messages went through it between Washington and Havana. Shultz and his assistant, W.H. McDonald, worked more than thirty-six hours straight sending and receiving messages after the incident that started the Spanish-American War. A home guard was set up to protect and patrol the wires between Punta Rassa and Fort Myers, lest they be cut by the Spanish during the ensuing conflict.

Killing of plume birds for fashionable ladies' hats in faraway cities had been going on for years, but with tourism came a desire to see and experience the beautiful water birds. Pressure to protect them began to mount. The Florida Audubon Society formed in 1900, and in 1903, President Teddy Roosevelt declared the nation's first bird sanctuary, Pelican Island, in Florida. By 1920, there were ten federal bird sanctuaries in the state. Nevertheless, plume hunting continued, and two Audubon wardens were killed on the job.

Probably the most striking thing about the time from 1900 to 1910 might be the variety of characters and happenings, from cultured to criminal, homesteader to hermit, engaged to isolated. When we look at the young Lee County of that time, we see an area covering 4,705 square miles, inhabited by only 3,071 people according to the 1900 census—roughly doubled in 1910 to 6,294. Lee County then encompassed what are now Lee, Hendry and Collier Counties, so Lee is now roughly a quarter of what it was a century ago. Most Lee County residents were on the mainland and Fort Myers, outside of the barrier islands and estuaries of San Carlos Bay.

Whether homesteaders, farmers, archaeologists, adventurers, tourists, fishermen, their families or friends, these were people willing to endure much to spend some time, or their remaining lives, on the isolated coast of southern Florida. As more arrived and conditions became easier, the social nature of residents and visitors became more visible. As one old-timer said, "You helped your neighbor, whether you liked him or not, because you had to rely on him if you got into a fix." Islanders relied on one another and were a quasi-family by default.

As the population increased, so did the use, even exploitation, of the natural resources surrounding the islands. In 1907, the Charlotte Harbor and Northern Railway opened between Boca Grande at Charlotte Harbor

and Arcadia and a phosphate dock was built. Pebble phosphate was being mined from the bed of the Peace River and shipped internationally. The businesses of farming, fishing, tourism, logging and other commerce increased. Chroniclers and adventurers explored and wrote about their finds, enticing others to visit. Among them were A.W. and Julian Dimock, father and son. A.W. had retired from Wall Street after having made and lost several fortunes. He enjoyed adventures on the water such as fishing for tarpon from a canoe, and wrote several articles and books describing his forays into the Everglades, Charlotte Harbor and beyond. Julian took photographs of his father's antics, often from a small boat or even a canoe, in open water, with the bulky cameras of the day. The Dimocks also collected live wildlife, such as manatees, for the New York Aquarium and Zoo and other organizations and shipped the creatures by train to the north.

Shultz's old barracks turned hotel burned down on December 30, 1906. Although the building and property were owned by Western Union, Shultz had invested in improvements totaling $20,000 just prior to the fire. Everyone got out safely, but all within was lost. The next month, replacement instruments for the telegraph station were delivered. In September 1907, a new building was under construction, thanks to financing by several of Shultz's wealthy sportsmen. The new hotel opened in January 1908 and stood strong through the 1910 hurricane.

One wing was designated for men only, Murderer's Row, a gathering of tarpon fishing fanatics. The other wing was reserved for families. The second hotel burned down in late 1913 and was not replaced. George Renton Shultz had come to Punta Rassa as a young man of twenty-four and stayed for fifty-five years, an extraordinary period. It was time to retire. Over the years, Shultz was telegraph operator, postmaster, customs inspector, quarantine officer, hotelier and justice of the peace.

The October 17, 1910 hurricane was especially damaging to the islands' agriculture. More than one hundred people were killed across the state, including seven men on Cuban fishing smacks in Charlotte Harbor. On Woodring Point, Flora Morris and Aurora Woodring, alone with two children, managed to get to the recently built clubhouse owned by the McCullough family and watched with amazement as the entire San Carlos Bay emptied and then later returned in a storm surge. On Captiva, a three-story hotel and the new Dickey house were pushed off their foundations. Major wind damage occurred to groves on the islands, as full-sized grapefruit flew like cannonballs from trees. The weight of the heavy fruit caused tree branches to twist and break.

The last Schultz Hotel at Punta Rassa, replacing the updated barracks at Fort Delaney, which caught fire in 1906. This structure burned in 1913. *Sanibel Public Library.*

When the second hotel burned at Punta Rassa, Clarence Snyder was caught short. He was founder and director of the Snyder Outdoor School and had planned to base the school at the hotel. He pictured the advantages of the location, its accessibility through the almost completed McGregor Boulevard and rail and water routes close by. The telegraph connections with the world reassured parents whose children would be attending. Nearby Fisherman Key sported a cottage, and he envisioned boys canoeing back and forth, exploring and camping and learning about the subtropical world. Snyder believed in a combination of work and play under the direction of experienced teachers and councilors. He touted "training and education in an outdoor setting for a happy and healthy mind and body." It is a formula considered excellent today. Twenty-five to fifty boys each season, from about age eight to the late teens, were carefully chosen. Luckily, Snyder owned property on Buck Key behind Captiva Island, and he quickly moved the school there for his first season. In 1914, he purchased the former Eyber Hotel on Captiva, and the school remained a part of the island winter until Snyder's retirement due to ill health in 1926.

It seems the school was rigorous but enjoyable. Emphasis was on English, Latin, algebra, history and science, with sixteen recitations each week and weekly reports to parents. A physician was on staff. One of the teachers at

Outdoor adventure like capturing an eagle ray was part of the curriculum at the Snyder School on Captiva. The pipe-smoker may be teacher Kent Curtis. *Sanibel Public Library*.

the school was Kent Curtis (1890–1957), a veteran of World War I. His classes were in French, Spanish and history, which he began teaching in 1920. Curtis had flown a Sopwith Camel for the Royal Flying Squadron in combat, and he was shot down behind the German lines, reported dead, but instead held captive for several months. Later, he wrote six adventure novels based in southern Florida and won a *Chicago Daily News* movie screenplay prize. He taught at boys' summer camps in Minnesota for more than thirty years. He spent considerable time in Paris in the 1920s, associating with several members of the Lost Generation, including F. Scott Fitzgerald, Sinclair Lewis and Archie MacLeish. Curtis was good friends with Alice O'Brien, also a Minnesotan and friend of Jay and Penny Darling. He spent winters on Captiva from the 1920s until 1957.

The outdoor dimension of the school included swimming, boating, hunting, exploring (and digging in) shell mounds on Sanibel, tennis and basketball and parties and dances at The Matthews or Casa Ybel hotels on Sanibel. Thomas Edison and former president Teddy Roosevelt visited the boys and gave testimonials to the school. The shell mounds were owned by Gerard Kessen, another World War I veteran, who sailed with the boys and helped them with fishing. Kessen later opened Sanibel's first museum

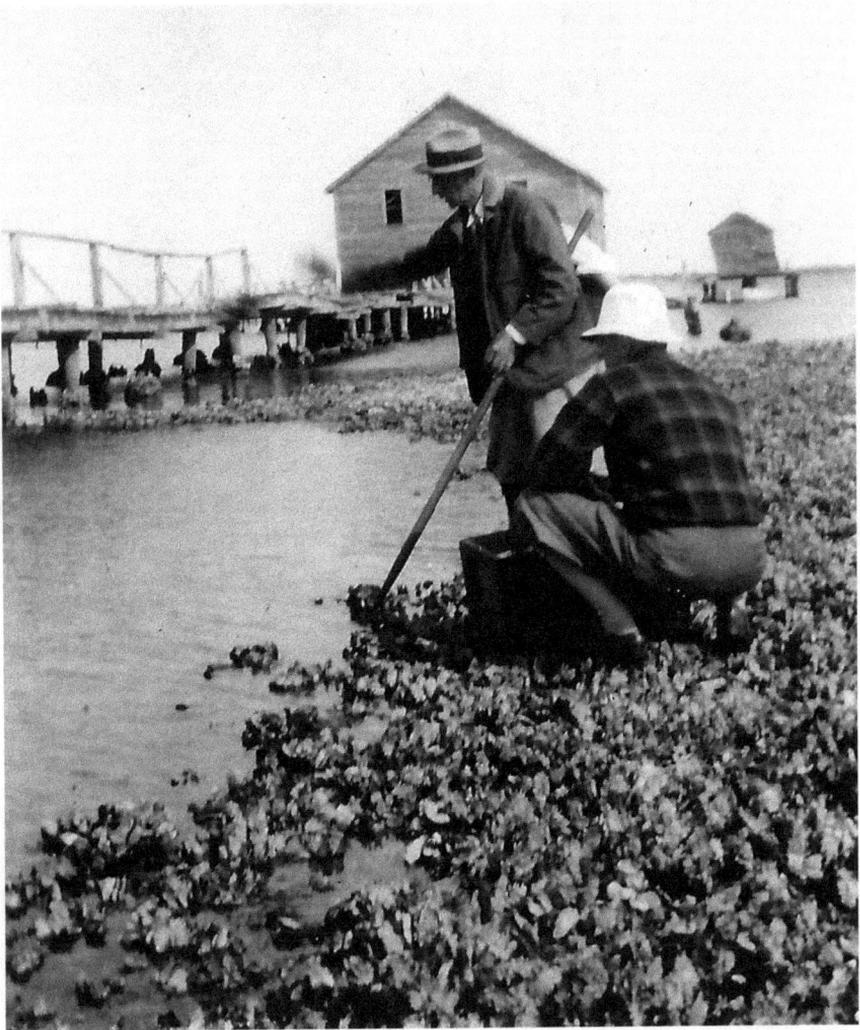

Oyster-raking at Tarpon Bay provided a good dinner. The packinghouse and fish house are in the background. *Linda and George Toft.*

of sorts, touring his mounds and showing off some of the materials he dug from them. He brought visitors to his museum by poling them across a bayou and urged them to first "feed the kitty" at the facility. The mounds, or what remains, have been investigated to various degrees by a number of archaeologists over the years and are now largely a part of the J.N. "Ding" Darling National Wildlife Refuge.

Now the corner of Periwinkle Way and Tarpon Bay Roads, the isolated farmhouse of John Bruaw built by George Cooper in 1895 still stands. *Sanibel Public Library.*

The end-of-season outing at the school was usually a cruise, such as the 1919 trip to the Everglades. Sailing was a passion of Kent Curtis's, and he introduced it to the students. They fished and explored the many rivers, including Shark River, where a factory ground mangrove bark for its tannin, and miles of commercial coconut groves on Cape Sable. The school was emphasizing the abundance and resources of Southwest Florida's natural world, and although instructors didn't always manage to completely embody conservationist principles, the attitude was being implanted in young men who would eventually be leaders in their world.

The October 1921 hurricane cut Captiva Island in half, creating Redfish Pass. Although it passed by offshore and the winds at Fort Myers only reached thirty-six miles per hour with moderate rain, what made the storm memorable was its storm surge. Flooding was at seven feet in Punta Gorda and nine feet in Fort Myers. Effects on Captiva in addition to the new pass can only be imagined. The Nutt family homestead, Gray Gables, was flooded to within a foot of the second floor as the Gavin family took refuge there. That was fourteen feet above sea level. Isaiah Gavin dove down into the kitchen for canned goods so Cordie Nutt could feed the huddled group. The late-season storm meant the soil saturated by salt had little following rain to clear it as the dry winter season began. Other storms passed nearby in 1924 and 1925, further discouraging farmers, while the railroad opened new and larger farm fields south of Fort Myers, beneficiaries of cheaper transport costs and economies of scale.

Although the 1920s were painful for farming on the islands, real estate sales were heating up. Several subdivisions were platted on both Sanibel and Captiva in the early years, notably Woodring's subdivision on Woodring Point. A number of Captiva ones appeared in platbooks at the Lee County courthouse in the early 1910s, possibly a consequence of the 1910 storm, as groves there were more vulnerable to broken trees that were slow to recover. A wiped-out tomato crop could be replanted the next year. A grove of citrus takes a dozen years to reach profitability.

A half-dozen subdivisions were formed, including F.A. Lane's Bay View along Palm Avenue, which ran from Gulf to bay. Fifty-four lots were laid out in 1912. The location is now named Andy Rosse Lane. Additionally, Lane did some augmenting of his lands, filling bay bottom and building a seawall along the bay on the northern limits of his property, near Dickey Lane.

On Sanibel, the Bailey family platted a subdivision in the Donax Street (Tulipa Way) area, and Dr. Harry Opre developed Sanibel Gardens along

Tarpon Bay and Island Inn Roads. Other entrepreneurs established the Sawyer and Sedgemoor subdivisions and several others.

W.E. Cogdell incorporated a development company for a number of subdivisions on San Carlos Bay and a ferry company to bring his prospective buyers to the island in June 1925. In October 1925, Cogdell contracted to purchase an eighty-foot-long barge, twenty-two feet wide, for $4,300, to be paid in eight payments, and $600 at signing. In addition, he ordered two four-cylinder Fairbanks-Morse engines, propellers, bilge pumps, an air compressor, fuel tanks, a generator and a multitude of other needed parts. The ferry would be built in Fort Myers. Cogdell bought land from the Nutt family, P.D. Camp, W.S. Reed, Dora Jenny, the Sanibel Development Company and several other early residents or their heirs, with several mortgages. Farmers were growing older and tired. The land was more valuable in speculation than in tomatoes. Cogdell intended to make a killing by selling lots in paradise, and he bought up everything he could. When the ferry began operating, his grand scheme would pay off all his indentures. He didn't count on the hurricane of September 18, 1926, which decimated Miami before it crossed the state.

The ferry began running earlier in that year, and when the storm appeared on the horizon, Cogdell had it taken upriver for safety—it disappeared without a trace. His proposed land developments on the islands also disappeared. On February 13, 1929, Cogdell's land was offered and sold in

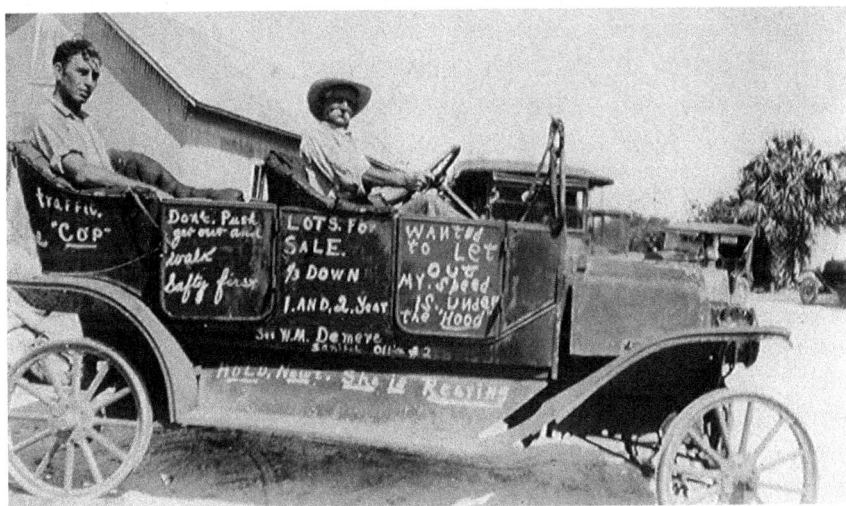

During the "boom" years, land speculation skyrocketed on the islands. *Sanibel Public Library.*

"NATURE'S MASTERPIECE ON THE GULF"

SANIBEL ISLAND
FORT MYERS

Sanibel Island, opposite the mouth of the beautiful Caloosahatchee river, in the Gulf of Mexico, has a wide sloping beach on the Gulf side and a number of exquisite inlets on the San Carlos Bay side. Sanibel is twelve miles in length and an average of two miles width.

The Cogdell Developments—SUNILAND Beach and LANTANA DEL MAR have a combined beach frontage of over three thousand feet with a depth of one half mile.

Destined to shortly become the tropical west coast playground and the beauty spot of the Gulf section, property values have steadily risen since the Cogdell developments have actually been started. And with Fort Myers fast becoming the metropolis of the South West Coast, SANIBEL offers the truly tropical and romantic of all Florida's water fronts.

With your own car, or our busses, leave wonderful Fort Myers, drive on paved roads to Punta Rassa at the mouth of the Caloosahatchee, transfer the car and yourself to the Cogdell Ferry Boat, over the beautiful bay to SANIBEL ISLAND in a few minutes.

Send NOW for our beautifully illustrated three color literature and full information covering home-sites and investment in this, the wonder section of South West Florida.

ADDRESS

The Cogdell Development Company
W. R. COGDELL, President
FORT MYERS, Florida

The Cogdell Development Company had big plans and dreams and brought the islands' first ferry to a short fruition. *Sanibel Public Library.*

foreclosure. Complainants included the several mortgage holders and local companies dealing with hardware, lumber and manufacturing, printing and other supplies.

The Florida "boom" had been stuttering even before the hurricane. In October 1925, as Cogdell was forming his nascent empire, a warning appeared in Minnesota newspapers that one should not invest in Florida, predicting that a "terrible crash is sure to come." Also, *Barron's Magazine* estimated that "twenty million lots have been laid out for speculation sale in Florida, enough to house half the U.S." Northern banks were concerned, seeing withdrawals of so much money for Florida investments. The bubble was close to bursting. The storm crippled Florida's boom, and yet another major storm streaked across the peninsula on September 16, 1928. While it left less physical damage on our coast, it killed more than two thousand people around Lake Okeechobee, as the lake emptied into the Everglades and wiped towns and communities from their moorings. Many bodies were never recovered. The October 29, 1929 stock market crash ended the era and ushered in the Depression years.

DEPRESSION, WAR AND REVIVAL

T here were probably few people who lived on the islands year-round who were directly affected by the stock market crash in late October 1929, although winter residents and visitors undoubtedly were. Bank closings in Florida and across the nation were felt on the islands, even though no banks existed here. In Florida, 146 banks closed and $100 million in deposits were lost. Cities across the state were defaulting on their municipal bonds. By 1935, two-thirds of the towns and cities in Florida had defaulted, due almost entirely to the inflated prices of lots through speculation in the boom times. Simply put, more bonds were issued than there was a taxpaying ability to pay as property values plummeted.

On the islands, the effects largely came from loss of tourism. Sport fishing and general travel were curtailed. The halcyon days of farming on the islands were largely gone due to uncompetitive transportation costs. What had seemed to be an opening connection to the world beyond our shores had closed again. For the few people remaining on the islands, it was a hardscrabble existence reduced to the basics. Rainwater collected with cisterns or artesian wells provided water. Gardens, chickens, fish, gopher tortoises and remnant citrus trees all fed people. If there was a little cash, a ferry trip to the mainland meant some Fort Myers shopping.

One job opportunity continued in the waters of Pine Island Sound—commercial fishing. From the time of the Calusa to the fishing ranchos and through most of the twentieth century, fish, crustaceans and shellfish have provided a living. But the commercial fishing industry had changed

considerably from the rancho days. The ranchos processed their catch by drying and salting the fish before sending it to Havana.

In 1887, Punta Gorda incorporated when the railroad arrived. This began the transitional flow of fish to the north, soon overwhelming and then choking out the few fishing ranchos, like those of Tarivo Padilla, that remained. Fish were now iced and sent whole in railroad cars through wholesale fish dealers like the West Coast Fish Company, Chadwick Brothers, Punta Gorda Fish Company, Desoto Fish Company or T.C. Crosland. It seemed a romantic era, unless, of course, you were working in the midst of it.

Fish houses were built up and down the waterways, including mobile units, called lighters or lighter barges. When Teddy Roosevelt visited Captiva, he stayed aboard a lighter, essentially a cabin built on a barge platform. Fish houses were way stations for runboats that ran a route, typically from the docks at Punta Gorda, where they loaded supplies for the fish house attendants and filled requests for the fishermen and sometimes their families. Supplies could be staples of food like flour, packages and mail, gasoline and fishing needs up to and including skiffs. The main load though, as the boat headed out, was ice in three-hundred-pound-blocks. Some of the runboats included the *Chase*, *Sea Belle*, *Teddy*, *Powell*, *Ray*, *Iris*, *America* and *Roamer*.

These fish or ice houses were built near deep channels but in a protected spot on or behind a sandbar in order to moderate heavy seas in windy conditions. The man running the fish house received and iced the fish, giving the fisherman a receipt tallying the poundage, number and kind of fish, creating a duplicate for the dealer. When the runboat arrived, the same fish were transferred in bulk with the paperwork. Mullet might net a fisherman a penny and a half per pound, with the fish company selling it for two cents per pound.

Ice was manufactured in the ice plant at Punta Gorda, and over time, it evolved into the town's first electric plant. The ice was sent down to the docks and loaded, and the runboat—on a typical route—would head south to each fish house owned or serviced by its company. It would deliver the ice and supplies, and fish that had been tallied at the stations were loaded into the hull on abundant flaked ice. On the return to the docks, the iced fish, still whole, would be loaded into railroad cars and dispatched north. Each boxcar could hold twenty thousand pounds of fish, and often several boxcar loads would leave in a day. The major portion of the fish was mullet, and it was usually destined not for the dining table but used as a fertilizer.

Over the decades, fish were netted in a number of ways. Commercial net-fishing was banned in 1995 in Florida, and many forms of netting had

been illegal for some time. Pound-nets were used in the open Gulf. These were strong funnel-shaped nets attached to pilings that trapped fish guided into them by the current and the wings of the netting. Hook-and-line fishing, stop-nets and gill-nets were used as well.

George Gatewood (1862–1947) described stop-netting in an article that appeared in his 1944 book *On Florida's Coconut Coasts*. A stop-net crew included six or seven men. The heavy nets were set at high tide, which was when the fish came through a pass between two barrier islands, Captiva Pass for example, from offshore. While the fish were feeding on the shallow flats, or shoal water, the nets were extended from island to island, involving perhaps as much as a mile of netting. Once the tide began to drop, the fish would be trapped as they came off the flats. The men would pen the fish by looping the net tighter and tighter, propping the cork-lines up so the fish could not jump over the netting and eventually bringing the lead-line under the mass of fish. Using one or several scows or skiffs as boxes, the men would fill multiple boats with their catch and then tow them to the fish house.

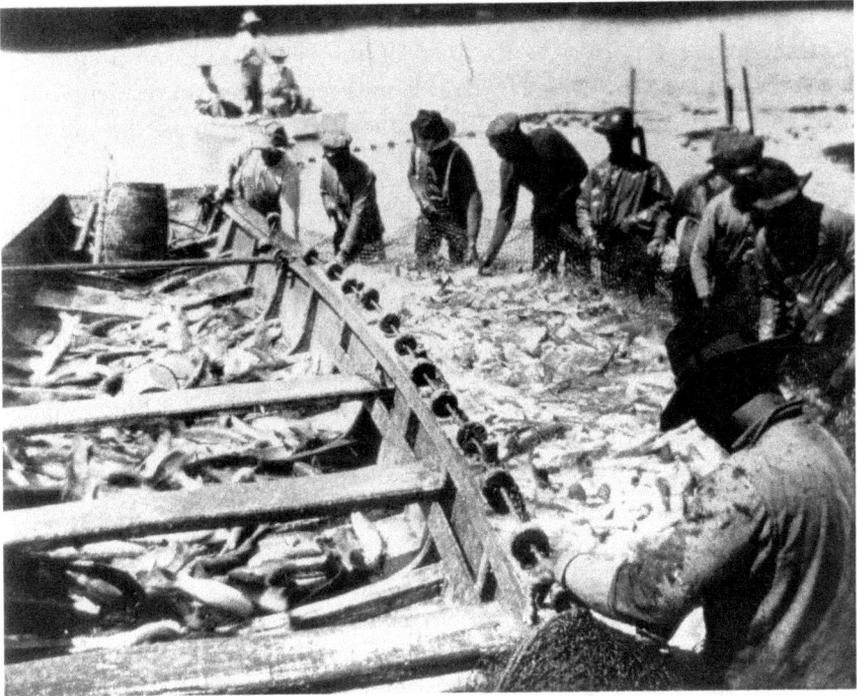

Commercial fishing has been a staple of the Pine Island Sound vicinity through centuries. *Sanibel Public Library.*

Gatewood wrote:

I was working once with Sand Brim's father, who had a crew of seven men, when he caught twelve thousand six hundred pounds of fish at one haul of the nets. It took us from daylight that morning until midnight that night to gather them up and get them into the ice house. Most of them were mullet, which are very desirable fish; but there were many trout, which bring a better price than mullet, and there was a sprinkling of other kinds of eatable fish. That was an unusual catch, but not as large as some others have made.

Gatewood mentioned that pelicans were seen as friends of the fishermen, as they hung around the men emptying nets. While the birds were looking for a meal as they clustered near the cork-lines, it frightened the mullet back into the net, so fewer fish jumped to freedom. Gatewood was a man of many parts, having settled in Southwest Florida in 1882. He roamed from Chokoloskee to Punta Gorda as a circuit preacher, census taker, postmaster, farmer, fisherman, real estate agent and finally a columnist and newspaper reporter. At the turn of the century, he ran a store on Sanibel Island with his wife. He likely knew every long-term resident in the area and maintained an interest in all they did. He remained a minister throughout his long life.

As the Depression wore on, islanders began finding creative ways to earn money, some more legal than others. The occasional liquor still operated on the island, and Justice of the Peace Frank Bailey was the closest thing to a law officer as the islands had. He stopped operations on more than one moonshining business. But even after Prohibition was repealed in 1933, home brewing and smuggling of liquor continued from the Bahamas and Cuba. Cubans sailing their beautiful fishing smacks around the islands often came ashore to trade and buy goods, including Cuban cigars and liquor. The fishing smacks were an occasional sight around the islands until the Castro regime took over the island nation. It ended a connection between the islands that had existed since the first Spanish sailed toward our coast.

Cuban smacks could fish for weeks, collecting fish in their holds, which were essentially huge live wells. The crew lived on the deck, cooking over a fire in a sandbox. Daily, someone would dive into the well to clear out dead fish, and the smack would be constantly on the move or in a current for the water exchange. If storms threatened, they often hid in the curve

The graceful Cuban fishing smacks were often seen offshore or in the San Carlos Bay until the Castro regime took over that island. *Sanibel Public Library*.

of Sanibel's harbor for protection, and more than once, fishermens' bodies washed ashore after hurricane weather and were anonymously buried on the island.

Some islanders went into the shelling business and gathered the windrows left on the beaches over the centuries to sell to wholesale outlets. The industry of selling and collecting shells for their beauty and for craftwork has always been a part of the islands. In 1936, the Pulitzer Prize–winning poet Edna St. Vincent Millay (1892–1950) came to the island to go shelling and checked in at the Palms Hotel, run by members of the Shanahan lighthouse family. She and her husband then walked the beach and, when they turned to go back, saw the hotel in flames. She lost an entire manuscript in the fire, a play she later rewrote from memory, called *Conversation at Midnight*.

While the Labor Day Storm of 1935 was devastating to the Florida Keys, killing nearly five hundred people, it brushed by us. In the wake of that storm came another environmental storm in north Florida. Just two weeks later, President Franklin D. Roosevelt ordered the start of construction of the Atlantic Gulf Ship Canal near Palatka. This potential canal would be a shortcut through Florida's peninsula. It was the same concept Pedro Menéndez hoped to find in 1566. The canal was designed to cut across the state at a constricted part of the peninsula and was meant to be dug at sea

level across its length. The opposition to the plan came hot and heavy, as conservationists pointed out the potential destruction of Florida's freshwater aquifer, and on the other side, railroads were appalled at the potential competition from barge traffic. Although Roosevelt halted funding within a few months, the project, as the Cross-Florida Barge Canal, would resurface in the 1960s.

Dr. Louise Merrimon Perry (1878–1962) and her husband, Nelson, came to Sanibel in 1918. They found the "conveniences" of the island so lacking that they wanted to immediately leave, but the Fort Myers boat was gone for the day. So they stayed at Casa Ybel for the night, then the weekend, then the winter. An ophthalmologist, Dr. Perry had a thriving fifteen-year practice in Asheville, North Carolina, but after that first season, she and her husband spent each winter on Sanibel, eventually building their house, *Spindrift*, near Casa Ybel. Nelson built Dr. Perry a laboratory there because she had become fascinated by sea life, particularly mollusks. Over the years, she experimented in the raising of molluscan spawn, dredging life from eleven fathoms in the Gulf. Her important studies with tarpon helped to unlock this mysterious fish's early life history. Her investigations were important to the sport fishing industry, and notable personalities and scientists supported her. In 1938, the New York Zoological Society and Yale University established a field laboratory on Palmetto Key (now Cabbage Key) in northern Pine Island Sound to study the tarpon's life cycle. The island was then owned by American mystery writer Mary Roberts Rinehart, who had befriended Dr. Perry and supported her tarpon research. When operable, the new lab began tracking the tarpon's breeding, migration and growth. The research was under the supervision of Charles Breder Jr., acting director of the New York Aquarium and a curator at the American Museum of Natural History.

Dr. Perry became a malacologist of significant renown and wrote a scientific guide to mollusks, *Marine Shells of the Western Coast of Florida*, that is still referenced. Some fifteen new species were named to honor her. She directed the Sanibel Shell Fair for many years and compiled the first bird list for what was then the Sanibel National Wildlife Refuge. On-island, if approached because of a medical need, she always helped and refused any payment. In her other home, Asheville, her eye clinic gave refractory exams to nearly 1,400 schoolchildren during World War II and never charged a penny. Perry's collection of shells was donated to Rollins College, and upon her death, her property was given to the J.N. "Ding" Darling National Wildlife Refuge, its only Gulfside holding.

Spindrift, Dr. Louise Perry's home and laboratory on the Gulf near Casa Ybel Hotel, in the 1930s. *Sanibel Public Library.*

Dr. Perry and a fellow scientist who came from Stanford University, Margaret Hamilton Storey (1900–1960), spent time on various projects together in the 1930s. Storey's main interest was fish. As an early woman ichthyologist, Storey wrote two Sanibel-based articles on fish mortality due to freezes on our subtropical island. She quantified nine freezes between 1886 and 1934, describing their differences in effects on both fishes and vegetation, such as temperature, the suddenness of the freeze, the type of fish, tidal range, wind, duration of the freeze and depth of water. Storey worked at Stanford's Natural History Museum as assistant curator, overseeing its ichthyology and herpetology collections.

At the start of World War II, author Theodore Pratt described Sanibel during his visit, saying:

> *Half or more of the population migrated to escape starvation. Shells have supported the remainder since. Always primitive, Sanibel became even more so. The few winter tourists were attracted by this very quality, and they least of all would change it.*
>
> *The hotels and some of the houses have their own generating plants, but there is no public light or power and most of the homes are lighted by oil*

lamps. There is no doctor, dentist, drugstore, fire department, movie house, bank, newspaper, soda fountain, sidewalk or pavement.

The year 1941 brought some major changes to the islands. The Lee County Electric Cooperative was formed in North Fort Myers, and Sanibel and Captiva were early beneficiaries. The prospect of electricity had come to the islands and greatly reduced the chances of accidental fire by spilled oil lamps. In December, war arrived, and it would bring change to the island. Fort Myers had two training centers, at Buckingham and Page Fields. Buckingham's was a major Gunnery Training School, and crews in training used portions of Sanibel's empty prairie as a bombing and practice range, flying across the island at Bowman's Beach and across Wulfert Point and Buck Key on strafing runs at offshore targets. After the war, gathering shell casings to sell for scrap metal in Sarasota or Tampa became a popular and lucrative activity.

The islands were under blackout conditions at night (just when they got electric light!) due to the threat of German submarines patrolling along the Gulf Coast. A submarine spotting tower was built next to the lighthouse tower on the eastern tip of Sanibel. The Coast Guard stationed observers and beach patrolmen in a cottage near the tower at the lighthouse. The dry land Coast Guardsmen were gifted with the belittling nickname "sand pounders." Army troops were also stationed on-island, patrolling the beach and living in tents on the shore. As Theodore Pratt mentioned, conditions were primitive. Rationing was nationwide, but on the islands, fishing, gardening and other eating-off-the-land opportunities continued. In 1944, another hurricane hit, and flooding caused considerable damage. During the storm, the lighthouse quarters were threatened to the point that the islanders and some Cuban fishermen sheltering there climbed into the tower for safety when the floorboards began being pounded by waves. Through the long night, they reported that the tower swayed as they sat on the metal stairs spiraling up to the light. The main road by the Community House was flooded more than two feet deep as people tried to walk to there for safety.

In the postwar era, scores of the soldiers who had been stationed in the area returned with their families for vacations, many eventually moving here as prosperity returned. Some built mom-and-pop motels along the Gulf in anticipation of the rise in tourism. In addition, artists and writers like Maybelle Stamper, Robert Frost, Thornton Wilder, Clifton Fadiman, Fletcher Knebel and Robert Rauschenberg discovered what others like

"Ding" Darling and Edna St. Vincent Millay had already experienced. Marjory Stoneman Douglas published the Everglades book *The River of Grass*, and in 1947, the Everglades National Park was dedicated by President Truman.

The islands remained primitive, but more change loomed. A tidal wave of tourist expansion was on the horizon, and the islands' resources and wildlife were being stretched.

1

ARISING CONSERVATION ISSUES

I n general, the modern trend of American conservation efforts diverged about 1850. Conservationists as we define them today split from a common ancestor philosophy. The viewpoints of the other allied branch, the preservationist movement, were not synchronized with the modern conservationist position, and by the mid-nineteenth century, the conservation ethic was growing and expanding across the United States and became mainstream. The first major national conservation organization was the Boone and Crockett Club. The club was founded in 1887 by future president Theodore Roosevelt. Today, conservationist organizations include such stalwarts as the National Audubon Society, and on Sanibel and Captiva Islands, the local Audubon Society and the Sanibel-Captiva Conservation Foundation carry the conservation torch. The preservationist attitude is still alive and functional in such groups as the Sierra Club.

Fashion from New York to Paris demanded that ladies' hats be adorned with sweeping bird plume feathers, even whole birds and bird nests. Plume feathers only emerge in mating season, when young are being anticipated and cared for on the nest. By 1886, to supply this demand, plume hunters had scoured South Florida and the Everglades, shooting entire rookeries and leaving baby birds and eggs to wither and die in the sun. The demand was so intense, shipments to Europe were in tons; feathers became worth twice their weight in gold as the numbers of plume birds shrank dramatically. An estimated five million birds were killed in 1886.

To address the veritable slaughter of the plume birds in the southeastern United States, the Massachusetts Audubon Society was founded in 1896.

In March 1900, the Florida Audubon Society formed, and in May, the Lacey Act of 1900 passed in Congress and was signed by President William McKinley. It was a conservation law prohibiting trade in illegally taken wildlife, including plume birds. The intent was good, but there was a lack of enforcement, and killings continued.

In 1901, like-minded associated groups within individual states joined together to share a common interest of protecting colonial nesting birds targeted by the plume hunters. A bird protection committee was formed by the American Ornithologists Union in 1901, and this committee worked with the Florida Audubon group to help push the Florida legislature to act on behalf of its state's wildlife. The Audubon Model Law, an act essentially outlawing plume hunting, was passed and became effective in Florida.

The Florida Audubon Society moved quickly and authorized the hiring of wardens to protect the plume bird colonies in 1901. Guy Bradley, a resident of a tiny settlement known as Flamingo, near Cape Sable at the southern tip of the Florida mainland, was hired as the first Audubon warden in 1902.

Audubon groups in other states soon followed Florida's lead and hired wardens with similar authority. The National Audubon Society was founded in 1905, and it worked tirelessly to improve laws that would provide more protection to all birds, just not egrets and other plume bird species. Smaller songbirds were being stuffed and attached to hats, and even their nests were included in this fashionable trend. The National Audubon Society then assumed responsibility for the warden program, and Florida's wardens were retained in service.

Audubon wardens were based close to major colonial bird rookeries and patrolled them regularly, but plume hunters were wise to their habits and continued to slip into rookeries and take birds illegally. The poachers were desperate men who saw the wardens as their enemy, endangering their pocketbooks and way of life. Consequently, Guy Bradley was shot and killed by a plume hunter neighbor while on duty on July 8, 1905, near Flamingo.

Tragically, a second Audubon warden, Columbus G. McLeod, was killed while on duty in northern Charlotte Harbor—not many miles north of Sanibel and Captiva Islands. McLeod was sixty-three, a bachelor and longtime resident of Placida, Florida. He disappeared from his rounds on November 30, 1908, and his boat was later found in Turtle Bay, partially sunken with two sandbags under the thwarts and still containing his

Audubon warden Guy Bradley patrolling before his death in 1905; he was murdered by plume hunters. *Public domain.*

bloodstained hat, gouged with what appeared to be hatchet gashes. His body was never found, doubtless washed out to sea. Less than two months before his disappearance, he noted:

> *The small number of plume birds that I had last breeding season, and that I was so proud of, have not returned this season to nest on Sunset Island* [Devil Fish Key]. *I suppose they must have nested somewhere in the interior and long since been shot. However, I saw a few lately on the breeding ground. I do hope that the flock of Pink Curlews* [roseate spoonbills] *have escaped this summer and will pay me a visit now soon. It is not yet time for the flock of White Pelicans to put in their appearance.*

These Audubon wardens were paid thirty-five dollars per month and provided with a naphtha-powered launch.

The deaths of these dedicated early wildlife officers struck the conservation morality of the nation and reached deep into peoples' core values. In a united effort, conservationists appealed to the highest level of government, and the Migratory Bird Treaty Act was implemented in 1918. The plume birds began a long but mostly successful recovery.

The Great Depression (1929–38) wreaked havoc on Sanibel and Captiva Islands. The earlier boom years, land price inflation and expectations had made the shock of the fall hard, as in most of the country. Most out-of-state patrons of the islands' few cottages and hotels could no longer expend funds for such extravagance as long winter vacations to Florida. Longstanding

A magnificent white pelican shot down in Roosevelt Channel. A man displays its ten-foot wing-spread. *Sanibel Public Library*.

repeat reservations that were regularly booked by middle-class clientele plummeted, staff members were laid off and upkeep and maintenance of structures waned. There was little work on the islands, and those residents who remained and were already struggling tightened their belts and struggled more. Many moved away during the decade.

Resident and migratory birds were again being threatened, as were native mammals and some reptiles. Without work, many families on both islands reverted to an earlier lifestyle of almost completely living off the land and water. Anything edible was harvested from the waters surrounding the islands, as were consumable wildlife species that ranged through the uplands and interior wetlands of the barrier islands. For example, unprotected gopher tortoises were collected whenever found, and hungry people regularly dug into the turtles' deep burrows to remove them. Gopher and rice was a common dish prepared and served at mealtime by some island families up until at least 1970.

That economically deprived islanders, black and white, openly took resident wildlife species and migratory waterfowl at will bothered seasonal residents and the financially better-off homesteaders. The Migratory Bird Treaty Act protected birds in the United States beginning in 1918, but hard-pressed locals paid the law no heed—they had to feed their hungry families. The Depression added insult to injury. The islands' farming economy had crashed in 1926 after the storm surge of a catastrophic hurricane completely inundated most of both islands, and the railroad had finally moved south of Fort Myers, opening larger lands to agriculture with significantly cheaper transportation costs. Rebuilding a small farm to compete with mainland larger operations was not money-wise. Many people couldn't cope and had already abandoned the islands. Those who remained had no place else to go.

By 1930, a different mindset, a public mood that wanted to see illegal taking of wildlife come to an end, began to influence the residents. Slowly, the seeds of conservation that were sown during that generation began to bear fruit locally in 1935. The initial crop of improved environmental stewardship matured in 1939 when the Florida legislature, at the behest of Sanibel and Captiva Island residents and voters passed a special act that established Sanibel and Captiva Islands as a game and fish refuge. Many of the land and wildlife conservation successes on Sanibel and Captiva Islands that occurred between 1935 and 1945 were the responsibility of one man who worked exceptionally well with others of like mind—as long as he was in charge.

Jay Norwood Darling was born on October 21, 1876, in Norwood, Michigan. He was the second child of the Reverend Marcellus and Clara Darling. Nearly sixty years later, it would be his elder brother, Frank, who would introduce him to the barrier islands of Southwest Florida.

Jay's parents hoped he would have a future in the medical field, but that goal was altered slightly after he was suspended from his studies at Beloit College in Wisconsin. In his junior year, his rudimentary but developing artistic skills caused serious damage when he penned a caricature of four of the school's leading professors for the school's yearbook, *Codex*, for which he served as art director. After the faculty voted, he was suspended from the school for a year.

His love for the environment developed in his early years, and his participation in outdoor activities such as fishing and hunting took him to ecosystems that enraptured him. His conservation ethic was established early, and during his educational hiatus, young Jay Darling's love for wetlands and landscapes and the creatures that depend on these wild systems deepened. This conservation mindset would be close to his heart for the rest of his life.

During his suspension from college, Jay Darling toured as a bass singer in an all-male traveling quartet. Their road tour schedule included his first trip to Florida, where he was impressed by the state's relatively unspoiled environment. When the tour ended, he returned to Sioux City, Iowa, where he took a newspaper job with the *Tribune*. Jay re-entered Beloit to complete his senior year and graduated in 1900.

After graduation, Darling continued to consider medicine as his career choice, but his life changed when he was hired as a cub reporter by the *Sioux City Journal*, the *Tribune*'s competitor. When on an assignment, often in places like stuffy courtrooms, Jay would frequently sketch people, and he honed his skills in the art of caricature rendering. Soon, his work was brought to the attention of the *Tribune*'s editor, and his sketches were published in the newspaper and publicly acclaimed. His first cartoon related to conservation appeared in the *Journal* not long after Theodore Roosevelt ascended to the presidency.

Over time, Jay Darling's popularity as an editorial cartoonist grew, and major midwestern newspapers vied to entice him to become a member of their staff. He spurned their offers and loyally remained at the *Sioux City Journal* for six years. During that tenure, he married Genevieve "Penny" Pendleton on October 31, 1906. During their honeymoon in the West Indies, a telegram caught up with them, and its message was life-altering. It was a

job offer from the *Des Moines Register and Leader*. The Darlings shortened their honeymoon and returned to Sioux City to relocate to Des Moines.

Early on, he abbreviated his surname when signing his cartoons. Darling became D'ing, and the apostrophe replaced the letters a-r-l forevermore. "Ding" was his nickname at Beloit, and many of his male family members used it as well.

From 1908 until his retirement in 1949, Jay N. Darling's career soared. His conservation ethic was on an upward curve, as he penned conservation-related cartoons that were interspersed with his politically inspired biting artwork. His following quickly grew, and in 1911, he moved "up" to the *New York Globe*. In 1913, he returned to the *Register and Leader*. His cartoons became syndicated in 1916 under an agreement he had entered into with the *New York Herald Tribune* syndicate. Jay Darling's popular cartoons were now reaching 130 major newspapers across the nation. He went back to New York for a year but returned to the *Des Moines Register* (*and Leader* was dropped in 1916) in 1919.

Over the next three decades, his contributions to the conservation theme would expand. Among his many successes were:

1. He twice won the Pulitzer Prize for Editorial Cartooning, in 1924 and 1942.
2. President Franklin D. Roosevelt appointed him to head the U.S. Biological Survey in March 1934. This agency was the forebear of today's U.S. Fish and Wildlife Service.
3. J.N. Darling was elected as a member of the prestigious wildlife conservation group the Boone and Crocket Club in December 1934.
4. "Ding" Darling led the new Federal Duck Stamp program and designed the first of these stamps in 1934. This program continues, and today, this stamp is known as the Migratory Bird Hunting and Conservation Stamp.
5. He advocated and was a key player in the founding of the National Wildlife Federation in 1934. He served as the organization's first president.
6. The National Audubon Society awarded Jay N. Darling the Audubon Medal in 1960 for his achievements in the field of conservation.
7. Posthumously, in 1967, the Sanibel National Wildlife Refuge was renamed J.N. "Ding" Darling National Wildlife Refuge to memorialize the contributions Darling made to national conservation efforts.
8. The "Ding" Darling Wildlife Society–Friends of the Refuge was incorporated in 1982. Having been organized to support the refuge, the society completely funded, at a cost of $3.3 million, the construction

of the refuge Education Center in 1999. This included all the exhibits and interpretive materials displayed therein. It continues to support J.N. "Ding" Darling National Wildlife Refuge by financially assisting an internship program, funding new exhibits and trails, leading land acquisition campaigns and spearheading conservation advocacy efforts in Washington, D.C., where "Ding" Darling once worked his magic.

In 1934, four days after he had signed the new Duck Stamp Bill, President Franklin D. Roosevelt bit his tongue and crossed his fingers when on March 10, 1934, he asked Republican Jay Darling to come to the nation's capital. The president and "Ding" had telephone conversations about the job he was offered—the one he was about to take in the Roosevelt administration. The president appointed Darling to the directorship of the U.S. Bureau of Biological Survey, a struggling agency in the Department of Agriculture. "Ding" Darling proved to be an able administrator and selected capable men like Ira N. Gabrielson (1889–1977) and J. Clark Salyer (1902–1966) for leadership roles. Gabrielson would go on to become the first director of the U.S. Fish and Wildlife Service, and Salyer would be appointed the first chief of the National Wildlife Refuge System.

The Duck Stamp Act was passed, but its implementation was waiting, unfunded, in the wings of the Bureau of Biological Survey when Darling arrived in Washington. He soon made it his personal mission to see the Duck Stamp finalized and put into action to raise funds for the acquisition of an inventory of diminishing wetlands. He was so personally involved that he sketched the design that eventually went on sale as the 1934–35 stamp, the first Duck Stamp.

Following the recommendation of his elder brother, Frank, who had already visited Captiva Island, "Ding" and Penny Darling arrived here to winter in 1935. They took up residence that first winter at 'Tween Waters Inn. Over the next two winters, in both 1936 and 1937, the Darlings pulled a small house trailer from Iowa to Florida and back. He named the

Jay Norwood "Ding" Darling came to the islands in the mid-1930s and sparked a nascent desire to protect the land and wildlife existing here. *"Ding" Darling Wildlife Society–Friends of the Refuge.*

The first Migratory Bird Hunting Stamp, or Duck Stamp, designed by "Ding" Darling. *U.S. Fish and Wildlife Service.*

trailer *Bouncing Betsy* and even wrote a book about the adventures of hauling a house trailer back and forth. Over time, the Darlings purchased land and buildings on Captiva, and in 1942, he built his Fish House. This was basically an art studio on pilings in Pine Island Sound, and it was accessible by an elevated walkway over the water that sported a drawbridge he would raise when working. "Ding" Darling valued his solitude and privacy.

By 1936, Jay Darling had correctly interpreted that there were numerous residents on both islands who had proactive conservation principles that paralleled his own. He joined a group of his neighbors, and they formed the Inter Island Conservation Association. Soon, "Ding" Darling was leading another charge; this one was aimed at saving Sanibel and Captiva Islands from what he perceived as the treachery of real estate speculators and land developers. Those participating in the united effort saw realization of their success when the islands were recognized as a state wildlife refuge in 1939. The formal establishment of the Lee County Refuge Commission followed. The Florida legislature authorized this commission by specific language in the body of House Bill 1095.

Muggins Underhill carries a cast net as he wades a refuge creek.
Linda and George Toft.

Over the next twenty years, many leading island conservationists were appointed and served on this five-member refuge commission. Appointees included the following stalwart conservationists and well-respected citizens: Ernest Bailey, Hallie Matthews, Stella Mitchell, Webb Shanahan and Francis P. Bailey Jr.—all from Sanibel—and Belton Johnson, Max Hayford, and Allen Weeks from Captiva. After Tommy Wood entered on duty in 1949, he represented the U.S. Fish and Wildlife Service as an ex-officio member until the Lee County Refuge Commission determined itself to be obsolete, disbanding in 1960.

In 1943, the Lee County Refuge Commission hired George W. "Muggins" Underhill (1905–1988) to be its warden overseeing the state wildlife refuge. To be effective, he was commissioned a deputy game warden by the Florida Game and Fresh Water Fish Commission. Underhill remained in the position until Sanibel National Wildlife Refuge was created in 1945 and service patrolmen took over the responsibility for law enforcement on the refuge.

As conservation efforts evolved and islanders were working to realize the establishment of a national wildlife refuge, other conservation efforts were underway. By the early 1950s, a growing number of residents and visitors had special interests in field ornithology. They were then dubbed "birdwatchers," and they started to consolidate their special interests. Under the leadership of B.K. "Ben" Boyce (1886–1972), the Sanibel-Captiva Audubon Society was formed. Boyce, who was a professional naturalist and winter visitor, became the organization's first president in 1953. He would serve in that role until 1957. The Sanibel-Captiva Audubon Society officially became a chapter of the Florida Audubon Society on September 3, 1974.

Now, over sixty years after its creation, the Sanibel-Captiva Audubon Society is a conservation powerhouse and an important part of the islands' conservation history. In time, other conservation groups would emerge and rise to prominence in the island community.

8

THE BIRTH OF A NATIONAL WILDLIFE REFUGE

J .N. "Ding" Darling didn't stop prodding the bureaucrats in the top tier of the federal government after the Florida legislature passed House Bill No. 1095 on May 25, 1939. This statute established a state wildlife refuge on Sanibel and Captiva Islands and created the Lee County Refuge Commission. This commission consisted of five members who were selected from nominated island residents and then duly appointed as a commission member by the Florida Game and Fresh Water Fish Commission. "Ding" Darling viewed this as an opening that he hoped would soon lead to another level for protecting the islands—the establishment of a national wildlife refuge. He diligently pressed on with that goal in mind.

The Inter Island Conservation Association and the Lee County Refuge Commission launched a petition drive. Darling and the others discovered there were already approximately 2,500 acres of mangrove wetlands that were state and federally owned on the northern half of Sanibel. The islanders assumed that negotiations for the U.S. Fish and Wildlife Service (USFWS) to acquire that tidal mangrove habitat would be straightforward and simple. An individualized postcard-size petition was circulated that requested that a presidential executive order be promulgated to establish a national wildlife refuge on the islands. The cards were favorably signed by the majority of the property owners on both islands. The USFWS took this suggestion seriously and studied the acquisition of the land. The agency began the slow process of putting an acquisition process into action in late 1943, but by early 1944 it had struck a snag.

Originally, the state had agreed to sell its 2,500 acres of land to the federal government after an appraisal and a land survey. The agreed selling price would be $1.50 per acre. A confusing issue arose when the state balked and announced that it must follow rules and was required to sell the land at public auction. This change in attitude occurred after the news of the negotiated sale to the federal government leaked out. When the sale became public knowledge, a private real estate investor upped the ante when he offered $2.82 per acre. This news of the state's withdrawal from the pending sale reached Washington just ten days before the deal was to close, but USFWS's hands were tied because there was not enough time to plead the case to the Roosevelt administration for an increase in the original appropriation.

At the request of the Lee County Refuge Commission and some extensive personal interplay with "Ding" Darling, Florida governor Spessard Holland intervened and brought the land auction to a halt. Eventually, a lease agreement that would convey management of the state-owned land to the USFWS was finalized and executed on December 1, 1945. This action created the Sanibel National Wildlife Refuge (NWR).

Migration time at the Sanibel Refuge depicted by "Ding" Darling, with coots, gallinules, black-necked stilts, wood storks, herons, egrets, red-winged blackbirds and many varieties of ducks. *"Ding" Darling Wildlife Society–Friends of the Refuge.*

The first NWR in the United States was the Pelican Island Migratory Bird Reservation. President Theodore Roosevelt established this refuge on March 14, 1903, with the backing of leading ornithologists and the membership of the Florida Audubon Society. This five-and-a-half-acre island (in 1903) is located in the Indian River Lagoon about forty-five miles south of Cape Canaveral.

Teddy Roosevelt continued adding refuges to the new Migratory Bird Reservation System during his presidency. It would be renamed the National Wildlife Refuge System under President Franklin D. Roosevelt in 1942. A few of these early refuges were located near Sanibel and Captiva Islands: Pine Island NWR (established September 15, 1908), Matlacha Pass NWR (established September 26, 1908), Island Bay NWR (established October 23, 1908) and Caloosahatchee NWR (established January 1, 1921, by President Woodrow Wilson).

Beginning in 1945, all of the NWRs in South Florida, including Sanibel NWR, were administered from the office of Everglades NWR. The USFWS and the National Park Service shared expectations that all of the area within the refuge boundary would become a national park within ten years. Interim refuge manager Claude F. Lowe Jr. (1908–1984) set up headquarters in Coral Gables at Chapman Field. Lowe had served as a law enforcement agent of the Florida State Board of Conservation between 1941 and 1945. Daniel Beard (1906–1977) assumed the refuge manager position on October 26, 1945, after his discharge from the U.S. Army. He had vast experience in the region, and beginning in the late 1930s, Beard conducted considerable research in the Everglades on behalf of the USFWS and continued his work there until he was drafted in 1944.

Dan Beard surrounded himself with a staff who would protect the wildlife resources of the refuges under his jurisdiction. To Beard, law enforcement experience was an important asset for those hoping to be selected for his team, so he chose his candidates carefully. Several men, including Jack C. Watson (1913–1982), earlier served as National Audubon Society wardens before joining his force. Watson would eventually become manager of the National Key Deer Refuge, headquartered on Big Pine Key.

One of the USFWS's patrolmen was William C. "Bill" Lehmann (1916–1999). He was already in place in the late 1930s and assigned to patrol the Southwest Florida coastal refuges and rookeries across the state, including Pelican Island NWR. He worked out of his hometown of Mango, then a tiny community in Hillsborough County, Florida, located ten miles to the east of Tampa. Bill Lehmann regularly patrolled all of the refuges in Southwest

Florida and monitored the success of other colonial bird nesting rookeries that were not part of the NWR system. Collectively, these refuge islands were known as the Florida Islands National Wildlife Refuges. Additionally, Lehmann was authorized to protect non-refuge sites under provisions of the Migratory Bird Treaty Act. Like the Audubon wardens before them, the USFWS's patrolmen were collaterally commissioned as deputy Florida wildlife officers by the Florida Game and Fresh Water Fish Commission. Bill Lehmann frequently visited Sanibel Island during his patrols in the years before World War II.

The lands and water of Everglades NWR became Everglades National Park in 1947. Dan Beard transferred to the National Park Service to become the park's first superintendent on September 23, 1947. Gerald F. Baker (1904–1963) became refuge manger of Everglades NWR. The headquarters office was temporarily relocated from Coral Gables to a small frame building in Dania, close to Broward International Airport near Fort Lauderdale.

Progress was finally being made in the conservation effort throughout South Florida. Moreover, on December 2, 1947, President Harry Truman signed Presidential Proclamation No. 2758. This action designated a closed area on and around Sanibel Island and a small part of southern Captiva Island. The closure order, authorized by the Migratory Bird Treaty Act, extended beyond the original boundary of the Sanibel NWR. The proclamation's language specifically prohibited the pursuing, hunting, taking, capturing and killing of migratory birds or attempting to take, capture or kill migratory birds, within the closed boundary.

Several years after the establishment of the Sanibel National Wildlife Refuge, the USFWS decided it was time for the agency to permanently assign someone to Sanibel Island. Gerald Baker hired Sanibel Island resident Dewilton "Jake" Stokes (1909–1989) as a part-time interim patrolman in 1947. Baker wanted the USFWS to have an on-island presence until he found the perfect person for the permanent position. One of the first personnel options Baker considered was to move Bill Lehmann from Mango to Sanibel or Captiva and establish a headquarters for Sanibel NWR. Before the personnel action was finalized, Lehmann met "Ding" Darling. The two apparently did not hit it off. Darling used his charm and influence, and Baker withdrew Bill Lehmann as his top candidate. Lehmann remained with the USFWS and later became a special agent in its law enforcement arm.

The hunt continued for someone to fill the Sanibel Refuge position. In January 1949, Walter A. Gresh (1903–1992) from the USFWS's regional office in Atlanta visited Sanibel to interview potential applicants for the

job. Gresh would later become regional director, and Sanibel NWR would remain one of his favorites. Years later, his influence would lead to major changes at the refuge.

Refuge Manager Baker's next choice was Claude Lowe. Little information is available on Lowe's tenure, but he apparently did not like the isolation and other hardships of island living on Sanibel and Captiva Islands, so he resigned and returned to Tavernier. At least on the Keys he had a bridge connection to the outside world. Gerald Baker then offered the position to Patrolman William D. "Tommy" Wood (1903–1990), who lived on Key West.

Tommy Wood was born in Ozona, Florida, and went into the field of aviation at an early age, soloing in 1927. At the outbreak of World War II, he underwent some military training in Avon Park, Florida, a U.S. Army Air Corps complex, but was eventually assigned to the U.S. Navy. During his enlistment, he rose to the rank of lieutenant commander and served in the Pacific theater. He flew missions in multi-engine PBY seaplanes around New Caledonia, near Australia. After the war, he bought a single-engine floatplane and operated Wood Seaplane Service on Key West, Florida. Tommy Wood's operation was Key West's first charter fishing seaplane.

Tommy Wood was recruited into the USFWS in 1948 and became a patrolman with responsibilities related to Key West and the Great White Heron NWRs (established 1908 and 1938, respectively). Gerald Baker approached Tommy about a reassignment to Sanibel or Captiva Island. There was an element of interest, and Wood was sent to the islands for a few days with Baker's clear instructions that he must first pass muster when interviewed by "Ding" Darling before any transfer would be completed.

Tommy Wood was an excellent diplomat, and when he met Jay Darling on Captiva, the two men promptly bonded. They would soon enter a personal friendship that would last many years and reach a level of great respect between the men and their families. The opportunity of moving to the islands excited Tommy, and he accepted the position. This pleased "Ding" Darling, and he offered a small cottage he owned on Captiva Island as temporary housing for Tommy and his wife, Louise. The Woods made the move to Captiva in April 1949. This housing arrangement would last for several months until USFWS living accommodations became available. It was understood that living quarters were to be provided as a condition of Wood's employment.

After a major hurricane in 1947 caused considerable damage to the buildings at the Sanibel Island Light Station, the U.S. Coast Guard made

Sanibel-Captiva Conservation Foundation volunteers haul oyster shell to build habitat for oyster spat to grow upon. *Sanibel-Captiva Conservation Foundation.*

Two alligators tangle on the bank of an interior waterway. An intruder came too close to a female guarding her young. *Sally Thorburn.*

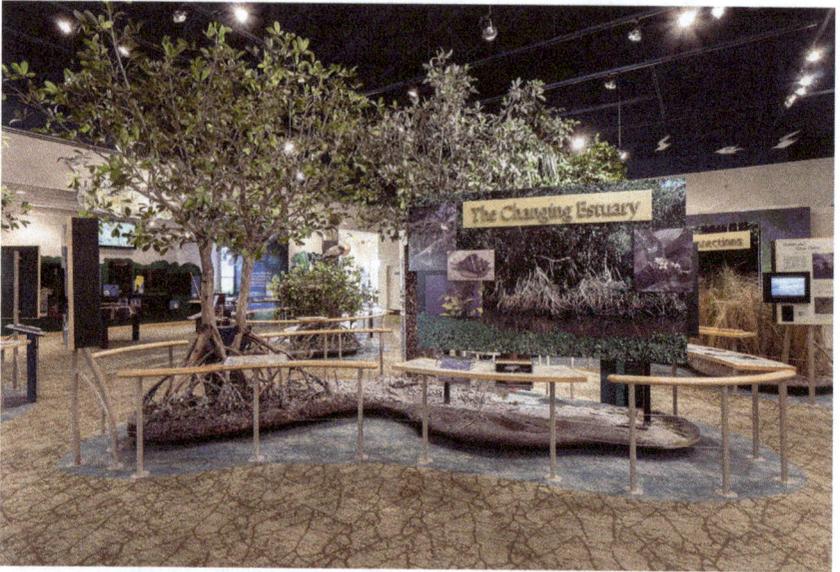

The interior of the Refuge Education Center. *"Ding" Darling Wildlife Society–Friends of the Refuge.*

The primitive anhinga stabs passing prey fish underwater and swallows them headfirst, then dries itself in the sun after exiting the water. *Cameron Anholt.*

This American crocodile's gaping mouth indicates a relaxed state and allows an excellent view of its dentition. *Regina Smith*.

The golden-footed snowy egret—one of the more aggressive small white egrets—is in full plumage in its breeding season. *Terry Baldwin*.

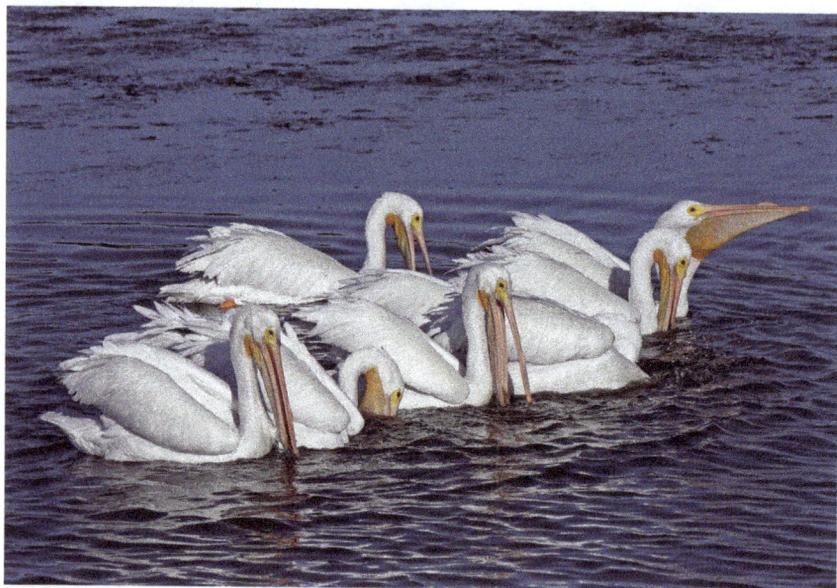

White pelicans are winter visitors from the northern plains and pothole states, overwintering in large flocks in Pine Island Sound shallows. *Terry Baldwin.*

A gopher tortoise builds its underground tunnel on sunny high ground and frequently shares its home with other creatures. *Cameron Anholt.*

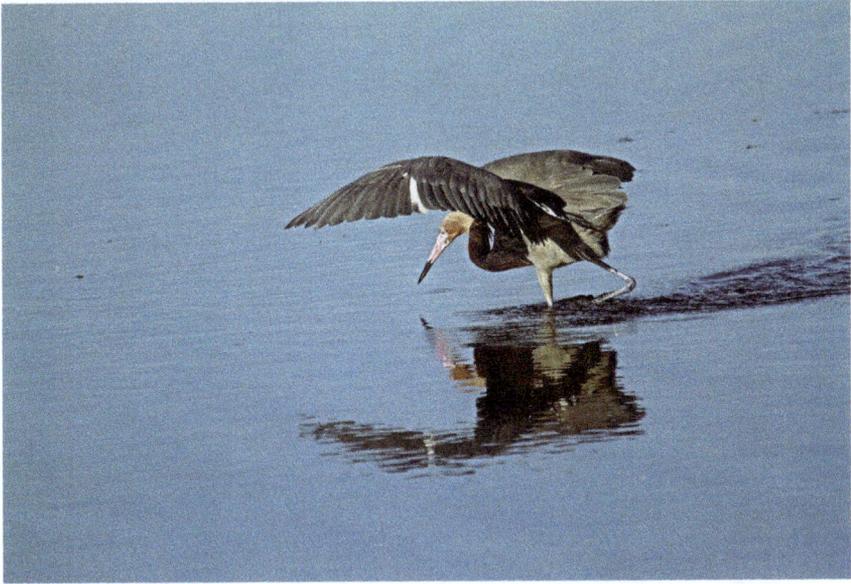

An active feeder, the uncommon reddish egret jumps around with its wings outspread to shade the water and allow it to see its prey. *Terry Baldwin.*

The reclusive mangrove cuckoo with its long, spotted tail can be observed in the mangroves of the refuge if one is especially lucky. *Terry Baldwin.*

Above: Spartina marsh extends along sections of the Sanibel Slough in the island interior. *Terry Baldwin*.

Left: The yellow-crowned night heron enjoys fiddler crabs and is usually a solitary traveler but nests in loose colonies to raise young. *Betty Anholt*.

A snowy egret faces down a wave to catch its meal in the surf. *Tom Braciszewski.*

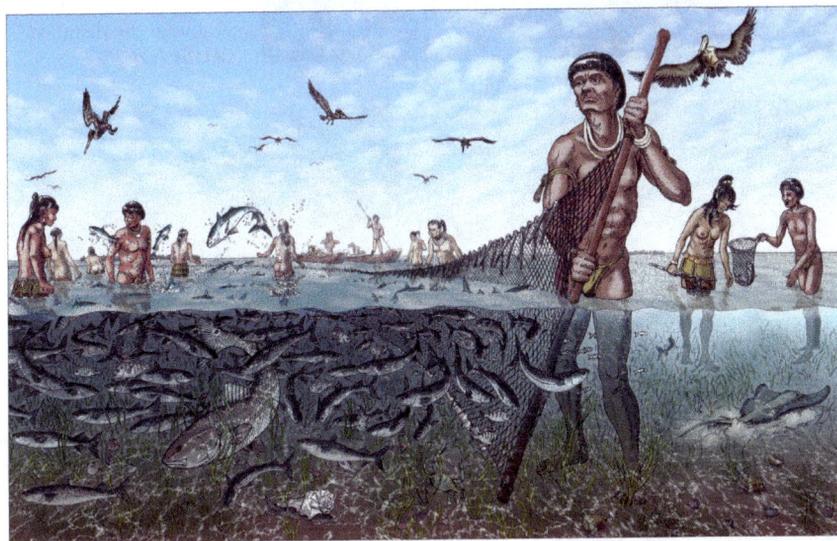

Net fishing has been part of Southwest Florida for millennia. The Calusa were talented net-makers and fisherpeople. *Art by Merald Clark, Courtesy Florida Museum of Natural History.*

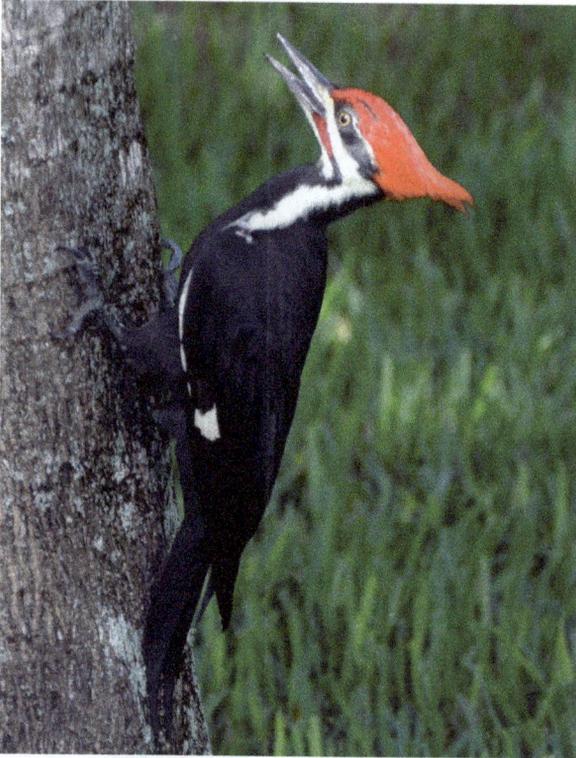

Left: One of the largest woodpeckers, the pileated is often seen exploring tree trunks or telephone poles for ants and insects. *Charles LeBuff.*

Below: Tommy Wood fueling the refuge seaplane in Tarpon Bay. A fish house is visible in the distance. *Charles LeBuff.*

The name *loggerhead* refers to the large head of this sea turtle. This female is secreting salty tears, which help to keep sand from her eyes while ashore nesting. *Charles LeBuff*.

The juvenile little blue heron, pictured here standing by black mangrove pneumatophores, starts out with white feathers, becoming blue after about a year old. *Charles LeBuff*.

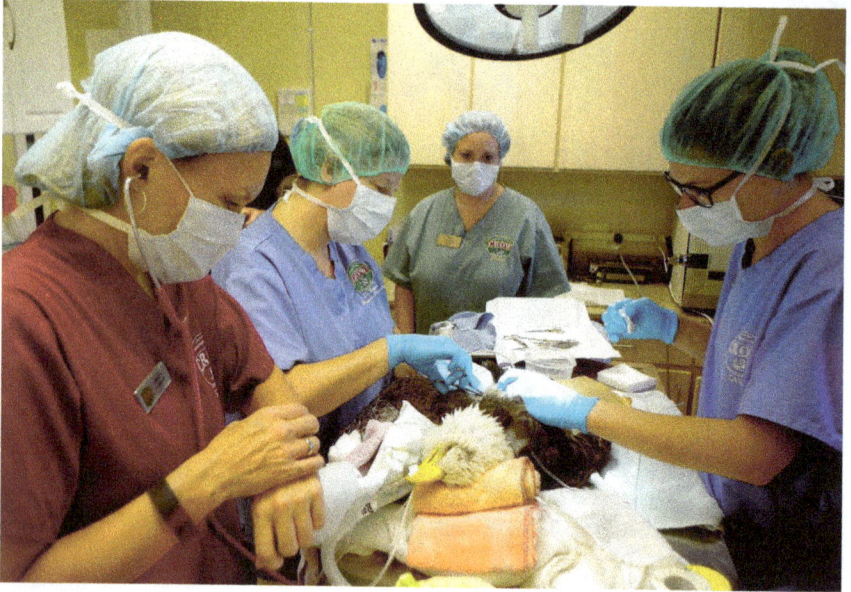

CROW surgeons operate on a bald eagle in their new facility. *Clinic for the Rehabilitation of Wildlife.*

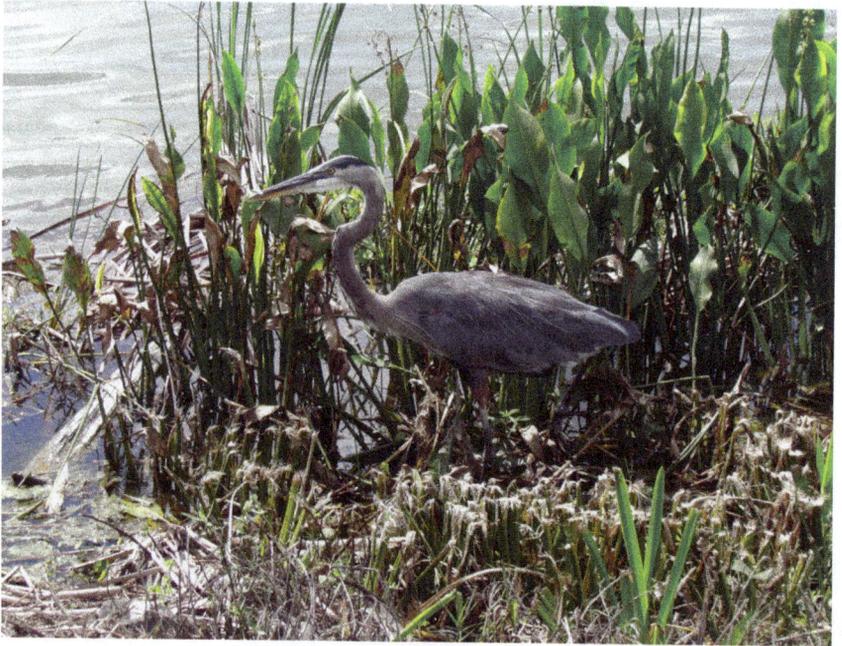

The three-foot-tall great blue heron is usually solitary, except during mating season. *Cameron Anholt.*

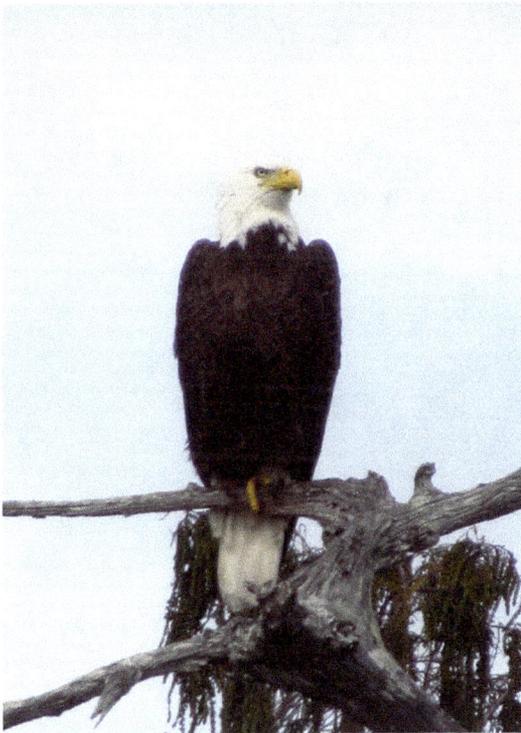

Above: A sunset from the mainland looks out over San Carlos Bay and the Sanibel Causeway as it stretches to connect the out-islands. *Cameron Anholt*.

Left: The imperial gaze of the bald eagle as it considers its next move is always striking. *Cameron Anholt*.

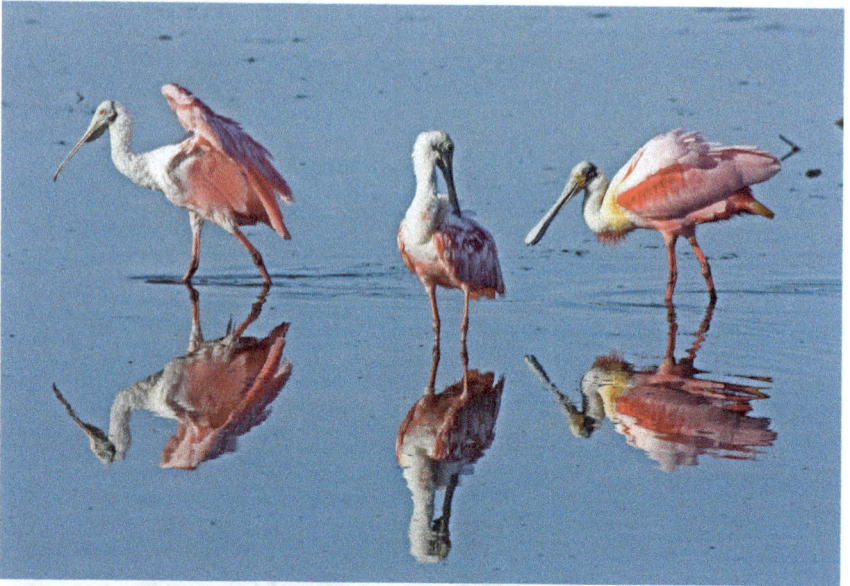

Above: The brilliant colors of the roseate spoonbill, along with the bird's unique bill, are a tourist highlight. *Terry Baldwin*.

Left: Air plants or bromeliads, like most orchids, attach to craggy bark on many trees, giving a spot of color in the forest. *Cameron Anholt*.

The delicate night-blooming cereus is a gift in the late spring, with large delicate flowers from ropey cactus that attract bats for pollination. *Cameron Anholt.*

A mat of air-breathing black mangrove pneumatophores extends into estuarine waters. *Terry Baldwin.*

A sunset lights up the still water surrounding sandbars. *Cameron Anholt.*

Railroad vine spreads out onto the hot sands of the beach and helps protect the beach from wind and water erosion. *Cameron Anholt.*

The industrious ibis with its red, curved bill and red legs always seems to be working for its dinner, rooting in the grass or the surf. *Cameron Anholt.*

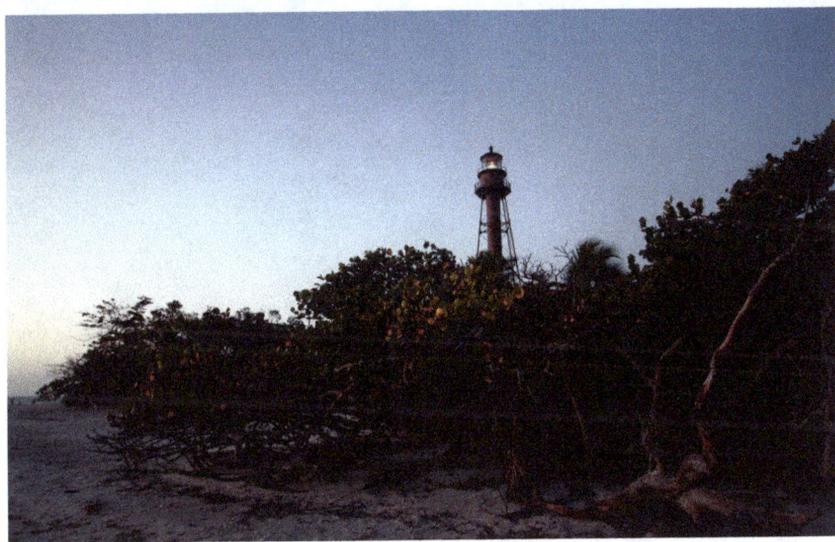

The Sanibel lighthouse at dawn on the eastern end of the island where the point has eroded and been naturally rebuilt by accretion over the decades. *Cameron Anholt.*

The serene beaches on the out-islands invite quiet contemplation of gentle waves and shorebirds as well as the pursuit of shells. *Cameron Anholt.*

A group of students from mainland Lee County's Treeline Elementary School assemble at the Education Center's entrance ramp while on a field trip to J.N. "Ding" Darling National Wildlife Refuge. *U.S. Fish and Wildlife Service.*

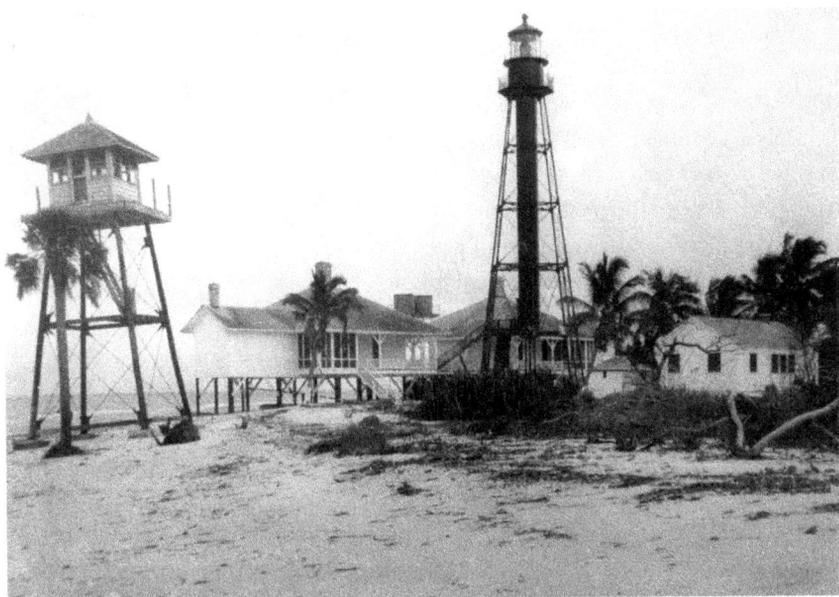

The light station post–World War II, with the submarine observation tower and troop housing added to the compound. *Sanibel Public Library.*

plans to move its light-keeping personnel and their dependents off of Sanibel Island. In early 1949, the Coast Guard classified the Sanibel Island light tower as automatic and unattended. The two original keepers' quarters were boarded up with hurricane shutters, and after sixty-five years as a manned station, the era ended when William R. "Bob" England Jr. (1920–2000), the last of the island's lighthouse keepers, and his assistant, James R. Garner, left Sanibel Island and moved to a new light attendant station on the Caloosahatchee in Fort Myers.

Tommy Wood notified Gerald Baker that the lighthouse quarters were vacant, and Baker contacted the Coast Guard's Seventh District leadership in Miami and inquired as to the availability of the property for refuge purposes. After negotiations, the USFWS and the U.S. Coast Guard entered into a revocable permit agreement on June 21, 1949. This gave the service use of the land and structures (excluding the lighthouse tower and the brick oil house next to it) for wildlife refuge purposes. Tommy and Louise Wood moved into Quarters 1 at the lighthouse a few weeks later.

Sanibel NWR now had a physical presence on the island with its headquarters at Point Ybel, Sanibel Island's easternmost tip. As Tommy and Louise Wood embraced the island communities, the conservation-

minded residents now had a permanent connection to a conservation movement that was slowly sweeping the nation. With comfortable relations established on Sanibel and Captiva Islands, the USFWS thought it time to move ahead and acquire land where wildlife management options could be applied. Working closely with the Lee County Refuge Commission, Tommy Wood and "Ding" Darling formulated a plan they hoped would enhance the island's interior wetlands. The central, low, savanna-like basin of Sanibel Island was a huge seasonally rainwater-flooded wetland ecosystem. This marsh was traditionally known to islanders as the Sanibel Slough. During the winter months, the open waters supported vast numbers of migratory waterfowl. During this early period in its history, the USFWS was in the duck business. To provide habitat for migrating and wintering

Robert England, the last Sanibel light keeper, bringing a large redfish home for dinner. *Sanibel Public Library*.

waterfowl was a goal at most of America's national wildlife refuges.

In 1951, the South Florida Water Management District and the USFWS entered into a license agreement. This was accomplished under the Migratory Bird Conservation Act, and 143,954 acres of impounded Everglades habitat became the Loxahatchee NWR. The USFWS purchased property outside of the above acreage, but it shared a common boundary with that leased from the water management authority. A refuge headquarters was soon constructed eight miles southwest of Boynton Beach, thirty-five miles closer than its previous headquarters. A refuge complex, South Florida National Wildlife Refuges, was established for supervisory oversight of all the refuges in South Florida. The name of Loxahatchee NWR was changed in 1986 to include that of a USFWS employee and local conservationist Arthur R. Marshall (1919–1985).

The administrative headquarters for South Florida National Wildlife Refuges relocated from Dania to Loxahatchee Refuge in 1957. Less than twenty years later, the complex of refuges known as South Florida National Wildlife Refuges would join Everglades NWR and drift off into history.

One major problem presented itself on Sanibel Island, and this was water management. Fresh water in the central slough basin was either feast or famine. In the late summer, precipitation would fill the slough to such a high level that the water would break through the Gulf beach ridge about eight-tenths of a mile west of the Sanibel Lighthouse and flow into the Gulf of Mexico. When it flowed, locals called it the "Sanibel River." Millions of gallons of water in the slough would drain through this opening for several weeks until accretion of sand once again blocked the opening. The cycle would repeat, and by May of any year, the Sanibel Slough would be completely dry because of the near absence of precipitation over the winter. The bottoms of shallow summer and midwinter open-surfaced water bodies cracked open from drought. Before the typical rainy season started in mid-June, the landscape of the barrier islands changed to an extremely dry environment. Many of the higher ridges were periodically arid, and the vegetation thereon wilted from lack of rain.

The Lee County Refuge Commission negotiated the purchase of an acre of smooth cord grass marsh from Sanibel Island farmer-grocer and large landowner Frank Bailey (1873–1952). This parcel was located to the west of Tarpon Bay Road and situated close to the center of the Sanibel Slough at its widest point—nearly a mile across. The USFWS executed a purchase option with Bailey for a larger tract that in the end would total one hundred acres. This piece of land was purchased for $5,000, and as part of the sales agreement, the Bailey family was assured the land would be forever identified as the Frank P. Bailey Tract. Years later, with the family's approval, this was shortened to the Bailey Tract.

Anxious to test his plan to keep the adjoining wetlands flooded for an extended period of time in the spring and summer, "Ding" Darling personally financed the drilling of a four-inch artesian well on the one-acre parcel. This well was 557 feet deep, and the pressurized artesian water it discharged was allowed to free-flow year-round until it and two other 6-inch wells that had been drilled later were plugged in the mid-1970s.

In addition, low-elevation dikes were bulldozed near the southeast corner of the Bailey Tract and around a more centrally located island-like group of red mangroves. These trees formed what is known as a mangrove head, and it was seasonally surrounded by fresh water. Red mangrove propagules had reached the center of the slough during a major hurricane event sometime in the past, had became established and were healthy and surviving in this freshwater system. Into the mid-1960s, this mangrove head was an impressive year-round night roost for colonial nesting birds, and many hundreds nested there each

Above: The Bailey Tract with the Bird Tower in the background. *Sanibel Public Library*.

Left: W.D. "Tommy" Wood, the first Sanibel National Wildlife Refuge manager, adjusts the artesian well flow in the Bailey Tract. *U.S. Fish and Wildlife Service*.

spring. As on the rest of Sanibel Island, there were no permanent freshwater bodies in the Bailey Tract. Throughout the slough, there were about twenty deep holes that were kept wallowed out by alligators, but as the freshwater aquifer continued to recede during a drought and disappear underground, the alligator holes became nothing more than mud wallows. The low dikes would later become walking trails, and in 1954, the refuge erected a popular observation tower that became known as the Bird Tower. Over time, this tower fell into disrepair, and it was torn down in 1976 and never replaced.

Another technique was employed in an attempt to bring year-round surface water to the Bailey Tract. Workers from other stations of the South Florida National Wildlife Refuges Complex came to Sanibel Refuge after a plan was promoted to dynamite the bottom of the Bailey Tract. Blasting sites were selected around the mangrove head. It was hoped that these would end up deep enough to retain fresh water during the annual drought periods. Several of these depressions were blasted when the wetlands were at their seasonal lowest levels. The resultant craters were just deep enough to reach the top level of the freshwater table, but the water level continued its recession until the daily rain pattern returned for the summer.

There was a successful aspect to this work. Once summer rains returned and alligators began to disperse from their limited and concentrated habitat, some adults found these dynamited depressions early on. The next spring, as water levels again receded, the alligators that had discovered and occupied the blasted depressions worked hard to wallow and enlarge them. This surface water provided survival habitat for small fishes and amphibians and watering holes for birds and mammals—many of which likely fed resident alligators. Permanent surface water was still a few years away for Sanibel Island.

Charles LeBuff, who had worked at the USFWS's Red Tide Investigation Laboratory in Naples, Florida, was appointed as the second permanent employee of Sanibel NWR. He entered on duty on January 5, 1959. His refuge career would span thirty-two years, until his retirement in 1990. LeBuff recalled some highlights of those early years that impacted his life and future:

> J.N. "Ding" Darling's health had been failing, and by 1958, he and Mrs. Darling had sold all of their real estate holdings on Captiva. This included his precious Fish House. Into the future, the Darlings planned to winter near Clearwater, Florida, to be close to their invalid son, John Darling, MD (1909–1973). It was completely unexpected, but the couple decided to make a final trip to Captiva Island in late 1959.

Before, during and after. Blasting a pool next to the Mangrove Head in the Bailey Tract. *U.S. Fish and Wildlife Service.*

According to the official Weekly Report of Activities *prepared by Refuge Manager Tommy Wood the Darlings were back on Captiva Island at 'Tween Waters Inn for Thanksgiving, and he visited with them there on Saturday November 28, 1959. His next week's report connects with me.*

On the morning of Thursday, December 3, Mr. Darling visited refuge headquarters. At first glance, I didn't know who he was, but as I was repainting the base of our flagpole, I noticed a car slowly pull up close to the office stairs and park. A large elderly man got out of the car, and using a cane, he walked in my direction. In a minute or so, he stood by me, and with a loud, deep voice, he spoke: "Hello, you must be the new man?" I rose and faced him, took his extended open hand in mine, shook it and replied, "Yes, sir I am." That said, he continued, "I'm 'Ding' Darling. Tommy wrote and told me all about you. I understand you're interested in snakes and turtles." He then launched a strong opinion on indigo snakes, as he loudly told me there were too many cars on the islands and they were killing and endangering these large, harmless snakes. Of course, I agreed with him, and one day automobile traffic would help eliminate these important animals from the islands. He then asked, "Is Tommy in? He's not really expecting me." I replied, "Yes, sir, he's up in the office." Then I added, "Mr. Darling, I remember that wonderful cartoon you did a few years ago to help save the Key deer. It really impressed me as a powerful conservation message to help them." As he started to turn and head for the stairs, he said, "Son, I sure as hell hope so."

I went about my work, and around fifteen minutes later, while I was cleaning my paintbrush, Tommy, who was sitting at his kitchen window, hollered, "Charles, come on up and have a cup."

I went upstairs and walked into the kitchen and fixed myself a cup of Tommy's favorite instant coffee (ugh) and joined him and Mr. Darling

at the huge kitchen table. I had briefly interrupted their discourse about the number of ducks that were using the refuge so far this fall. They continued talking exhaustively as I sipped my coffee and quietly absorbed the conversation. Moments later, the subject suddenly turned to sea turtle nesting on the islands the previous summer. This was right up my alley because I had worked with sea turtles in Naples, and since starting work on the refuge, I had regularly patrolled the island beaches over the past summer to protect nesting loggerhead sea turtles. After Tommy and I had brought him up to date on that subject, he addressed me directly, "Those little turtles don't have a…chance in hell without someone helping them. Charles, please, it's critical that you do everything you can to help and protect them. Someone just has to! From my discussions with old friends, I know there's a considerable amount of interest to save little sea turtles on Captiva and Sanibel, if you need any help."

Tommy interjected, "We'll try some things next summer that will help and once Charles really gets his feet on the ground he'll put something in action."

A couple of Saturdays later, Tommy and I did an early morning waterfowl survey in the refuge seaplane over Pine Island Sound and Charlotte Harbor. We landed twice and collected a good amount of large oysters from the first landing site. Then we flew back south across Charlotte Harbor into upper Pine Island Sound and landed next to a huge exposed mudflat. The tide was extremely low, and after Tommy gave me some instructions and showed me how to do it a few times, we spread out and walked around and pulled live stone crabs out of their burrows with special metal rods. We carefully removed one claw, the largest, from each crab and placed them in buckets we each carried. Later in the day, after he cooked the crab claws in his kitchen, Tommy invited me to go along with him, and we drove up to 'Tween Waters Inn. We were going to share our edible goodies with "Ding" Darling.

Mrs. Darling was out shopping with friends, so the three of us sat on the porch of the 'Tween Waters cottage they were staying in and enjoyed a filling of raw oysters, fresh stone crab claws and ample glasses from the bottle of whiskey Tommy had brought along. I remember this as a true conservation-inspired conversation. It was wide-ranging and weaved in and out of interesting topics. This would be the last time either Tommy Wood or I would see "Ding" Darling.

9

ONLY FOR THE BRAVE

A SERIOUSLY BAD PLACE TO LIVE OR VISIT

I n the mind's eye of most Americans, subtropical islands are seen as pleasurable and romantic. The thought of islands in general often conveys a mental image of an idyllic existence—one that is emotionally comfortable and fulfilling. Before the mid-1950s, none of these assumptions portrayed the true quality of life on Sanibel and Captiva Islands. Up until then, the islands were wild and almost lawless. There was no access to the outside world between sunset and sunrise. The roughly four hundred permanent residents living on both islands found it sometimes very difficult to cope with the oppressive environment and tough lifestyle. They were unique individuals who loved their island home and station in life. Winter residents visited at a time of year when the harsh environmental factors that were present in the summer were not usually experienced. They looked at their stays on the islands in the scattered beachfront cottage complexes as "roughing it."

There were still permanent resident families who lived on Sanibel and Captiva Islands under such harsh conditions, sans indoor plumbing and any electricity. Many children in Southwest Florida were still going to school barefooted. Air conditioning was a luxury that was basically nonexistent. Private island-wide telephones did not become available until the early 1960s. Potable water was drawn from individual shallow surface wells, surged from deep artesian wells or fell from the skies to be collected in cisterns. There were no medical facilities on either island, and by 1958, there were only two gasoline filling stations. The islands were slow to catch on.

There were other issues that periodically impacted life on the islands. Occasionally, major hurricanes struck the coast to wreak havoc on structures and bring more hardships to the population. However, the most awesome problem that residents faced was another natural phenomenon. This curse originated in the center of Sanibel Island. Black saltmarsh mosquitoes proliferated in such astronomical numbers that only a handful of persons who are still living on the barrier islands can comprehend and remember the discomfort they brought. The wrath of these nuisances sprang from the central wetland ecosystem, the Sanibel Slough.

The overabundance of mosquitoes on the islands was well known to state health officials, so it wasn't long before scientific studies on the slough's mosquito productivity were put into play. A mosquito control plan was developed by Dr. Maurice W. Provost (1914–1977) of the Florida State Board of Health and put into action. Dramatic changes to the Sanibel Slough ecosystem began in 1958. This was in response to the plan designed by Provost following a long-term study on the life history of the saltmarsh mosquito population on Sanibel Island. Essentially, these changes were not planned as an effort toward conservation in particular, but over time, these habitat alterations played a role in habitat improvement and conservation biology.

Sanibel Island was infamous because of the slough's production of saltmarsh mosquitoes. On September 15, 1950, a New Jersey light trap device located just south of the Sanibel ferry landing near the Sanibel Post Office established a remarkable record. This mosquito trap collected 364,672 individual saltmarsh mosquitoes. Making up this total were 265,216 females and 99,456 males.

These light traps were electrified and consisted of an all-night-burning, low-intensity light (a twenty-five-watt bulb). This illumination attracted the night-flying nuisances. A small fan at the top of the trap diverted the insects into a chemical-laced killing jar in its bottom. This receptacle also served as a collection container. The biologists who operated these traps and emptied them for counting reported that the fan motor of this particular trap had malfunctioned and had failed during the night of the record-setting collection. They opined that if the device had worked properly, many more mosquitoes would have been trapped that night.

The life cycle of the saltmarsh mosquito is unique. Females do not deposit their eggs on the surface of water as the majority of mosquito species do. Their lives begin when a female deposits her eggs on exposed damp soil. Each female can deposit egg clutches that exceed two

This aerial centered on Tarpon Bay Road shows the Sanibel Slough, Bailey Tract and the scars from roadways in the failed Sanibel Gardens 1920s subdivision. *Sanibel Public Library.*

hundred eggs each, and each insect can produce as many as two or three clutches during its short lifetime. Because of the outrageous number of reproducing adult females, the eggs can reach great densities. The study on Sanibel Island discovered areas in the slough that contained forty-five thousand eggs per square foot. The more optimum areas of the slough for mosquito egg densities contained quantities of eggs that far outnumbered the aforementioned numbers. Counts in those highly productive zones equated to two billion eggs per acre. The saltmarsh mosquito does not require a blood meal to reproduce. The Sanibel Island studies showed this species can reproduce autogenously.

With so many mosquitoes developing on Sanibel, the mosquito control agency also discovered that the saltmarsh mosquitoes that developed in the Sanibel Slough had the capacity for long-distance flight. In 1951, an experiment called for two million mosquito larvae to be hatched in water laced with a radioactive isotope (phosphorus-32). This marked each mosquito, and when light traps were sampled at pre-established distant locations, a Geiger counter was used to scan trap collections and identify

those radioactive individuals that were hatched on Sanibel Island. These adult mosquitoes can fly considerable distances to bother inland-dwelling humans, pets and livestock. Sanibel-hatched saltmarsh mosquitoes, with a little help from strong winds, have been collected on the mainland as far as fifty miles from the island where they hatched, spreading their misery in that wide swath.

In a June 16, 1959 letter to parishioners Cecil and Emmy Lu Read, Father Thomas Madden, vicar of the new Episcopalian St. Michael and All Angels Mission, wrote:

> *The mosquitos are plaguing all sections of South Florida: They really are bad this year and everyone is complaining about the lack of control: In the meantime no one is interested in a [b]ridge to Sanibel—it would be just too convenient to such an infested area. The ferry men were telling me of the droves going over on Saturdays and returning by the first ferry Sunday mornings: just could'nt [sic] take the punishment.*

The saltmarsh mosquito in Florida can become more than just a humming blood-drawing nuisance. The insect is a potential threat because it is a vector and capable of transmitting diseases to humans and pets such as Eastern equine encephalitis, Venezuelan equine encephalitis and dog heartworm.

The plan that the Lee County Mosquito Control District developed was primarily one of water management. In theory, the zealous scheme required that the slough-flooding water table aquifer would be maintained as high as hydrologically possible without causing long-term flooding of developed human-inhabited lands. Simply put, maintaining as high a water level as feasible as far into the dry season as possible will interrupt the saltmarsh mosquito's life cycle. This flooding would cover the once prime mosquito egg-laying habitat with water and prevent egg deposition. Flooding would reduce the historical high levels of mosquitoes by denying them their required reproductive habitat.

Part and parcel to this action plan was a concept of biological mosquito control. Ditching with draglines would provide permanent surface water and connect waterways to all the swales of the Sanibel Slough. Mosquito larvae–eating fishes such as the mosquitofish would disperse into the swales when water levels rose during the summer rainy season. Flooding from precipitation gave this minnow greater dispersal, and these tiny mosquito predators were present to consume mosquito larvae as they developed.

Left: Tommy Stewart examines a waterway for mosquito larvae to determine when best to larvacide or spray. *Sanibel Public Library*.

Below: Three DC-3s spray the vicinity of Blind Pass and Clam Bayou as a helicopter photographs their work. *Lee County Mosquito Control District*.

In conjunction with water management to help reduce mosquitoes, the mosquito control district also employed an arsenal of chemicals. These were applied from truck-mounted sprayers—a highly effective aerial application of pesticides. The dangerous chlorinated hydrocarbon DDT was used early on, but its use was curtailed because of the growing data that the chemical caused deleterious environmental impacts and seriously impacted the reproductive success of many birds, including ospreys, bald eagles and brown pelicans.

Malathion was found to be far more species-specific than DDT. Over time, however, adult saltmarsh mosquitoes began to develop a resistance to Malathion. Therefore, on July 2, 1965, the Lee County Mosquito Control District began to use Baytex as its primary insecticide in their aerial adulticide program.

Over time, a rift developed between the mosquito control agency and Sanibel and Captiva Island conservationists. The question of the ongoing and random use of the adulticide Baytex over the islands was debated in the public discourse. The leading anti-pesticide protagonist was retired Sanibel Island resident George R. Campbell (1918–2004). Campbell, who was a trained zoologist, mounted a virtual anti-chemical crusade and was widely supported by island environmentalists. He argued, and rightly so, that the chemicals were being applied counter to their label, and the active ingredients were known to kill honeybees and shrimp.

By this time, the USFWS was somewhat in agreement with Campbell's position, so the application of mosquito-targeted adulticides was better regulated. Mosquito control pilots were required to disengage their discharge apparatus when they entered airspace above refuge lands. This in itself became controversial because no matter how careful aircrews were, the incidental windborne drift of the chemicals reached the refuge lands and waters.

Today, mosquito populations on Sanibel and Captiva Islands are almost tolerable year-round. In part, the biological control elements of the program envisioned by Dr. Maurice Provost came to fruition. However, there are those biological administrators and a few authors who suggest that the Sanibel Slough was irreversibly damaged because of the ditching program supervised by T. Wayne Miller (1927–2016), director of the Lee County Mosquito Control District. Those who raise the issue and deny the efficacy of the ditching program never saw the slough as a pristine system and blame the invasion of a variety of plants that have encroached into the habitat for its "demise."

Charles LeBuff knows the Sanibel Slough intimately:

> *In 1959, to the west of Tarpon Bay Road, the wetlands of the slough were nearly pristine. The exceptions were the Bailey Tract and some old platted developments from the boom years of the twenties like Sanibel Gardens and Tarpon Bay subdivisions. These existed, but other than some primitive and abandoned road layouts, there were no structures. Island Inn and Rabbit Roads were the only roadways that entered the slough to the west of Tarpon Bay Road. There were no subdivisions south of Tradewinds subdivision, and that was basically at the northern end of the slough system. I've watched the Sanibel Slough system change from its original unaltered state for over fifty-eight years. I've flown over it, waded through it, canoed its natural deeper channels, hiked its dry and cracked bottoms and mired motor vehicles in its mud.*

More factually, any degradation of the wetland habitat in the Sanibel Slough is more than just the fact that higher land elevations exist where they once did not. The encroaching plant species, many of them native and others noxious exotics, first sprang up on the ribbons of elevated landscape that the excavated spoil piles along the waterways provided. Two issues share the blame. First and foremost is our inability to manage water on Sanibel Island. Realistically, the slough's natural drainage ended when land development east of Beach Road altered the course of the historical "Sanibel River." In the early 1950s, the USFWS and the Sanibel Community Association had started to plan for a large water control structure that was to be installed on the beach where the river discharged. Developers foiled this concept with their finger canal developments of, first, Sanibel Estates and the moating of Kinzie Island, and next, Shell Harbour subdivision further expanded the initial modification. After these alterations, drainage of the slough's seasonal eastern outfall was temporarily plugged at Beach Road.

In 1959, the Mosquito Control District dug a wide channel perpendicular to Sanibel-Captiva Road on the freshwater side and continued it on the opposite tidal side to connect it to Tarpon Bay. A large concrete water control structure was built to separate the aquatic systems. This dam utilized removable flashboards so that in the event of major storm incidents, water could be discharged to reduce interior flooding. The elevation of water in the slough was kept as high as it could without causing serious island-wide long-term flooding. It's true that many homeowners were infuriated when

high water levels backed up, but then they considered the alternative. Better wet feet than wiping blood-gorged mosquitoes off your body.

There was no intention to deviate from the Provost plan and discharge water excessively. Water levels were purposely maintained far higher than they are today. This policy subjected lower parts of Sanibel to frequent flooding events. It was not uncommon for unhappy island residents who owned marginal but developed wetlands to trespass at the fenced Tarpon Bay water control structure and unilaterally remove flashboards in order to further lower the levels of the Sanibel Slough.

Ultimately, in 1974, the newly formed City of Sanibel took over the responsibility of island water management. Without any consideration for extending the hydroperiod in the slough, the sill elevation at the Tarpon Bay mosquito control structure was lowered to further reduce neighborhood flooding events. Subsequently, new larger structures were installed at both Tarpon Bay (A) and Beach Road (B). The risers (weir crest) are set at 3.3 feet above Mean Sea Level (MSL) at A and that at B is set at 2.7-feet above MSL. A maximum level of water in the slough is not being held long enough to flood and kill the woody invasive plants. Anyone can visually verify this by simply looking at those sections of the slough where the undesirable exotic Brazilian pepper has been removed. The native buttonwood has replaced it and has the same deleterious effect on the slough that the pepper did. The buttonwood strands that are developing in the slough need to be removed. To wait much longer makes it costlier.

The water management strategy needs to be reconsidered and improved, but it will take considerable amounts of wise engineering and money. Some leveling of the piles of spoil along the Sanibel River corridor is a consideration, and this has been done in parts of the slough.

In essence, the slough was historically like a tub that filled with rainwater. When the ridges surrounding the wetlands were broached, water ran off into the marine system, but it was when the water levels reached that point of overflow that plant succession was prevented because invasive native and exotic vegetation drowned and the savanna-like ecosystem prospered.

The second issue related to the present state of the Sanibel Slough is simply the absence of sweeping fires that once roared through the nearly dry wetlands and helped maintain its vegetative integrity. After about 1940, wildfires were typically suppressed by residents. Today, fire in the form of prescribed burning is being used by conservation land managers. This is helping to return the savanna-like characteristics, as described by Dr. Strobel in 1833, in some slough tracts. If a cyclic approach using high water levels

were implemented, fire would be more effective. Areas of the Sanibel Slough could be impounded and pumping stations installed, superflooded when sufficient water is available during the rainy season and held high long enough to drown both invasive native and exotic woody plants. If systematically followed up months later by controlled burns, this methodology would help to more quickly restore habitat.

Ditching of the Sanibel Slough furnished Sanibel Island with exposed and permanent fresh surface water. Before channelization, the slough was primarily habitat for an abundant over-wintering population of migratory waterfowl that found their food sources in the still-flooded Slough beneficial until it was time to fly back north. As surface water dwindled through the coming late winter and spring there was no long-term advantage for the non-migratory resident wildlife species. The channelized Sanibel Slough has provided that advantage and when that ditching project was completed resident wildlife species in that ecosystem found that their food sources were more successful; each species was more broadly and permanently distributed; reproductive levels were higher; some predator levels were more balanced, and wildlife diversity expanded because species were no longer solely dependent on the island's fringe tidal system or a few seasonal drying alligator holes in Sanibel's unique interior wetlands. The island now had a permanent central freshwater ecosystem, one that no longer morphs into an almost sterile desert-like habitat when it loses its water.

Just before the Lee County Mosquito Control District completed its work in the Sanibel Slough, Refuge Manager Tommy Wood and the mosquito district director, Wayne Miller, met to discuss the district's further work on Sanibel Island. The two men had earlier agreed that when the machines crossed Tarpon Bay Road, the ditching would not include the Bailey Tract. One of the district's dragline operators, Colon Moore, was directed to excavate a sixty-foot-wide canal along the southern boundary of the Bailey Tract. This half-mile-long ditch was to become the Seaplane Canal—the new home base for the refuge aircraft. On November 16, 1959, Tommy Wood moved the seaplane from its refuge-funded wooden dolly ramp. This was located on his personal property out on the very tip of Woodring Point on Tarpon Bay. A similar moveable ramp was built at the east end of the Seaplane Canal, and refuge flight operations would henceforth begin and end in fresh water, not in corrosive salt water.

At the urging of his fellow members of the J.N. "Ding" Darling Memorial Sanctuary Committee, Tommy agreed to act as their chief engineer. The committee was struggling to somehow begin to memorialize "Ding" Darling

and have something to show for it on Sanibel and Captiva Islands. In general, Wood approved the group's idea to develop access into the leased state land of Sanibel National Wildlife Refuge. This was located in the mangrove ecosystem north of Sanibel-Captiva Road. A recent survey by the Bureau of Land Management had disclosed there was a fifty-foot-wide easement that left the highway just to the east, abutting the present location of the Sanibel School. Wood conferred with Miller, and the two came up with a concept for a sizeable project that would in essence impound all of the mosquito-producing tidal areas contained in the lease. These were lands that flooded and produced mosquitoes only during extreme tides when higher water than normal covered the Sanibel Sandflats. Sandflats are part of the intertidal zone but are only infrequently covered with water during spring tides. They were soon to be encircled by a four-mile-long dike. If fully effective, a mosquito control dike that kept those areas flooded would prevent saltmarsh mosquito reproduction.

On October 2, 1962, two draglines left the shoulder of Sanibel-Captiva Road and started work in alignment with the easement. One of the machines was under the skilled control of Colon Moore. After they had crossed the dry upland of the mid-island ridge and reached the dense red mangrove fringe, progress slowed. Each dragline had a set of heavy thick timber mats that it dragged behind it. The operator worked the drag bucket so that a tooth caught a cable loop attached to the mat. When it was hooked, it was swung around to the front of the machine and the dragline crawled onto it and resumed digging. In the flooded tidal areas, spoil from the bottom of the excavated marginal canal was heaped up in front of the machine and rough-smoothed with its bucket. Then the dragline crawled ahead so its tracks no longer rested on the mat that now extended behind the machine's tracks.

It was slow work. Each mat had to be properly placed in succession and aligned under the dragline as it moved along to prevent the heavy piece of equipment from sinking into the mud. The second machine was moved after a few weeks to ditch an area east of Dixie Beach Boulevard in what is now The Dunes subdivision. While working in this area, the dragline in use actually slid off of its mats and fell over. Operator error was blamed.

Colon Moore continued working on the mosquito dike alone. Over the next four years, he dug down one side of the dike, and when he reached the end, he started back in the opposite direction to complete the project. A slight route change where he had to backtrack on his first pass because he encountered deep water has signage that identifies the site as Colon's Point. As the heavy machine made progress, a mosquito control bulldozer

Colon Moore digs a channel and builds the Wildlife Drive. Note the wooden mats the dragline sits on. *U.S. Fish and Wildlife Service.*

was periodically transported to the dike and graded its surface. Soon, automobiles were regularly entering the area, and the refuge's now famous Wildlife Drive was born.

Construction of this dike was not without controversy. An organization known as the Lee County Conservation Association threatened to intervene. Its leader, Bill Mellor, was angry because he and his biologically astute associates knew the adverse impacts this dike would have on the ecosystem in general. The conservation group threatened a lawsuit; members wanted the dike removed. Mellor claimed the dike had a negative impact on the local estuary because there was no interchange between the impounded and tidal waters. The suit never came to fruition because the USFWS promoted the installation of permanent water control structures that would provide the tidal interchange the Lee County Conservation Association demanded. Funding was finally budgeted, and the first set of functional water control structures were installed in 1979–80.

CONNECTIONS TO THE MAINLAND

T he first mode of transportation that made it possible to reach Sanibel and Captiva Islands was used during prehistory. The Calusa traveled freely about the estuaries and nearshore Gulf of Mexico using finely crafted dugout canoes and double-hulled catamarans. It has been suggested the Calusa traveled to the distant northern Caribbean using their sole mode of transportation and there was some interchange among cultures, but there is no evidence they sailed. They made progress with paddles and by using strength and determination.

Years after European contacts in 1513 and 1521, Spanish ships occasionally visited Sanibel Island to take on potable fresh water from the island's surface water aquifer. As time passed, other sailing vessels landed on the island. These were Cuban smacks, at first small sloops with built-in live wells that could hold five thousand pounds of grouper. Much later, some larger modified schooners also fitted with live wells came into use in the fishery. Small boats and skiffs were used by Hispanic net fishermen who worked the scattered fishing rancheros. In the late nineteenth century, small commercial steamers regularly included Sanibel and Captiva Islands as ports of call. At the turn of the twentieth century, excursions to the barrier islands from Punta Gorda and Fort Myers became popular and were regularly scheduled. Machinery, like farm equipment, and building materials and motor vehicles were carried by these coastal steamers and sometimes barges to either Matthews Dock on Sanibel's bayside or to Wulfert Point. The water vessels also transported the crates of vegetables and citrus produced on the islands to markets on the

mainland. Initially, farm produce and citrus were shipped by boat to the nearest railhead, which by the late nineteenth century only reached as far south as Punta Gorda. The railroad finally reached Fort Myers in 1904, and Sanibel tomatoes were shipped to New York City and other major cities in the Northeast. They became famous because of their high quality and flavor. A single-lane wooden bridge first connected Sanibel to Captiva in 1918. Prior to that, a barge served as a ferry and carried goods and vehicles across Blind Pass to connect the islands.

The first ferry operation is discussed earlier in chapter 4. It was short-lived. The Kinzie Brothers Steamship Company was granted a county franchise to operate a ferry service between Punta Rassa and Sanibel Island. At first the Sanibel ferry landing was located near Bailey's General Store. This is where the mail boat made two daily stops until 1963—one incoming, the other outgoing mail. The Kinzie brothers next purchased a block of land closer to the lighthouse. This large parcel stretched from bay to Gulf, and it abutted the western boundary of what remained of the Sanibel Island Light Station Reservation. The ferry dock was relocated there on the bay, and the Sanibel Post Office moved to a small nearby building on the double-lane road that led to the ferry landing. Mail delivery continued to be handled at the Bailey Dock by the mail boat and transported to the post office for sorting. Its operators had an iron-clad contract with the Post Office Department, and mail would be delivered by boat until the contract expired at the end of 1963. When ferry service closed down in May 1963, the surviving Kinzies (brother and sister Ernest and Charlotte) were operating four ferryboats: the *Best, Islander, Yankee Clipper* and *Rebel.*

There were ways to connect the islands other than boats. A seaplane landed at the beach in front of Casa Ybel Hotel and 'Tween Waters Inn and made daily delivery of the *Fort Myers New-Press* as long as the weather cooperated. In 1952, Casa Ybel Hotel created a 2,800-foot airstrip just north of the resort. Vacationers regularly landed small privately owned aircraft onto the grass-covered, bumpy field. The Federal Aviation Administration and the City of Sanibel closed the strip down in 1979 after Pointe Santo de Sanibel Condominium was built and encroached into the airspace needed for safe aircraft operations. The Butterknife subdivision now covers the bygone footprint of the forgotten Sanibel Airport. Captiva Island had its own sod strip, too. It was dangerously short, and not many pilots would chance to use it. When South Seas Plantation expanded south to its present entrance area, Captiva's airstrip disappeared. An airstrip continues to operate on North Captiva.

By 1960, rumors had spread around the barrier islands that a Swedish-born New York–based businessman, Hugo A. Lindgren (1902–2003), who had large real estate holdings on eastern Sanibel Island, had convinced the Lee County Board of County Commissioners that it was time to connect Sanibel to Punta Rassa with a toll bridge/causeway system. That this was a reality rang true when the county applied to the various federal and state agencies for permits and announced the pending sale of bonds to finance the project. It goes without saying that some islanders favored the connection; they had tired of the element of isolation. Others, the conservationists, would resist. The U.S. Fish and Wildlife Service did not get directly involved in the fray but issued a biological opinion related to the poor design of the structure. The Florida Game and Fresh Water Fish Commission and the Florida State Board of Conservation concurred. The agencies opined that unless the roadway was elevated above the water for its entire length, the filled sections (causeway approaches and islands) would do irreparable damage to the estuary by altering the tidal flow. In short order, the inadvertent salinity changes were expected to eliminate the small scallop-harvesting industry in Pine Island Sound. Fresh water coming from the Caloosahatchee would be trapped behind the fill islands. The U.S. Army Corps of Engineers sided with the county and announced it would favorably process the permit request.

The Sanibel-Captiva Audubon Society, then the only large consolidated conservation group on the islands, openly opposed the causeway. One of its board members, Willis Combs (1884–1979), founded the Sanibel Safety Committee. This group quickly grew as opposition to the bridge spiked and financial support to fight it trickled in. The organization later changed its name to the Sanibel-Captiva Taxpayer's League. Arguments between causeway supporters and those who opposed the plan grew boisterous. It alienated most conservationist citizens from the residents who professed the desirability of the connection. The Taxpayer's League battled the bridge all the way to the Florida Supreme Court in an attempt to block the validation of the bond issue. The group lost, and Lee County moved forward. The first piling for the $2.73 million crossing was driven in San Carlos Bay on February 6, 1962. The Sanibel Causeway, with a $3.00 round-trip toll for passenger cars, opened on May 26, 1963, and life was never the same on the barrier islands. By the mid-1970s, with only one main two-lane corridor for ingress and egress and city-lowered speed limits on-island, traffic became gridlocked in winter on a daily basis. Day-trippers found beach parking usually unavailable. Long-term visitors and residents tried to cope, but

An aerial view of the nearly completed first Sanibel Causeway in 1963. Note the drawbridge, bare islands and toll booth with side pass-through for large vehicles. *Islander Trading Post.*

many threw up their arms in disgust. Quietly, many of the residents who pushed for the causeway sold out and left the barrier islands, frustrated by the decline in their quality of life and the crush of people.

By 1990, the bridge structures had come close to their design lifetime, and a multimillion-dollar stopgap rehabilitation was implemented. Traffic loads from overweight trucks and machinery necessary to support the huge growth in population, its housing and service requirements, ballooned. Sections of the aging bridges had to be replaced for safety. This prompted a new bridge design, and engineers went to work. When it was made public that Lee County would replace the then forty-year-old bascule bridge—a drawbridge that had only twenty-six feet of vertical clearance when closed—with a new high-rise modern bridge, people on Sanibel Island erupted. Many favored the drawbridge because it was thought to provide some security and created a "gated island" ambiance. They claimed that the existing drawbridge was of historical significance and should be retained. The entire bridge should be repaired, notwithstanding that continual on-demand raising and lowering of the draw, which sometimes stuck in the raised open position, impeded traffic flow. Random openings jammed-up creeping and overheating vehicles and made it impossible to keep traffic

moving. Emergency vehicles were hard-pressed to exit the barrier islands fast enough to save lives.

In 1999, as part of an election process, the City of Sanibel requested that a referendum be included on the ballot to indicate the will of the people as it applied to the future of their link with the mainland. The future of the Sanibel Causeway was not seriously at stake—Sanibel does not own the bridge. Forty-one percent of the island voters turned out, and 91 percent of them supported keeping the existing causeway and its drawbridge. In the end, Lee County went ahead and sold bonds to finance three new bridges for a total cost of $134 million. This included demolition of the drawbridge and a replacement fixed span bridge with a vertical clearance of seventy feet above the mean high tide level at the main channel leading to the Caloosahatchee. Traffic flow on the causeway improved. Bird kills dropped from hundreds a day in season to one or two. Most birds, excluding ospreys, cannot perch on the wider and much smoother aluminum railings of the new bridges and fly into traffic when they take wing. When ospreys leave their occasional railing perch, they fly away from the structure toward the water and do not attempt to make a roadway crossing until they have gained some altitude. With the new bridge, opened in 2007, came a rise in toll rates—$6 round-trip. Anyone can purchase an annual fee transponder and make the trip for two bucks.

The scallop fishery has never recovered.

THE BIRTH OF ISLAND CONSERVATION GROUPS

With the completion of the first causeway in 1963, the genuine and cherished island lifestyle on Sanibel and Captiva changed forevermore. Soon it was clear that residents of the islands were committed to protect their environmentally sensitive ecosystems and conserve their diverse plant and animal populations. This had attracted mostly like-minded people to our shores. However, the easy access from the mainland was a magnet to speculative real estate investors and land developers. These were the personalities that J.N. "Ding" Darling had feared most. Change was imminent, and by 1967, it had begun in earnest.

When it was completed in 1963, the Sanibel Island Causeway had only half-opened the gate to change. It was not until 1966 that a water distribution utility connected most island homes to its system. This availability of potable water opened the floodgates, and development started to boom. The Island Water Association was founded by a group of five island businessmen. Among these were two subdivision developers (Joseph Green and Edward Konrad), a restaurateur (John Kontinos) who would later become a major land developer, a grocer (Francis Bailey) and a businessman (Paul Stahlin). For some, their underlying intent was development-motivated, but all the individuals seriously aimed to improve the quality of life for islanders by providing safe and readily available on-demand potable water. Islanders were no longer concerned about an absence of rainfall in the late spring meaning their cisterns going dry.

Those who were initially drawn here were attracted because of the islands' uniqueness, open space, beautiful uncrowded beaches and wildlife diversity.

Sport fishing and seashell collecting on the beaches and on the tidal mud flats increased as the reputation of the barrier islands spread. For the most part, these new residents who were filling the growing number of subdivisions and condominiums became quickly entrenched in our conservation ethic, recognizing the value of protecting the islands' resources. Real estate developers would win many skirmishes with conservationists, as governance of the islands lay with county and state officials, but in the end, it would be a conservationist mindset that won the day and "saved" the barrier islands from destruction. That epic episode in the history of our conservation ethic will come later. Over time, the interests of islanders fostered a number of highly specialized and successful conservation efforts.

SEA TURTLE CONSERVATION

In the 1950s, sea turtles in Florida were protected only while they were on the beach in the act of nesting. A closed harvesting season covered the summer months of May through August (May 1 to September 1) and included all five species that are known to nest on the state's beaches—the loggerhead, green, Kemp's ridley, hawksbill and leatherback sea turtles. Otherwise, during the other eight months, should one venture ashore, it could be taken under the state's Salt Water Fishing Laws. Sea turtles could legally be harvested year-round while in the water. Only the loggerhead sea turtle was known to nest on the beaches of the barrier islands of Southwest Florida. The other species were known to periodically occur in adjacent waters, albeit rarely. Commercial net fishermen in the tidal waters around Sanibel and Captiva Islands regularly took sea turtles in their gill nets and seines for personal consumption. All except the leatherback and hawksbill were harvested by net fishers from nearshore waters. The leatherback is a pelagic species and prefers deep water. The hawksbill is rare in our waters and is known from a few live captures and stranded individuals.

Sea turtle populations were estimated to be waning statewide. Legal commercial sea turtle fisheries continued in operation at this time in the Florida Keys and around Cedar Keys on the upper Gulf Coast. Legal taking of sea turtle eggs persisted until 1953, when the Florida legislature passed Public Law 28145. This was applicable statewide and prohibited the possession of any sea turtle eggs in Florida. Prior to enactment of this law, sea turtle eggs were collected and often eaten raw or added to baked goods by some.

Illegal harvesting of sea turtle eggs persists. Most summers, some human violators are apprehended and face hefty fines and imprisonment for violating the Endangered Species Act.

People digging eggs from nests was never much of a problem on Sanibel and Captiva Islands. Mammals, on the other hand, traditionally raccoons, feral hogs and now coyotes, can devastate the success of sea turtle eggs on the barrier islands. In an attempt to curtail this depredation, large sections of welded wire are now staked over nests to help protect their contents from the wild thieves.

Charles LeBuff took the sea turtle inspiration that "Ding" Darling conveyed to him very seriously. He would expand the sea turtle program beyond patrolling solely for law enforcement purposes. Sea turtle poaching continued on Sanibel and Captiva as members of several longtime island families habitually continued to take loggerhead turtles for consumption at their dinner tables each summer. Law enforcement patrols were made to harass would-be "turtle turners" to keep them off the beach.

In May 1960, LeBuff began to apply basic conservation principles during his beach patrols. First, after inspection, he started to move loggerhead turtle nests that were deposited too close to the water. Further, he investigated several methods to mask nest odors so that predatory raccoons would have difficulty locating and digging nests. A variety of chemical solutions, including human urine and even burning dry palm fronds around a nest, were used in hopes of thwarting raccoons from smelling and locating eggs. Nothing ever proved to be highly effective in protecting the eggs—on average there are 108 per nest.

Refuge Manager Tommy Wood endorsed the work his assistant had started. LeBuff was given free rein to develop a management plan and put it into effect for island sea turtles. Thus began a major sea turtle conservation program that would mature over time. Although some vehicle maintenance costs were borne by the refuge, LeBuff's turtle project was a volunteer one, not a part of his official duties.

By 1963, the program had expanded to include tagging nesting sea turtles. At first, Monel metal cattle ear tags were attached to the foreflippers of post-nesting females. These tags were originally supplied by the Sanibel-Captiva Audubon Society for another of LeBuff's biological investigations—an ongoing capture-recapture study pertaining to the American alligators on Sanibel Island. When the supply of these tags was nearly exhausted in 1968, the late Dr. Archie Carr, the famed green sea turtle specialist with the University of Florida, provided a series of his sea turtle tags for

the Sanibel Island tagging program. Later, in 1968, LeBuff furnished a fundamental report of his sea turtle work to the newly organized Sanibel-Captiva Conservation Foundation (SCCF). The foundation published this as a special report and distributed it to its growing membership.

The report stirred interest in the community, and with it came the inspiration to establish a more formal organizational aspect to the sea turtle work. LeBuff selected a board of directors consisting of Sanibel, Captiva and mainland residents who had shown an interest in sea turtle conservation to serve as a start-up group. The organization was named Caretta Research, after the scientific name of the loggerhead sea turtle, *Caretta caretta*. The first public meeting to announce the proposed work of Caretta Research and the need for funding was held at the Captiva Community House in February 1969. That the program was launched on his beloved Captiva Island would have pleased "Ding" Darling.

The objectives of this new approach to sea turtle conservation in Southwest Florida were reviewed for the attendees and enthusiastically supported by the conservation community on both islands. The SCCF was excited by this genuine conservation effort and offered to assist. An agreement was reached whereby donated funds for sea turtle work would be received by the foundation. In this way, earmarked monies for sea turtle conservation would be tax exempt for the donors. The proceeds would periodically be distributed to Caretta Research as grants. With that arrangement solidified, contributions for sea turtle conservation were forthcoming from the community and around the country. "Ding" Darling was right when he said that islanders would solidly support sea turtle conservation.

One of the ideas to first become reality was a head-starting program in which hatchling loggerhead sea turtles would be held in tanks until they were large enough to elude predators at sea. At the time, head-starting little sea turtles was a primary conservation practice in many parts of the world. The State of Florida enthusiastically supported the concept because the Florida Department of Natural Resources had been head-starting young green sea turtles at the House of Refuge Museum on Hutchinson Island near Stuart, Florida, for at least a decade. Caretta Research was issued a state permit to operate a head-start program, and it would eventually be located on Tarpon Bay on property that was leased to private operators as a marina and commercial enterprise by the USFWS.

This sea turtle nursery was in operation for two years, but successive cold winters caused an unacceptable level of mortality among the young turtles. The head-starting effort was curtailed, and the conservation work returned

to the nesting beach. Jeopardized eggs were moved into hatchery enclosures immediately after they were deposited. Hatching success studies on both undisturbed and hatchery eggs were implemented, as was collection of voluminous data related to clutch size and hatchling size.

Caretta Research purchased its own series of tags in 1969, and the tagging work with adults continued. This always included recording of a tagged turtle's shell dimensions and head width. Additionally, for several years, post-nesting females were weighed on Sanibel Island.

As time passed, a considerable amount of information came to light on the biology of loggerhead turtles. Multiple nesting among barrier island loggerheads was documented. This behavior is known to occur among all sea turtles. Female loggerheads will deposit multiple clutches of eggs each summer on about eleven-night intervals. One Sanibel Island loggerhead was discovered nesting six times in 1973, and that individual deposited a total of 920 eggs during that season. Satellite telemetry has shown that some loggerhead turtles in Southwest Florida are capable of nesting up to eight times a year. However, the egg count of the loggerhead from Sanibel represents the highest accurate number of eggs for the species to be actually physically counted and recorded.

Most sea turtles were believed to be tenaciously loyal to their nesting beach, returning to the same beach in successive nesting seasons. But Caretta Research found that some tagged individuals would move more than fifty miles between nesting sites that were less than two weeks apart. One actually nested on Sanibel Island one year, and two years later, the same turtle was discovered across the state nesting on an Atlantic coast beach.

The low point for loggerhead sea turtle nests on Sanibel Island since record-keeping began was seventy-one nests in 1970. Captiva Island did not get complete record-keeping and nightly coverage until 1975. After 1992, nest numbers began to rise. Sea turtle nesting is cyclic, and it is not at all unusual for low years to occur after high years, but the data have generally shown a steady upward line of progression since about 1990.

Over the years, protection of sea turtles has improved in Florida. In 1978, all five species were included under the federal Endangered Species Act. Today, three are listed as endangered in the United States. These are the hawksbill, Kemp's ridley and leatherback. The Florida populations of loggerhead and green sea turtles are considered to be threatened. The illegal take of sea turtles began to drop, but one major sea turtle conservation battle remained.

Caretta Research's Jim Anholt (*left*) and Charles LeBuff weigh a female loggerhead sea turtle on a night inspection of the Sanibel beach in the early 1970s. *Caretta Research.*

Each year, a number of dead sea turtles, mostly loggerhead, green and Kemp's ridley, wash ashore or strand on the beaches of Sanibel and Captiva Islands. These have died because of a variety of reasons: diseases, boat impacts, consumption of mollusk and crustacean prey with loads of brevetoxin in their systems—produced and released by the organism that causes red tide events—ingestion of plastics impacting their gastrointestinal tracts and by drowning after being trapped in shrimp trawls. Overall, an estimated 12,500 turtles were dying each year in U.S. waters because they became entangled in shrimp nets.

The Gulf waters offshore of the barrier islands are a primary pink shrimp fishing area known in the industry as the Sanibel Grounds. Large commercial trawlers from Fort Myers Beach regularly harvest the "pink gold" from these waters. These locally based boats and others around the Gulf of Mexico were seriously impacting sea turtles. Sea turtle conservationists along the southeast shore of the United States were documenting an increasing number of turtle strandings, and this was thought to be commensurate with shrimp harvesting. Fishery biologists with the National Marine Fisheries Service of the National Oceanic and Atmospheric Administration joined with the commercial shrimp trawl manufacturing industry, and they developed a device to be sewn into trawls to reduce sea turtle deaths from drowning. This apparatus became known as a Turtle Excluder Device, or a TED, and it creates an obstacle for larger fish and turtles while allowing the shrimp to reach the bag end of the shrimp net. It allowed the turtle to be freed before it drowned in the net. Complaints that the TED caused shrimp loss diminished as the apparatus design improved. Today, all shrimp, whether domestic or foreign, must be certified as having been caught with TED devices.

In 1972, Caretta Research decided to become self-sufficient. In 1973, Caretta Research became a section 501(c)(3) foundation and became Caretta Research Inc. In 1972, when Florida's permitting system was revamped, Charles LeBuff was issued Florida's first exclusive sea turtle permit, STP-001. He would continue to hold this permit for forty years. The organization began to grow, developing volunteer units to support its objectives on fourteen nesting beaches along the Florida Gulf Coast. Additionally, the organization operated one special tagging project in Brevard County on a beach that has since become the Archie Carr National Wildlife Refuge. By 1976, the organization had 120 volunteers in the field, summer after summer, doing good deeds for sea turtles.

In 1992, the decision was made for the Caretta Research Inc. sea turtle conservation program to draw to a close. The work was transferred to the

SCCF, and it continues to provide a helping hand for local sea turtles as suggested by "Ding" Darling almost sixty years ago. It is astonishing, but during the 2017 nesting season, there were a total of 649 loggerhead and 34 green sea turtle nests on Sanibel Island. Due to the pervasive 2018 red tide, the nesting season results will be an anomaly. Since 1991, three Kemp's ridleys and two leatherback sea turtles have visited and nested on the Sanibel Island beach. Green turtles have once again established themselves as a nesting species in Southwest Florida. We suspect that in all likelihood it is the hard work of sea turtle conservationists who have faithfully worked on the Gulf beaches of Sanibel and Captiva Islands and other barrier islands for these past fifty-eight years that has helped the reproducing sea turtle populations of the eastern Gulf of Mexico recover.

ALLIGATOR PROTECTION AND CONSERVATION

By the early 1960s, American conservationists feared the demise of the nation's American alligators was at hand. Although the alligator was protected throughout its range, by 1962, illicit hunters were killing them with near impunity to meet the demands of the overseas crocodilian leather industry. The alligator was finally federally protected under the Endangered Species Preservation Act of 1966, a precursor to the Endangered Species Act that Congress passed in 1973. This important legislation continues to protect many jeopardized forms of wildlife and plants today. The American alligator was considered recovered from the brink of extinction and removed from the list in 1987. Alligators remain on the Endangered Species List only to the effect that they are afforded limited protection because of their similarity in appearance to other listed crocodilians.

The alligator has made a dramatic comeback in the United States. Periodic surveys of the population indicate we may be nearing two million alligators in Florida alone.

Alligator conservation and management on the barrier islands has not always been widely accepted and often has undergone contentious debate. Everywhere alligators occur close to humans, there are interactions of some kind between the two. People are divided in their opinions if they happen to live next to a water body that has a resident alligator population. Some take pleasure in seeing these representatives of wild Florida and are knowledgeable on how to coexist with alligators. Others fear for the safety

of their children and pets. The fear is certainly justified if children are left unsupervised and pets are allowed to roam at will.

A limited American alligator population existed on Sanibel Island when Sanibel NWR was created in 1945. Dr. Benjamin Strobel noted their presence in 1833, although by the 1930s, they had become nearly locally extinct. Dr. Louise Perry imported alligators from the Everglades to maintain the island population of the reptile. Habitat was extremely inadequate for these reptiles on Captiva Island at that time. And it still mostly is.

When spoil ponds were excavated by developers to fill land or build roads for subdivisions, island alligators benefited. Spoil ponds and borrow canals are the result of cut and fill development. Fill dirt, or spoil, is excavated with heavy equipment, leaving a body of water the size and depth of which is related to the amount of fill needed to raise the elevation of the adjacent land being developed into a roadway or subdivision. Their "gator holes" had been dug for them, and alligators quickly discovered and occupied those deep new water bodies. Once humans were ensconced in residential subdivisions that were created in the middle of the ecosystem, public conflicts with the reptiles arose.

Prior to 1960, nuisance alligators, those that stalked and killed loose pets or that in some other way concerned residents, were simply hunted and shot. Sometimes a member of one longtime Sanibel Island family would be called in on the sly to kill them. They took a chance, but it was profitable. Illicit alligator hide buyers would visit the island periodically to meet with these hunters and pay up to thirty-five dollars a foot for salted hides. In some cases, alligators were caught, removed from the island and then spent a lifetime in captivity. As more people moved to the island and more alligator habitat was transformed for homebuilding, the conflicts between people and alligators increased.

Early in 1960, Sanibel NWR was drafted by the island community to manage nuisance alligators on Sanibel Island. The Sanibel-Captiva Audubon Society offered support for the capture-recapture aspects of island alligator management. The organization purchased a series of Monel metal tags and applicators for use on both translocated nuisances and wild alligators at large. These tags were applied to the tails of alligators after the animals were captured, measured and sexed. At first, nuisance alligators were relocated miles away from their capture point to more remote sections of Sanibel Island. This proved to be folly, as alligators have a remarkable homing ability, and most individuals returned to their point of capture, their perceived home, within a week.

From 1960 until 1973, the situation did not improve, and alligator complaints increased. The refuge staff had dropped out of regular nuisance alligator handling in 1971. Private party conservationists then assumed responsibility for nuisance alligator management as the alligator population generally increased and the animals spread into a growing amount of alligator habitat—real estate spoil ponds. Over time, men like George Weymouth, George Campbell and Mark Westall became the contact people for alligator complaints.

Conservationists on Sanibel and Captiva Islands didn't want to destroy alligators if complaints were baseless. After negotiations, state wildlife officials agreed that the islands could operate their own nuisance alligator program. George Campbell spearheaded the effort and formed a multi-organizational group that became known as the Southwest Florida Regional Alligator Association in 1973. Well-trained and responsible individuals operating under this group were issued state permits to capture, tag and relocate any alligators that were clearly identifiable as nuisances.

When Campbell was no longer physically able to remain active, Mark Westall assumed the lead role in island alligator management for a few years. He would later train a number of Sanibel police officers, and at the end of his alligator career, he handed off the responsibility for alligators to the City of Sanibel.

Following a successful pilot test in 1977, the State of Florida launched its Nuisance Alligator Control Program in 1978. The Florida Game and Fresh Water Fish Commission contracted with private trappers, who were known to be experienced and much more effective at taking alligators than their wildlife officers were. They were financially motivated, inclined to stay on point and were generally successful, and since they were inspired financially, they readily responded to complaints. Trappers skinned and tagged hides properly, and the hides were correctly cured. Salted hides were turned over to state authorities who managed their sale. Trappers received 70 percent of the proceeds, and the state retained 30 percent to help recoup funds tied to the overall operational costs of administering the program. Meat sale price sharing caused some dissention, resulting that in 1979, 100 percent of the income from meat sales would be retained by the trapper.

By 1970, another alligator-related issue had become commonplace on the barrier islands. People were feeding alligators to attract them for photo ops and to entertain guests. Floating foodstuff like bread was being tossed toward an alligator, which would respond with speed to ingest it. Then someone, who shall live in infamy, started to feed them marshmallows.

Janie Howland and Mike Blackmore truss an alligator prior to moving it while Mark "Bird" Westall holds its mouth closed. *Charlie McCullough.*

Word of marshmallow-craving alligators spread, and people were buying an inordinate amount of the sweets from our grocery stores. Alligators apparently *love* marshmallows, and there were some persons who even tried to hand-feed the morsels to the reptiles. Even more frightening, some parents allowed their children to walk up to basking alligators along the refuge's wildlife drive, reach out and touch them, even pose them for photos. Undercover refuge officers witnessed this craziness more than once and issued verbal warnings.

For all intents and purposes, feeding alligators on Sanibel Island ended when the act became illegal in 1975 after the city council passed Ordinance

75-29. This prohibited the feeding of alligators within the city limits. In 2006, the Florida Game and Fresh Water Fish Commission followed suit, adopting Rule 68A-25-001, and incorporated it into its wildlife code book. This rule prohibits anyone from feeding wild alligators throughout the state. Enforcement remains difficult, but the practice is rare today.

The self-sufficient Sanibel Island alligator program abruptly ended in 2004. Earlier, on September 11, 2001, eighty-two-year-old Sanibel resident Robert Steele was bitten by a large alligator and lost part of his leg as he attempted to save his dog from the reptile. He died from a massive loss of blood. The alligator responsible was caught and killed. On July 21, 2004, fifty-four-year-old Janie Melsek, a popular island landscaper, was attacked from behind by a twelve-foot-long alligator that charged fifteen feet out of the water and grabbed her. Despite the valiant efforts of first responder Jim Anholt and other neighbors who fought to prevent the alligator from pulling Janie into deeper water, she perished two days later because of a massive infection. Police officers on the scene shot and killed the animal.

After this second fatality, the Sanibel City Council responded and adopted the general state policy. Now alligator trappers operate the nuisance alligator program on Sanibel Island. Any alligator, four feet or larger, that shows a limited fear of people or that somehow frightens anyone is subject to removal. Some island conservationists fear that sexually mature alligators, based on the minimum removal size criteria alone, will be killed excessively and a viable wild population of American alligators on Sanibel Island may not be sustainable in the long term. Time will tell.

Fire Commissioner Mike Lawrence (*right*) shakes Jim Anholt's hand after presenting him with the Medal of Valor in 2004. *Cameron Anholt.*

Before we leave this discussion, it is important we add some information on another crocodilian that calls the barrier islands home. American crocodiles are known to have wandered through the estuaries of Southwest Florida for over a century. Their center of population in Florida is the upper reaches of Florida Bay near Key Largo. In 1979, an adult crocodile was photographed by a visitor on the western end of J.N. "Ding" Darling NWR. It later moved to neighboring Pine Island, where state officials caught and marked it. They then relocated it onto state land about fifty miles south of Sanibel Island. In a matter of weeks, this animal returned and established the refuge as the center of its territory. She would remain here for thirty years. In 1997, this crocodile's sex was determined when she unexpectedly started to construct nest mounds into which she deposited consistently infertile eggs.

This female crocodile, the largest female of her species ever to be measured in Florida, died in 2010 during a near-freezing weather event. Age and the lethally cold temperatures are suspected to have contributed to her demise. This crocodile's skeletal remains were rearticulated and are now on permanent exhibition at the Education Center of J.N. "Ding" Darling NWR. Since this animal's death, two other American crocodiles are known to be occupying various habitats on Sanibel Island.

OSPREY CONSERVATION:
THE INTERNATIONAL OSPREY FOUNDATION

The large native raptors of Sanibel and Captiva Islands, our bald eagle and osprey, were never able to build large sustainable populations on the barrier islands. In part, this was because of the absence of tall native trees that would provide suitable nesting sites. Frequent hurricanes managed to help prevent preferred tree species from maturing and reaching the minimum height of trees these birds search for. By the late 1960s, a pair of bald eagles had finally accepted the introduced Australian pines on Captiva Island. They built a nest and reared young on an undeveloped parcel near Roosevelt Channel for several years until residential construction encroached close enough to cause them to abandon the nest tree.

Ospreys continued to select a few of the tallest and most prominent red mangroves in the J.N. "Ding" Darling NWR for nesting sites. Because of nest site unavailability, eagles and ospreys were never expected to develop the robust populations that the area had the capacity to support. Over

time, many pairs of ospreys opted to build their nests atop the poles of the Lee County Electric Cooperative. This led to osprey electrocutions and power outages.

In 1974, with the cooperation of staff members at J.N. "Ding" Darling NWR, the first artificial osprey nesting platform was erected along the refuge's wildlife drive. It was well received by a pair of ospreys almost immediately, and thereafter, six to eight of the platforms were erected each year by a group of volunteers.

At first, the nest platforms were installed on conservation lands with the assistance of the electric cooperative. Naturalist George Campbell spearheaded the program in the beginning. Before 1974, it was customary for line crews of the Lee County Electric Cooperative to remove any nesting material when the beginning of osprey nest construction was discovered to be underway anywhere on the islands' expanding electric grid. Campbell maneuvered diplomatically (this was unusual behavior for him, as he often came across, to those who did not know him, in a borderline rude and antagonistic manner—his style was in-your-face), and he persuaded the power company to set platforms next to osprey-targeted electric structures to provide a safer and better site for nesting.

This policy worked well for ospreys and reduced repeated problems for the electric utility, including the man-hours and equipment costs required to remove nesting material from poles. Soon, osprey poles were being erected on private lands when property owner interest in helping the birds surged. This was the island conservation ethic in action and in one of its finest hours.

Mark "Bird" Westall (1952–2016) conducted an aerial survey to locate all active osprey nests on Sanibel in 1979. Osprey nests are almost impossible to locate on the ground, and the altitude gave the survey an advantage. Thirty-five active nests were tallied, and it was estimated that all of the territories combined within the scope of the survey contained sixty to one hundred ospreys. Westall, an interpretive naturalist, professional canoe tour leader and pilot, went on to become a member of the Sanibel City Council and served a term as mayor. He championed the establishment of the Environmentally Sensitive Lands Conservation District. Mark Westall founded the Sanibel Island–based The International Osprey Foundation (TIOF) in 1981. Today, six volunteer teams working in the scope of this organization's objectives monitor all osprey nests on Sanibel Island.

The younger generations of ospreys that hatched on Sanibel were banded. These banded birds show an adaptation to nest in lower mangrove trees than was customary in the distant past. They apparently now disregard the fact

Four refuge guides (*left to right*): Mark "Bird" Westall, George Weymouth, George Campbell and Griffing Bancroft. These men were leaders in the conservation movement on the barrier islands in the 1970s. *U.S. Fish and Wildlife Service.*

their territory overlaps that of the adults at a neighboring active nest. Island ospreys are becoming more tolerant. The water quality and shallowness of the waterways created by the unification of the Charlotte Harbor and the Caloosahatchee estuaries in Pine Island Sound have created one of the most productive fishery nurseries in America. With a population that is estimated to have reached four hundred individuals within a forty-four-square-mile zone that includes both Sanibel and Captiva Islands, these barrier islands may now have the densest population of ospreys in the world.

The number of nesting pairs of our other large native raptor, the bald eagle, has also increased. During the 1958–59 nesting season, there were

three bald eagle nests on Sanibel Island. None was active. Nearby Pine Island hosted nineteen active bald eagle nests during the same period. In the mid-sixties, a pair of eagles attempted to build a nest in the mangroves on land that is now refuge on the northern end of Dixie Beach Boulevard. A pair of ospreys battled them for the site, and the ospreys won the tree. At this writing, there are four known nesting pairs of bald eagles with the possibility of a fifth on Sanibel Island. One nest is known to be active on Captiva Island, as is one on North Captiva Island.

CLINIC FOR THE REHABILITATION OF WILDLIFE

In the late sixties, then Sanibelian Shirley Walter encountered an injured brown pelican on the Sanibel Causeway. It had apparently just been struck by a motor vehicle, and the bird was severely hurt. Shirley thought the logical thing to do was to go to the Sanibel Lighthouse and report this bird to the staff of J.N. "Ding" Darling NWR. Certainly, she thought, as wildlife professionals, they would attend to the bird's needs, perhaps even rescue it and save its life. Shirley was advised that the refuge staff was ill-equipped to capture and treat hurt birds. She was told that when such birds were brought to the refuge they were euthanized because the staff had no facilities to properly care for injured birds or other wildlife species. Charles LeBuff recalls that day:

> It was not that Refuge Manager Bob Barber and I were unsympathetic. Every time one of us at the refuge drove across the causeway bridges we saw the carnage. Early on, in 1963–64, representing the Sanibel-Captiva Audubon Society, I had an ongoing dialogue about excessive bird mortalities with the Lee County toll-facility manager. I managed to get the causeway speed limit dropped from forty-five to thirty-five miles per hour. Our Audubon Society, of which I was president at the time, erected two huge Slow—Bird Crossing signs in the shape of least terns. These were visible as a driver came onto the first spoil island they reached going to or leaving Sanibel Island. After Hurricane Donna in 1960, I personally patrolled the Sanibel beach with the refuge Jeep to collect live injured pelicans and cormorants that I could catch—I mean by the dozens. I had no choice but to humanely euthanize them.

This was not acceptable to Shirley, so she left disappointed. At the time, she and Jesse Dugger (1936–2008) owned a popular framing studio/ gallery on Palm Ridge Road known as Fur, Feathers, and Scales. Not long after they failed to get help on the pelican case, they rescued two injured royal terns from the deadly causeway. This time, Shirley and Jesse were determined to help these birds themselves. The women were persistent and thereafter devoted more of their time to rescuing injured wildlife. After necessary state and federal permits were acquired, their home in the West Rocks subdivision soon turned into a wildlife rehabilitation center. They worked diligently to fine-tune their abilities and worked as pioneers in this new field of wildlife rehabilitation.

Wildlife hospitals and rescue enterprises were not in vogue at this time, and technology was limited. The name Care and Rehabilitation of Wildlife (CROW) was selected to identify their organization, and soon they were receiving or picking up injured patients from throughout the barrier islands—treating as many as five hundred birds the first year. There was a steady flow of fishing line–entangled pelicans and other seabirds. The automobile bird strikes continued on the causeway, and many species that perched on the railings flew into the traffic. Most were killed outright, but some survived the impact with speeding motor vehicles and were rescued and transported to CROW.

It was not long before the founders had outgrown their financial ability to support the needs of patients, so they decided to incorporate as a nonprofit organization in 1972. The residents of Sanibel and Captiva Islands became engaged in another conservation-related venture and opened their billfolds and purses to provide the necessary monetary support. The organization was renamed Clinic for the Rehabilitation of Wildlife in 2000. It continues to use the same acronym, CROW.

Many of their West Rocks neighbors were sympathetic to the objectives of CROW, but injured and caged wild birds draw free-flying wild birds, and complaints mounted. A wildlife hospital did not fit well in a residential community, and the operation was not considered a compatible use by city officials. The complaints were finally vocalized before the newly established Sanibel City Council, and the only solution was for CROW to cease operations temporarily and find another site. The wildlife hospital closed in 1975.

It took time, and after a year of searching for a new location, the late Captiva conservationist Adelaide Cherbonnier (1926–2008) came forward in 1976 and offered some of her Gulf-front Captiva land and her guest

house as a temporary home for CROW until a permanent site could be found. After their work resumed, Holly Davies took over management of CROW during the time it was headquartered on Captiva. On October 11, 1979, CROW managed to acquire a parcel of land from John and Virginia Sawbridge. This ten-acre tract on Sanibel-Captiva Road is across from the Sanibel School. A much-improved wildlife hospital was built there, and the operation relocated from Captiva back to Sanibel in 1981. This is the location where its facilities are located today. CROW hired its first veterinarian in 1987, and the organization has grown to far exceed the early expectations of its founders.

Shirley Walter occasionally returns to Sanibel to proudly see firsthand the more than fifty-year evolution of her contribution to the conservation ethic of Sanibel and Captiva Islands. She rightfully admires the progress that the organization she created has made.

CAPTIVA EROSION PREVENTION DISTRICT

It is not a stretch to include a beach erosion prevention taxing district in our list of conservation groups that contribute to our conservation ethic. From a human perspective, healthy beaches are essential for protection of roads and structures and our quality of life. This is particularly true and problematical as we anticipate sea level rise into the future. Healthy beaches also contribute to wildlife and dune vegetation conservation, and their overall condition and stability is important to shorebirds like the snowy plover and various terns. Of course, beaches also provide nesting habitat for sea turtles.

The Captiva Erosion Prevention District (CEPD) was established by the Florida legislature under Chapter 161.32, Florida Statutes, on June 19, 1959. As a beach and shore preservation district, it was granted powers that are authorized for a special taxing district. The district's boundaries include all of Captiva Island beginning at the centerline of Blind Pass and extending north to the centerline of Redfish Pass. The boundary extends offshore westerly into the Gulf of Mexico for a distance of three hundred feet.

Attempts at erosion control on Captiva were initiated several years before the creation of CEPD. Sanibel and Captiva Islands businessman Paul Stahlin promoted the installation of an anti-erosion system known as dog-bone groins. These were interlocking concrete fixtures that were designed as an acceptable way to slow the rate of erosion on beaches. Stahlin, along

with nine Captiva residents, formed Beach Aid Inc. In 1955–56, the groins were installed in areas where erosion was at its worst. They were positioned perpendicularly from the beach and assembled in irregularly aligned groups. Each unified groin section was positioned about fifty yards from the next and systematically placed along the Captiva shoreline. Each member of Beach Aid Inc. contributed funds toward the purchase and installation of the groins. However, despite this effort, Captiva Island was continuing to slowly disappear, as it has been doing for centuries.

When CEPD was authorized by the Florida legislature, it became a special taxing district. Paul Stahlin was its authorized agent, and he would have that position for twenty years. In 1961, 107,000 cubic yards of spoil were pumped from the bay to the Gulf side of Captiva, following Hurricane Donna. This was considered a beach fill operation and was done in conjunction with an experimental new groin field. The first major attempt to deal with erosion on Captiva Island occurred twenty years later, in 1981. South Seas Plantation applied for the state and federal permits that were necessary to dredge spoil from an offshore borrow site and discharge it onto 10,032 lineal feet of their beach. Over several years prior, beginning in the late sixties, Lee County's Department of Transportation had continued, on an as-needed basis, to haul huge volumes of fill by truck from a spoil storage site on the refuge's Bailey Tract. This was accomplished under a cooperative

Concrete dog-bone groins were an attempt to slow the erosion on Captiva Island. Likewise, wooden groins were used on parts of Sanibel Island. *Sanibel Public Library.*

agreement between the Fish and Wildlife Service and Lee County. The refuge wanted open water bodies to enhance wildlife habitat excavated, and the county wanted fill to save Captiva Road. This fill was critical to stabilize the Gulf-front road—the only road—which was vital for day-to-day travel, fire suppression, emergency vehicles and evacuation. The pavement was periodically being undermined by encroaching erosion, falling away into the surf in front of 'Tween Waters Inn. The South Seas project would employ a hydraulic dredge to place 655,000 cubic yards of sand from a borrow pit outside Redfish Pass onto the beach at South Seas.

The remainder of the Captiva Island beach was renourished in 1989 and periodically since. That year, 1.6 million cubic yards of dredged spoil were pumped from offshore to widen Captiva's beach. Beach renourishment is a tool in sea turtle conservation in that if the dredged spoil is comparable in quality, it restores sea turtle nesting habitat. Wide, high beaches are essential for sea turtle nesting. Caretta Research Inc. and later the Sanibel-Captiva Conservation Foundation have monitored nesting success on Captiva Island for decades. During renourishment operations in 1981 and 1989, Caretta Research Inc. contracted with CEPD and monitored the beach each morning to manage sea turtle's nests. Eggs were excavated when found and moved within the limited post-deposition time frame that was allotted for translocation. Hatcheries were positioned on sections of beach not scheduled to receive dredge spoil. Egg protection and relocation were among the conditions of the permits so that renourishment could continue into the summer months. Hatching success was on par to that expected from natural nest complements that were not manipulated, and the egg transplantation effort was considered a success.

Sanibel also has erosion issues on segments of its beaches, just not to the extent of what occurs on Captiva, and those areas have needed beach renourishment. The City of Sanibel monitors known "hot spots" and has teamed with CEPD in gaining permits for projects when renourishment is needed south of Blind Pass, an area facing the Gulf's wave action in the same general angle as Captiva.

Other areas of concern involve the section from approximately the beachfront Chateau sur Mer subdivision down to the northern end of West Gulf Drive. This beach segment is turned slightly more north–south than most of Sanibel's Gulf beach and is thus subject to stronger erosion potential. It has needed beach renourishment in the past, in 1996. That year, 229,000 cubic yards of dredged spoil were deposited on 3,400 linear feet of the island's beach south of Blind Pass. Additionally, the bay beaches

near the causeway have eroded due to current changes interacting with the bridge abutments and, always, constantly changing Point Ybel, the site of the lighthouse, which has grown and receded over time and overlooks a shallow submerged sandbar stretching beyond the island. When the original Coast Guard pier and its pilings were removed in 1972, the position of the fishing pier replacing it was one hundred yards to the west. This also altered inshore tidal flow and augmented erosion at the point that will need attention.

SEASHELL CONSERVATION: RESTRICTIONS ON LIVE SHELLING

Among the great public debates that occurred during Sanibel Island's recent history is the controversy over the collection of living seashells. For generations, live seashells were collected by shell collectors on the island's Gulf beach and adjacent tidal shallows. Collecting was always best after powerful and prolonged winter storms swept across the Gulf from the northwest and loosened the mollusks from their shallow underwater habitat. Then winds and tides stranded them in the surf or at the high-water wrack line on the beach in numbers that are rarely equaled today. Shell collectors waited for the passage of these weather events and then they pounced on the barrier island beaches to look for rarities to add to their collections.

There were a variety of opinions on the controversy. Many people thought, perhaps logically from a layman's viewpoint, that even though stranded shells were still alive when they came to rest on the beach, they would soon die. Therefore, live shells that were cast high and dry were destined to die anyway, and longtime shellers proclaimed their beach collection was not as serious a biological event as some "radical environmentalists" were claiming.

On the Gulf beach, many people made daily hikes in the morning to pick up and toss live shells back into the surf. More than likely these perished anyway because they had been dislocated from a more stable habitat generally free from the surf's turbulence. The turbidity of nearshore waters would likely have slowly killed them. Mollusks that remain in the water or on wet sands at low tide line can quickly fall prey to other marine organisms and birds. The submerged empty shells are at the whim of currents and tides. They are left to roll about on the bottom and may eventually end up on the beach, where they will be picked up by some future sheller and dropped into a bucket.

Of more concern to some members of the island community was the taking of live shells in habitats that were not usually subject to storm dynamics. Both the temporarily tidally exposed and deeper but wadeable mudflats of the estuary were being seriously invaded by shell collectors. Although collecting live shells was prohibited on J.N. "Ding" Darling NWR, the flats in Roosevelt Channel and shallows surrounding Buck Key and in Blind Pass were open for collecting. Many first-time bay shellers were crafty. They would first hire a shelling guide to visit the flats and learn the location of the most productive shell beds and the collecting techniques. Then they would hire a boat on their own and return to seriously over-exploit the delicate area. Hundreds upon hundreds of live shells were taken each day to shell-cleaning stations that were sported by every cottage complex, motel or hotel. Sanibel Island had become known as America's foremost shelling beach, and that reputation continues—and it is true.

Esperanza Woodring was the island's first female charter shelling and fishing guide. She took parties in her skiff from her home dock on Woodring Point on Sanibel Island to the mudflats, where she specialized in finding much sought-after live angel wings, alphabet and Florida cones and crown conchs (pronounced conks) for her guests. She likewise guided sport

Esperanza Woodring and Tommy Wood share coon oysters at her dock on Woodring Point. *Sanibel Public Library.*

fishermen who hoped to land snook, redfish, spotted seatrout and tarpon. On Captiva Island, Belton Johnson was a popular fishing guide, and "Ding" Darling was a regular client. Former refuge patrolman Jake Stokes became a popular fishing guide, and he specialized in offshore shell-dredging trips. His patrons brought back highly prized and valuable junonias, lion's paws and spiny oysters.

In 1961, twelve islanders formed the Sanibel-Captiva Shell Club, and its membership has swelled to over 150 members. The organization hosts what once was called a shell fair, but the event, traditionally held on the first Thursday, Friday and Saturday of March each year, is now known as the Sanibel Shell Festival. In 1909, the hotels at The Matthews (now Island Inn) and Casa Ybel advertised their third annual shell show, a competition between guests at the two hotels. The festival is an expansion of the first shell fair, launched in 1928 at what is now Island Inn. Today it is recognized as the longest-running event of its kind in the United States. The organization's goals as stated on its website are:

> *The purpose of the club is to promote the study of mollusks and the shells they create, to give assistance and information to others interested in this subject, and to promote and encourage the understanding of ecology and conservation. As a group we are responsible collectors devoted to increasing our knowledge while searching for perfection and diversification in shell specimens.*
>
> *The objectives of the Sanibel-Captiva Shell Club are to provide a forum for the exchange of information in the field of conchology and malacology; to foster public education and intelligent conservation of those and related ecological resources; to encourage and support studies and research activities in those fields.*

By the mid-seventies, there was a growing trend among residents to make the claim that living seashells were being over-harvested by the hordes of seashell collectors that often crowded the beaches in the winter. On the other hand, many shell-collecting citizens argued that over-collecting was a hoax. The sheer numbers of mollusk recruits in deeper adjacent waters would immediately repopulate any habitats from which shells were removed. The reproductive output of mollusks is bountiful. This was the opinion of many collectors, and some marine biologists agreed.

The conservation-inclined islanders wanted to restrict the take of live shells and perhaps completely shut down the act of live shelling within the

Cleaning Sanibel shells to be sold at retail or through commercial outlets. *Jerry Lauer*.

Sanibel city limits. The city council took the first step and formed the Sanibel Live Shelling Committee, charging members with the task of reviewing the issue. They were to compile evidence to support the notion of regulations if they were deemed necessary.

Those appointed to the Live Shelling Committee included a variety of people who were interested in the issue. The appointed membership included strict "by-the-book" environmentalists, shell collectors, shell shop owners and a live shelling guide. The consensus of the committee was that a scientific study should be implemented to determine if there was a measurable ongoing decline in the seashell populations in the marine and estuarine ecosystems around and within the city limits. If so, was it connected to over-collecting, or was the take sustainable over the long term? What measures could be applied to reduce take and conserve the island's seashell resources?

The committee determined that a scientific study was advisable to support any conclusion that indicated collecting was harmful to the resource. They then interviewed several qualified marine biologists who were interested in conducting such an investigation. A graduate student from the University of South Florida was selected, and she was asked to submit a proposal for the work. That's as far as the idea ever got because it was determined by council that there were no funds available to underwrite the expected high costs if the proposed study were to go forward.

Seashell conservationists did not rest. In the late 1980s, the City of Sanibel used a different route in the service of seashell conservation. The city directly petitioned the Florida Marine Fisheries Commission to request that live shelling be restricted on all Sanibel Island beaches. The commission concurred and enacted Rule 46-26. This restricted the collection of living seashells to a bag limit of two live individuals of any species per person on the same day.

Over time, the above rule and subsequent changes to it ended up becoming a complete ban on taking live seashells. This became effective on January 1, 1995.

In an interesting coincidence of time, the Bailey-Matthews National Shell Museum, dedicated to increasing the scientific knowledge of, and appreciation for, mollusks and their shells, opened in 1995 with the writer Anne Morrow Lindbergh, who wrote her best-selling book of essays, *Gift from the Sea*, on Captiva Island in the 1950s, cutting the ribbon at the grand opening. The actor Raymond Burr was the campaign chair in building the museum.

On March 1, 2002, the Florida Fish and Wildlife Conservation Commission acted on a January request by the Lee County Board of County Commissioners. A similar ban on live shelling became effective county-wide.

THE IMPACTS OF RED TIDES

Red tide is a disastrous marine event that occurs periodically along the coast of Southwest Florida. Not a recent phenomenon, it has been observed in our waters since the 1800s and probably existed much earlier. An organism that is known to scientists as *Karenia brevis* is a single-celled marine dinoflagellate, photosynthetic and always present in the water of the eastern Gulf of Mexico. With some frequency, it "blooms" and multiplies so fast that its densities rise from a normal level of about one thousand cells per quart of water to staggering levels that reach millions of cells per quart. During severe blooms, the water may appear viscous, like syrup, and may turn rusty red. The responsible organism, which some microbiologists classify as an alga, multiplies rapidly but is short-lived and dies quickly. At death, it releases a compound chemical known as brevetoxin, a neurotoxin (damaging to the nervous system) that drifts through the water column to kill fish. Filter-feeding organisms like sea squirts and shellfish absorb and condense the toxin in their digestive systems. Brevetoxin affects fish by paralyzing their central nervous systems, shutting down proper gill function so they cannot breathe. During red tide blooms, both sea squirts living in marine grasses

and pen shells contain consolidated and dangerous levels of brevetoxin. Manatees consume the grasses and secondarily ingest the tunicates, while loggerhead sea turtles relish pen shells. These creatures and several others can be mortally impacted by their food choices.

The worst red tide episodes the authors ever experienced around Sanibel and Captiva Islands occurred in the late summers of 1971 and 2018. From all indications and memory, they were about equal in severity. Both blooms lasted for many weeks and invaded the tidal waters well into the estuaries. In 1971, it affected fishes as far up the Caloosahatchee as the Franklin Lock, thirteen miles east of Fort Myers. The brevetoxin affects humans, too. The toxin easily becomes aerosolized and airborne, especially in rough and windy weather. It has an odor peculiar to itself that some people find intolerable. When that smell is mixed with the stench of millions of dead fish and other marine organisms, it is overwhelming, and people flee the beaches until the red tide dissipates and air quality returns to normal.

The differing impacts these two red tide episodes had on sea turtles is remarkable. In 1971, when the loggerhead sea turtle nesting population on Sanibel Island was at its lowest on record, 18 loggerheads died from brevetoxin and came to rest on the island. The prolonged red tide between October 2017 and October 2018 killed 242 documented sea turtles (124 loggerheads, 82 Kemp's ridleys, 34 greens, and 2 others too decomposed to identify). These were found dead or near death around Sanibel and Captiva Islands. At this writing, as the red tide event wanes, the numbers continue to increase. Experts considered these to be victims of this unusual long-lasting red tide that occurred along with a rare combination of other ecological disasters. The 2018 red tide, which received coverage on major television networks, was coupled with upriver blooms of blue-green algae. This separate outbreak pooling in dead-end canals and on river edges created havoc in peoples' backyards and drew international attention to the water quality problem here. The situation is thought to have been aggravated by nutrient-contaminated fresh water flowing down the Caloosahatchee from surplus water regularly discharged from Lake Okeechobee by the U.S. Army Corps of Engineers to reduce lake levels. The nutrients, many of them elements of man-made fertilizers, are thus flushed down the river and reach the estuary. If such discharges are coincidental with high counts of *Karenia brevis*, they may stimulate and expand the bloom. There is much yet to learn about this toxic environmental nightmare.

During the 1971 red tide bloom, manatee mortality was locally negligible, but in 2018, dozens of manatee deaths were determined to have resulted

from brevetoxin—as in the case of the sea turtles, this was probably commensurate with a similar increase in the manatee population during the forty-plus-year interlude.

We still do not comprehend what triggers a red tide bloom. Some laypersons blame nutrients being discharged into the Caloosahatchee estuary. Most red tide events that reach our barrier islands get started well north of the estuary of the Caloosahatchee, from eleven to forty miles offshore of the Venice area, so blaming this river's nutrient-laced and naturally dark tannin-rich water is questionable. When these local "plumes" of dark water reach the fringe of the Gulf of Mexico between the Points Bowditch and Ybel, the fresh and salt waters begin to mix. The inshore littoral current, combined with tidal flow, captures and moves that water south and not north. There are other factors at play that are as yet not fully understood.

The microorganism that causes red tide was first isolated and named scientifically in 1948. The cells used for this taxonomic identification were collected near Venice, about forty-three miles north of Captiva, during a 1946–47 bloom. In December 1946, "Ding" Darling witnessed this same major bloom, and in his letters to many public officials, he described a massive fish kill that was impacting Captiva Island and its southern neighbor Sanibel Island. It extended along the Gulf Coast between our barrier islands and Sarasota County. He was very impressed by the catastrophic sight and wrote to Oscar Chapman, then the undersecretary of the Department of the Interior:

> *If any individual, corporation, or alien enemy had threatened the health, destroyed the economy, food resources and employment of as many families as has resulted from the so-called "Red Tide" on the west coast of Florida, every Department of Government including Congress and the Army and the Navy would have been up in arms. Hundreds of millions of food fish have died, practically all marine life is extinct over a 75-mile stretch of these coastal waters, and the total consequences in economic losses can hardly be estimated at this time.... The Division of Fisheries, official custodian of marine life, has participated in this emergency to the total extent of two letters and a quite erroneous diagnosis released from Washington to the Press.*

"Ding" Darling then contacted the University of Miami Marine Laboratory and offered to pay the cost if the university would dispatch a team of biologists to observe and study the situation. The lab agreed and

sent over a team to do some preliminary work. Another red tide bloom in 1952, although not as severe as the first one he witnessed, spurred "Ding" Darling's interest, and he kept pressing his many contacts in Washington to take some action. It was most likely through his volatile correspondence that government officials were prodded into action. In 1955, the Department of the Interior finally took an interest in the red tide that occurred in Southwest Florida. In 1956, the U.S. Fish and Wildlife Service's Bureau of Commercial Fisheries opened and staffed a research field station in one of the World War II Army Air Corps barracks at the Naples airport. A forty-eight-foot twin diesel Chris-Craft research vessel, the *Kingfish*, was also assigned to the lab.

Since the start of red tide research in the mid-fifties, much has been learned about the organism, where it blooms, how it affects marine and human lives and when it is likely to appear. The questions that remain elusive are why it blooms and what the triggering factors are. Although our population increase, which has multiplied dramatically since the mid-1950s, has undoubtedly exacerbated the water quality problems we face, red tide, or harmful algae blooms, have occurred and been reported in the Gulf since the 1500s and likely long before. An offshore red tide may not affect the islands if the winds remain easterly, while consistent westerlies will pile dead sea life on our beaches. One factor being examined is the iron-rich Saharan dust that is often experienced in spring, sometimes turning the sky a hazy pinkish tint. The Sahara and other deserts have become more arid over the last decades, creating an increasing amount of airborne particles. It is theorized that the dust helps feed *Karenia brevis*, allowing it to out-compete other phytoplankton, eventually blooming and continuing to feed on nutrients leaching from the dead fish it creates. Nitrogen and phosphorus are implicated in the blooms, as is the loop current and subsequent upwelling along our continental shelf. Both nitrogen and phosphorus are also added due to runoff from the land from Orlando south, whether cow pasture, city or agricultural fields, particularly when rain amounts are heavy.

Some general points:

1. In 1956, the microscopic culprit responsible for red tides was considered an animal. Today, microbiologists classify the causative organism as an alga.
2. The responsible organism's scientific generic name was changed from *Gymnodinium* to *Karenia* to honor Dr. Karen Steidinger of Florida's Fish and Wildlife Research Institute.

3. In the fifties, microbiologists assumed that red tide blooms were associated with inshore Gulf waters. Today, it is generally accepted by the current generation of scientists that a Florida red tide bloom begins in low-nutrient waters between eleven and forty-six miles offshore.

4. In 1956, microbiologists assigned to the Naples field station discussed a relationship between red tide and high levels of iron in the water column during blooms. That Saharan dust atmospheric delivery could be responsible was never considered.

5. Today, technology has evolved to the extent we can more quickly determine the organism's densities and predict red tide outbreaks.

6. Commensurate with those technological advances, authorities who monitor cell counts can quickly close the harvest of shellfish to prevent human consumption of brevetoxin-loaded clams and oysters. The harvest of shellfish closes when cell counts reach five thousand per quart of sampled water. Fish caught live in red tide–impacted waters can be eaten because the toxin remains isolated from the flesh. A properly filleted food fish caught live in water with high levels of the organism is considered safe to eat.

Over time, this Naples red tide laboratory introduced and connected two individuals to the Sanibel National Wildlife Refuge. Refuge Manager Tommy Wood was detailed to serve as part-time aircraft pilot for the field station, and Charles LeBuff would regularly fly with Tommy in the refuge float plane to collect water samples from Pass-a-Grille, in Pinellas County, to Marathon, in Monroe County. They also flew inland to sample the headwaters of the Caloosahatchee at Lake Okeechobee in Glades County. Later, when the laboratory relocated to St. Petersburg, LeBuff, who started his federal career as a staff member of the red tide laboratory, transferred to the Sanibel National Wildlife Refuge.

One red tide research trip stands out. In 1956, LeBuff and a co-worker were sent to collect water samples in Charlotte Harbor by boat, and the outboard motor quit. He related,

> We managed to make it to Gasparilla Island (Boca Grande), and the next morning Tommy Wood flew me to Pine Island, where the vehicle and trailer were. Then I would make the long drive around to Placida to meet the disabled boat.
>
> The marina operator there refused to let us use his ramp to pull out the boat because we lacked the fee and he despised the federal government and

anyone who worked for it. We searched for a place to haul the boat out, and I discovered a sign saying Cape Haze Marine Laboratory. I went into the office, where I was greeted by Dr. Eugenie Clark (1922–2015), its director. This was early in her career, which culminated in international recognition of her work in marine conservation and shark research. Dr. Clark was a pioneer in using SCUBA in her research, became known as the "Shark Lady" and wrote books introducing the public to marine issues.

I explained our predicament, and she kindly gave us permission to haul the boat out using her ramp. A few years later, the Cape Haze Marine Laboratory was renamed and moved to Sarasota. Today, it is known as Mote Marine Laboratory, and it is one of the leading institutions in the field of red tide research.

THE METAMORPHOSIS INTO
MAJOR LAND PRESERVATION

J ay Norwood "Ding" Darling suffered a massive stroke and died on
February 12, 1962. He was eighty-five years old. His obituary appeared
in the evening edition of the *Des Moines Tribune*, and the next morning,
the *Des Moines Register* ran a front-page article about "Ding's" passing.
This was accompanied with a centrally positioned Darling cartoon he had
drawn well in advance of this event, and the editors had agreed to publish it
as an announcement of his passing. The cartoon was titled "Bye Now—It's
Been Wonderful Knowing You."

"Ding's" daughter, Mary Darling Koss (1912–1981), and her husband,
Richard, had continued to stay on Sanibel Island for several winters after
her father was no longer able to make the trip. Each winter, they occupied
a cottage at the Colony Resort. This was then a cottage complex west of the
lighthouse and next to the eastern side of what seasonally became the mouth
of the Sanibel River. Earlier, the couple and their son, Christopher Darling
"Kip" Koss (1935–2013), would vacation on Captiva Island with the Darlings.

On Tuesday, February 13, the refuge telephone rang, and Tommy Wood
left his lunch table in Lighthouse Quarters 1, walked through his living room
and entered the refuge office to answer it. The caller was Mary Koss. She
was calling all of her father's key friends on the islands from Des Moines to
inform them of her father's passing. Charles LeBuff recalled the moment:

> *My wife, Jean, our four-year-old daughter Leslie and I were in our kitchen
> having lunch when I heard Tommy calling me. I went out on my porch,
> which was separated only a few feet from his, to see what he wanted.*

'BYE NOW—IT'S BEEN WONDERFUL KNOWING YOU.

"Ding" Darling's farewell cartoon, to be run at his death, in 1962. *"Ding" Darling Wildlife Society–Friends of the Refuge.*

I knew it had to be something very important. He was standing at the railing wiping his eyes with a handkerchief. He composed himself and blurted, "Mr. Darling died yesterday. Mary Koss just called and told me. She said that groups in Des Moines and here on the islands hope to develop something in his memory."

The two of us were in a somber mood for the next few days, but Tommy seemed very depressed. He snapped out of it before the week was out

when Mary called again and told him that island friends were going to meet and form a memorial committee to study how her father could best be memorialized at the local level. Further, she told Tommy that she had insisted to everyone she talked to that he was to become a member of the committee. He perked up after getting that news.

Events unfolded, and a group of Darling's friends and admirers on Sanibel and Captiva Islands assembled and created the "Ding" Darling Memorial Sanctuary Committee. A few weeks later, the J.N. "Ding" Darling Foundation was formed in Des Moines. The foundation was organized as a not-for-profit, and for nearly five years, it would serve as a tax umbrella for the barrier island committee. Tax-deductible donations from those supporting the Memorial Committee would be sent to Des Moines, and the plan was for funds to be distributed back to the islands. This would not always work smoothly and would eventually cause the Memorial Committee to consider the feasibility of incorporation as a not-for-profit group and take control of its own destiny and finances.

Among the initial committee members were Alice O'Brien (1891–1962) and Harold Bixby (1890–1965), representing Captiva Island. In November 1962, Alice was traveling the Mississippi River aboard her seventy-two-foot yacht, the *Wanigan III*, from Minnesota to Florida and stopped in Des Moines to attend a board meeting of the J.N. "Ding" Darling Foundation. She was suddenly stricken with an aneurism and died before she had signed a check for $25,000 that she intended to present to the foundation. The sum was to be applied to the work of the Sanibel and Captiva Islands Memorial Committee. Her estate honored her intention and eventually granted the money. It was later used to build an observation tower, a mangrove overlook/boardwalk and two floating canoe docks. Funded along with the latter were a series of specialized directional markers for an extensive canoe trail through the tidal red mangrove forest. This was located outside the mosquito control dike turned wildlife drive when the refuge's wildlife drive became functional.

Emmy Lu Read (later Mrs. Herbert Lewis, 1904–1990) and Refuge Manager Tommy Wood represented Darling's Sanibel Island legacy. Harold Bixby was a winter resident and a close friend of Darling's, as was Miss O'Brien. Emmy Lu was an active member of the Sanibel-Captiva Audubon Society and an ardent conservationist. Although she had never met "Ding" Darling, Emmy Lu was elected chairman of the Memorial Committee. Over the next few years, other island personalities were added to the committee's membership. By 1966, the committee consisted of the following islanders:

Mrs. Herbert Lewis (chairman), Mrs. Willis Combs (secretary), Roy Bazire (vice chairman), James Jack, Joe Gault, Hervey Roberts and Refuge Manager Tommy Wood. All of the members lived on Sanibel Island with the exception of Roberts, who was a Captivian.

Early on, the committee would develop a set of goals. In the beginning, the "Ding" Darling Memorial Sanctuary Committee shared many objectives with the Darling Foundation in Des Moines. The primary goal of both was to establish a memorial wildlife sanctuary on Sanibel Island to honor the life achievements of "Ding" Darling in the field of conservation. Secondarily, both groups hoped to see this goal achieved by federal action that would result in Sanibel National Wildlife Refuge (NWR) being renamed J.N. "Ding" Darling NWR. Included was a desire that the refuge lands that were leased from the state under the 1945 agreement would be federally acquired and the refuge boundary considerably expanded. Because Tommy Wood served on the committee, he reported to his superiors in the Fish and Wildlife Service that there was a growing gap between the two Darling-related organizations. The service leadership pushed for them to come together before they would move forward and begin helping.

South Florida National Wildlife Refuges manager Richard Thompson came over to Sanibel Island from Loxahatchee Refuge for a few days in 1966. He and the Sanibel Refuge staff studied delineation of a possible boundary on the ground during that visit. State Road 867 (Sanibel-Captiva Road) was a perfect, well-defined southern boundary, as was the shoreline of the waters of Pine Island Sound to the north. Dixie Beach Boulevard was selected as the demarcation line for the eastern boundary. Selection of the western boundary was problematical.

The staff of Sanibel Refuge hoped to see Wulfert Channel become the western boundary so that all of mostly unspoiled Wulfert Point would be included in the new boundary. In finality, the suggested boundary was agreed upon, but it excluded anything west of a section line that ran north and south adjacent to the eastern property line of Caloosa Shores subdivision. The final refuge boundary recommendation was submitted to the Regional Office of the U.S. Fish and Wildlife Service in Atlanta, Georgia. The staff found it to be reasonable and concurred.

Walter A. Gresh was promoted and appointed regional director of Region 4 on February 1, 1954. He ascended to the post after Regional Director James Silver retired on January 31, 1954. Silver had supported the concept of a refuge on Sanibel Island since taking the helm of Region 4 in 1940. His interests in Florida included protection for the Key deer.

Walter Gresh was familiar with the situation on Sanibel Island, and when the pressure from the "Ding" Darling Memorial Sanctuary Committee and the "Ding" Darling Foundation was mounting to enlarge and rename the refuge, he became an advocate.

In the mid-sixties, some of Gresh's staff saw a major stumbling block in the service's path because of ownership issues related to the leased state lands on Sanibel Island. Under the Swamp and Overflow Act of 1850, the State of Florida had a considerable land interest in Sanibel Island. In the opinion of some people, this was such a serious obstacle that a few refuge system officials under Gresh recommended that the potential refuge be eliminated from the refuge system altogether.

The following pessimistic opinion was once shared by Lawrence S. Givens, supervisor of wildlife refuges, to the regional office staff. "Look, we can't do anything in terms of management, the ownership is so screwed up that we're going to have to get rid of this refuge." (*Credit: Libby Herland/USFWS*)

Regional Director Gresh stifled this idea at the outset and allowed the land acquisition process on Sanibel Island to proceed.

Two regional office staffers, wildlife biologist Royston "Rudy" Rudolph and realty specialist William "Bill" Ashe, were assigned to coordinate the Sanibel Island project. Years later, Ashe's son, Dan, would become the director of the USFWS. Dan Ashe was appointed to the office in 2011and served as director until 2017.

During an oral history interview in 2011 for the USFWS Digital Library, Bill Ashe talked about how things evolved during that questionable period. The following was taken from the transcription of that interview. (*Credit: Libby Herland/USFWS*):

> *Rudy and I undertook an effort to do what we could and Rudy wrote up a biological report, which cited the value, biologically, of Sanibel. I looked into the history of the Swamp and Overflow Act and other real estate type matters. I worked out an exchange with the State of Florida through the Trustees of the Internal Improvement Fund. What it was, was the state would convey all of the wetlands north of Periwinkle Drive [sic, Sanibel-Captiva Road], which is the road that goes straight through between the two township lines, it would convey all of their interests in the land under the Swamp and Overflow Act and we gave them lands at Anclote Key and St. Marks Refuge. They made a small park at St. Marks; I don't know what they did with Anclote Key. But that gave us clear title to most of the lands in that refuge.*

We would get all of the state lands and water bottoms between the two township lines. One township line was just east of Tarpon Bay, and the other one was on an entrance to Captiva Island. And it was bounded by Periwinkle Drive, that's the Sanibel-Captiva Road.

We worked out that exchange and that solved our problem; that solved the state's problem. Now the state thought they were getting the better of the deal and looking at it from a certain standpoint, they were. I mean they got developable lands on Anclote Key, but when we combined the state and federal land ownership on lands between the township lines, I don't care how you look at it; biologically, we came out a real winner. And if you wanted to make an appraisal, from a commercial standpoint, because we solved all the title problems there, we didn't lose anything, I can tell you that.

In this land exchange, the refuge received 2,956 acres of submerged tidal lands, including the water bottoms, and mangrove islands.

After transfer of the state lands was finalized, funds were appropriated by Congress and acquisition of private lands within the approved refuge boundary began. The public at large learned of the acquisition plans after an illustrated Refuge Concept Plan was published by the USFWS in August 1967. Two years earlier, a major problem surfaced relative to private holdings. An underlying issue that would slow the timely purchase of the privately held lands arose. This matter was based on a confusing Sanibel Island survey that had been done in 1876. There was an overlap of townships, and the property lines of some tracts were uncertain. To try to resolve this problem the USFWS and the Bureau of Land Management, both agencies in the Department of the Interior, executed an agreement. The Western States office of the Bureau of Land Management dispatched DeWitt Crain, a cadastral surveyor, to Sanibel Island for several months to ostensibly identify federal public domain lands remaining on the island. With this survey completed, the lands that Crain so identified would have raised further issues and eventually lead to prolonged litigation. His survey was never accepted as the final word in land ownership.

To work around this problem, the USFWS contracted with Johnson Engineering. This firm is a highly respected Lee County land surveying and engineering company that regularly and validly surveyed lands on Sanibel Island. This contract was founded on the abundant evidence that the registered work of this firm was viewed as reliable in the Florida court system. The resultant survey would be generally acceptable to the courts and the landowners.

With this survey finalized, the land acquisition program went ahead. Since most of the land was vacant, the process started off smoothly, and willing sellers were financially satisfied. These agreeable landowners reached negotiated selling prices, and those lands were purchased. However, there were some owners of large parcels of land, even one that was being developed as a waterfront subdivision, who refused to sell. These properties were acquired by the USFWS after a Declaration of Taking was issued. It is within the power of the U.S. government to acquire private property for public use. The controlling legislation enacting this power is known as the Federal Declaration of Taking Act, and constitutional provisions must be followed. Simply put, the acquisition is done by condemnation and the owner of the private property so taken is to receive just compensation for the property that is taken.

The purchased and condemned properties were immediately posted as refuge property by the staff at J.N. "Ding" Darling NWR. The plaintiffs would have to slog through the federal court system and wait for a jury to award them the amount of money that that body of their peers thought justified.

Lawrence S. Givens, the USFWS supervisor of refuges for Region 4 in Atlanta, made a complete reversal in his onetime position that the refuge on Sanibel Island should be abandoned. This occurred about four years after he had expressed his negative opinion. His view had changed because of the progress made by Bill Ashe. Givens was now fully on board with the highballing memorial train. On January 22, 1970, Larry Givens attended the Third Annual Sanibel-Captiva Conservation Conference. During this period, the agency of the USFWS that was responsible for national wildlife refuges was the U.S. Bureau of Sport Fisheries and Wildlife. Givens made an eloquent and profound speech that efficiently conveyed the way the USFWS interpreted the sentiments of the residents and environmental threats that faced the islands at the time. It was so noteworthy and inspiring that the words of his entire address are restated here. (*Credit: Lawrence S. Givens/ USFWS*):

> *I have been asked to tell you why the U.S. Bureau of Sport Fisheries and Wildlife is interested in Sanibel Island. There are some obvious answers. The J.N. "Ding" Darling National Wildlife Refuge, as all of you well know, is here.*
>
> *As your federal agency is charged with the responsibility of managing and protecting the migratory bird resources, other fish and wildlife—including endangered species—it is only natural that the Bureau of Sport Fisheries and*

Wildlife should be concerned. It is our duty and responsibility to be concerned. Our interest and our reasons are based upon legislative authorities reflecting the desires of the people of this nation through the Congress.

But—I kept searching for a deeper and more basic reason. Man has always been drawn to islands—just as you and "Ding" Darling were drawn to Sanibel. Our literature is filled with adventure stories, stories of romance associated with islands. There is always a sense of adventure when we take a journey to an island.

Islands are different. There are unusual and unique plant and animal communities associated with islands.

In thinking about Sanibel and the National Wildlife Refuge System, it occurred to me that the first refuge was an island—Pelican Island. Many of our most beautiful and productive refuges are islands. Only recently Wassaw was added to the list. Islands have always been of special interest to Bureau officials charged with preserving for posterity a segment of the unusual—our natural landscape.

And so we are interested not only because of the J.N. "Ding" Darling Refuge—Sanibel is a living ever-changing entity. Destroy any part and you have affected the whole. The web of life is woven more closely together on an island than any place else. We are concerned that this chain of life not be broken to the detriment of all.

Sanibel Slough runs nearly the length of the island and is connected with beautiful Tarpon Bay. Draining and filling of any portion of the Slough would result in ultimate destruction of the biotic balance and the scenic beauty of the Slough as well as the Tarpon Bay estuary. Sanibel Slough, Tarpon Bay, and J.N. "Ding" Darling Refuge are ecological units, separate in many respects, yet interdependent on each other. Placing all remaining space under protection is not the answer to the retention of the island's uniqueness. Rather, acquisition of key tracts must be coupled with pollution abatement and well-planned residential, recreational, and commercial developments. Here lies an unusual opportunity for private citizens and organizations and local, state, and federal governments to set an example of how a total environmental community can be established for wildlife and people to live in harmony on an otherwise crowded shoreline.

Time is running out at Sanibel Island. It is truly an island under siege. The people still come with their campers, their cars, their trailers, and their families. Developers still build their residences, their motels, and their shopping centers. Sewage disposal becomes an ever increasing problem and pollution of the aquatic environment is already apparent.

Time is still left to complete acquisition of key tracts, to develop quality recreational programs, and to manage the resources on Sanibel to the best benefit of men and wildlife. Massachusetts still has its Walden Pond (nearly as tranquil as when Thoreau was there 125 years ago).

Many a developer would gladly have built on the shores of Walden Pond summer cottages or impressive mansions had it not been for the foresight of the local people, the State of Massachusetts, and various organizations.

Florida can still have its Sanibel Island with the quiet bays, mysterious mangrove, tropical woodlands, and unpolluted waters. Let it be said in the year 2000 that at least a portion of Sanibel Island is nearly as tranquil as when J.N. "Ding" Darling sat with pen in hand there on the beach in the year 1950.

The refuge was officially renamed the J.N. "Ding" Darling NWR on August 15, 1967. Tommy Wood elected to retire from his post on January 9, 1971. Charles LeBuff served as acting refuge manager until Robert "Bob" Barber entered on duty to assume the manager position on April 19, 1971. The J.N. "Ding" Darling NWR became administratively independent from the South Florida National Wildlife Refuges in March, a couple of weeks before Barber arrived on Sanibel.

Glen Bond followed Bob Barber as manager when the latter transferred to the regional office on October 28, 1973. Bond would serve as manager from December 13, 1973, until 1977. Delano "Del" Pierce replaced Glen Bond as refuge manger on November 21, 1977. It was during Pierce's tenure that the refuge was officially dedicated—on February 4, 1978. The refuge staff also vacated the refuge headquarters at the Sanibel Lighthouse and moved into modern facilities on Sanibel-Captiva Road in 1982, during Pierce's term as refuge manager. Del Pierce transferred away from Region 4 on January 8, 1983. Since his departure, the following refuge managers have served as the project leader for the J.N. "Ding" Darling NWR Complex: Ron Hight, 1983 to 1990; Lewis Hinds, 1990 to 2001; Robert "Rob" Jess, 2001 to 2008; and Paul Tritaik, 2008 to the present.

The formal dedication ceremony of J.N. "Ding" Darling National Wildlife Refuge was well attended by the public and private and governmental agencies that were involved and worked so hard to see the memorial to Jay Norwood "Ding" Darling come to fruition. The speakers were Sherry Fisher representing the J.N. "Ding" Darling Foundation in Des Moines, Emmy Lu Lewis of the Sanibel-Captiva Conservation Foundation, and Executive Director Robert Brantly of the Florida Game and Fresh Water

Official dedication of the J.N. "Ding" Darling National Wildlife Refuge, 1978 (*left to right*): Lawrence Givens, Robert Brantly, Sherry Fisher, Emmy Lu Lewis, Robert Herbst and Lynn Greenwalt. *U.S. Fish and Wildlife Service.*

Fish Commission. Lawrence S. Givens spoke on behalf of the Atlanta Regional Office of the U.S. Fish and Wildlife Service. Assistant Secretary of the Interior Robert Herbst and Fish and Wildlife Service director Lynn Greenwalt, both from Washington, D.C., also addressed the crowd. Retired manager of the National Key Deer Refuge Jack Watson and U.S. Congressman L.A. "Skip" Bafalis were among the audience that cool and windy day.

In 1976, 2,619.13 acres of the J.N. "Ding" Darling NWR were added to the National Wilderness Preservation System. This designation provided additional protection to this section of the refuge to help meet its wilderness character. Its southern border is the refuge's wildlife drive. In 1993, the State of Florida established the J.N. "Ding" Darling NWR/Sanibel Conservation Zone. Fishermen in boats entering this zone are mandated that if any marine species are to be harvested by nets they must be taken from nonmotorized vessels only. The City of Sanibel established a Slow Speed–Minimum Wake Zone where vessels are restricted to slow speeds that create only a minimal wake. Both zones include the entire refuge

and its wilderness area. Further, in 1993, the refuge restricted motorized boat use to specific locations in the wilderness area. This was intended to reduce or eliminate propeller damage to seagrass beds and boat-related disturbance to feeding, loafing and breeding birds.

The primary goals of the "Ding" Darling Memorial Sanctuary Committee were accomplished on August 15, 1967, when the Sanibel NWR was renamed J.N. "Ding" Darling NWR. It both honored the man who was significant in the islands' tilt to conserving and saving the area's wildlife and lands and established a lasting memorial to his memory and achievements.

It would seem the committee members' job was done, but the benefits of their grass-roots experience and contacts were too noteworthy to allow them to disappear. The USFWS, in the local guise of Tommy Wood, pressed them to maintain their position as a local representative of the refuge and its goals. Emmy Lu Lewis and former Sanibel-Captiva Audubon Society leader and committee member Roy Bazire (1917–1998) traveled to Des Moines to discuss the situation with the umbrella group. They returned with three possibilities: first, to continue operating under the aegis of the nonprofit J.N. "Ding" Darling Foundation as before, with limited abilities to influence decisions (this had been an element of contention for some time between the two organizations); second, withdraw and reorganize as an independent foundation; third, simply dissolve.

The second option was clearly the logical one, and Roy Bazire, who worked in island real estate, asked a question that has resonance to the present day. "Real estate developments are bound to take place....Can some sort of standards be set up to permit the inevitable to take place, but at the same time hold ecological damage to a minimum?" Several years prior to the incorporation of the City of Sanibel, the desirability of having a policy islands-wide on controlling development and protecting unique environment was looming in people's minds.

By October 1967, the Sanibel-Captiva Conservation Foundation Inc. (SCCF) had been formed with the same set of officers as the now-dissolved local "Ding" Darling Memorial Sanctuary Committee. Their five years of experience in obtaining their refuge goal would stand them in good practice for what was to come. They would continue oversight of the refuge's land acquisition plans and work to preserve the marsh and wetlands of the Sanibel Slough, targeted for development. Universities indicated interest in doing scientific research on the islands, and educational and research opportunities, in part for islanders and also for visitors, were another objective.

An early policy statement was this: "The primary purpose of the SCCF shall be the mitigation of human impact on the natural ecosystems and environment so that Sanibel and Captiva may be better places in which to live."

Chair of the board of the foundation at its incorporation was Emmy Lu Lewis, with Roy Bazire as vice-chair. Early meetings included Ann Winterbotham, Opal Combs, Griffing Bancroft, Joe Gault, James Jack, Hervey Roberts, W.D. "Tommy" Wood, Charles LeBuff and Tom Mitchell. Working for or retired from national and local businesses and organizations, the nascent SCCF team had an abundance of resources and connections on which to draw. An early aim of protecting the island's interior wetlands was augmented by support from Everglades biologist Dr. Frank Craighead, and Dr. George Cooley and the Nature Conservancy facilitated initial land acquisition funding. The National Audubon Society recommended a nature center, finally placed in approximately its current position in 1977, allowing access and trails to the interior freshwater wetlands.

At first, the SCCF tried to protect land through zoning, but it soon realized land ownership would be the safest alternative. By 1981, more than six hundred acres of land were owned or controlled by the organization, and the need for management was increasing. Over the years, projects have included island and Caloosahatchee water quality, elimination of noxious and exotic plants such as Brazilian pepper, erosion control, seminars and workshops on many scientific subjects, a native plant nursery, sea turtle and shore bird research and wide numbers of educational talks, cruises, beach walks and more. Another ambition was that of a marine center for biological research, postponed for decades but now a reality.

In 1974, 64 percent of Sanibel Islanders voting agreed to incorporate as a city, due largely to Lee County's indifference to potential destruction of much of the island's natural resources as tourist and development worries multiplied. The Sanibel Causeway's opening in 1963 had brought huge pressure to a very small place, with little remedy or concern from the county. Assisting the city in formulating and enforcing environmental regulations in the organization's early years was a priority, and the relationship continues in an advisory and watchdog role today.

Many individuals made considerable donations of their time, talent and money to see the programs of SCCF succeed. Among these were notables such as George R. Cooley (1896–1986). Cooley, a winter resident of Sanibel Island, was a New York investment banker who made significant contributions to Florida botany. In 1955, he published a paper in the journal

Rhodora entitled "The Vegetation of Sanibel Island, Lee County, Florida." He later worked tirelessly and connected the land acquisition effort of SCCF and J.N. "Ding" Darling NWR with the Nature Conservancy for their financial assistance in difficult land acquisitions. The Conservancy often purchased, held and later sold lands to SCCF or USFWS. The George R. Cooley Library is an essential part of the University of South Florida Herbarium Library.

CBS radio commentator Griffing Bancroft (1907–1999) and his wife, Jane, retired to Captiva Island. He became a founding member of the first SCCF board of directors, and when needed, he took the temporary post as executive director of SCCF until the first permanent director (Dick Workman) was selected for the position. Bancroft's father was a respected ornithologist, and Griff followed in his footsteps. He later became a popular birding guide on the islands and authored four books on birdlife. He also published in the scientific journal of the American Ornithological Society, *The Auk: Ornithological Advances.*

Hal H. Harrison (1906–1999) a Pennsylvania naturalist and author of such bird-related books as the Peterson Field Guide *Field Guide to Birds' Nests East of the Mississippi*, relocated to Sanibel Island in the mid-sixties with his wife, Mada. They befriended Griff and Jane Bancroft, and the two men shared their mutual interests in ornithology. Hal became very involved in the work of SCCF and served as a member of an early SCCF board.

Malcolm Beattie (1900–1985) served on the advisory board of SCCF and became co-chairman in 1983. The Malcolm Beattie Preserve is a seventeen-acre tract within the SCCF inventory of protected conservation lands.

William "Bill" Hammond was an early supporter of SCCF and served as both a consultant to the board and a member of that body. He helped guide the development of the SCCF Nature Center and its early efforts in environmental education. Hammond is known for his contributions to a generation of students as an environmental educator in the Lee County public school system. One of his major successes in land and wildlife protection was encouraging Lee County citizens and politicians to save the Six Mile Cypress Slough Preserve on the mainland. This is a 3,500-acre park that was acquired because of Bill's efforts and is owned and operated by Lee County. At this writing, Bill Hammond continues to lead the Calusa Nature Center and Planetarium in Fort Myers.

As interior protection stabilized, the SCCF looked to a number of other issues and solutions. It was involved in the education of residents and visitors as to the special character of the island during and after the city

incorporation process and helped in the publishing of *The Sanibel Report*, a thorough study of the island's natural systems, including water, beaches, interior wetlands, uplands and mangrove zones, in which the Sanibel Plan was articulated. In addition, it published Dick Workman's *Growing Native* and a series of "green books," pamphlets illuminating aspects of wildlife, water, archaeology and birds of the islands. Newsletters and internet presence provide timely information.

As the SCCF has matured, emphasis on education of the continual flow of new residents and visitors has a high priority. Numerous special events and programs are used to draw people to the knowledge and experience they need to appreciate the special character of the islands today. In addition, habitat management of the acreage under SCCF's control is a continuing practice. Maintaining savanna and marsh lands in the constant threat of exotic growth can involve prescribed burns and heavy equipment. Protecting threatened mammals, reptiles, birds and plants on an island is ongoing. Providing a helping hand through, for example, barn owl boxes or artificial nest platforms for ospreys or eagles, helps to maintain the creatures' presence.

The volunteer contingent at the SCCF has always been one of its greatest strengths. Whether trail or center guides, nursery workers, "Hammerheads" who build and repair much of the infrastructure or simply those who are members, donors and visitors, the number of contributors over the years has been invaluable to the organization. Interns from all over the country also leave their mark on SCCF, as well as the long-term and dedicated staff. Sanibel-Captiva Conservation Foundation has received numerous kudos and awards over the years for its dedication to its purpose, but perhaps the greatest award is the preserved acres of the islands and the understanding of their importance taught to so many over the years.

The local volunteer success at the SCCF seemed to leave an empty spot of sorts at the J.N. "Ding" Darling NWR. While ably and professionally managed, as a federal agency with federal employees, the staff found themselves with a shortage of time to address the burgeoning interest in visiting and exploring the refuge's lands. Locals were interested and invested in the refuge but had no real hands-on contributions to make any longer, unlike at SCCF. That was about to change.

In the early 1980s, Sanibel naturalist Mark "Bird" Westall became the first official volunteer at J.N. "Ding" Darling NWR. The volunteer program was new to the USFWS, and as it matured, other conservation-minded persons joined the ranks. In 1982, when the refuge office was officially relocated

from the Sanibel Lighthouse to share a new Refuge Visitor Center at the head of Wildlife Drive, the information desk was manned by a cadre of volunteers. They were overwhelmed—eleven thousand visitors converged at the center the first month it was open. The volunteers decided they must grow and support the refuge further. In coordination with the refuge, they formed a board of directors and went on to become the "Ding" Darling Wildlife Society (DDWS), duly incorporating as a not-for-profit organization on October 6, 1982.

In the beginning, DDWS solicited donations and set up a tiny retail book sales operation in a vestibule in the visitor center. Funds from profits were used to support refuge activities, and new volunteers were recruited and trained. They would staff the information desk and assist the refuge staff in interpreting the new exhibits to the visiting public. Over time, the DDWS has grown far beyond the expectations of its founders. It raised $3.3 million in funds to build the refuge's new Visitor and Education Center, and the enthusiastic volunteers have grown to a force of 280. From the original 7 founders, the membership has swelled to 1,500 and continues to grow.

During its decades of operation, the DDWS has been the recipient of such awards as the National Voluntary Service Award in 1991 from the National Recreation and Parks Association, the Friends Group of the Year in 1999 from the National Wildlife Refuge Association and the Southeast Regional Directors Award in 2009 for its help with distributing funds for refuge employees who were affected by Hurricane Katrina. In 2012, the Lee County Visitor and Convention Bureau awarded the society its Chrysalis Award for Education, and the Society of American Travel Writers (SATW) bestowed upon the society and refuge its global Phoenix Award for conservation in tourism.

ISLANDERS TAKE CONTROL OF THEIR DESTINY

T hose who were living on Sanibel and Captiva Islands a decade earlier in the early '60s remembered the battle over the growing threat of a bridge that would ultimately connect Sanibel Island to Punta Rassa. Now a much more controversial issue had arisen and was the center of most conversations among islanders, many of them were heated arguments. Some came close to fisticuffs, and there were rumors that some altercations did result in the exchange of blows. On Sanibel Island, the topic was debated at dinner tables, in taverns and restaurants and on the fishing pier. The contentious attitudes altered friendships.

A group had formed and was pushing hard to convince neighbors to join forces and break away from the Lee County government seated in Fort Myers. This movement evolved from the concept of home rule, and it would become a serious struggle for independence. That islanders could actually be on the cusp of self-governance shook real estate developers and investors to their core. Concerned land developers and construction companies started to crowd the county's building and zoning department offices just in case "those crazy islanders" were successful. A rumor circulating in the construction industry implied there would soon be a building moratorium in play if incorporation really happened. Builders were rushing to beat the clock. If home rule eventually won the day, it would be an achievement that would have pleased "Ding" Darling to no end.

The islands already had a citizen's group, the Sanibel-Captiva Planning Board, but it had little real authority. The real planning power was held

close to the vest of the five county commissioners, who generally acted more against the barrier islands than cooperatively. Like their predecessors in the pre-causeway fight, their mentality was focused only on increasing the county's tax base. Earlier, these commissioners had refused to enact a growth policy for the barrier islands, and current zoning regulations could see ninety thousand residents crowded onto Sanibel and Captiva Islands. In 1973, the local planning board conducted a straw poll to get a feel for the islanders' opinion on the issue of incorporation and becoming a self-governing municipality. Residents of Captiva Island rejected the idea of joining Sanibel Island if it steered a course toward becoming a city and attaining self-determination. Captivans had different concerns than Sanibelians and didn't share the virtuous opinion that self-governance was the sensible approach. The fear of being ruled by a majority on a connected island may have caused an underlying sense of caution. The people of Captiva Island did what was right for them.

Next came the establishment of the Home Rule Study Group, and residents stepped up to the plate and made substantial financial contributions to fund this group. Its leaders invited Aileen R. Lotz (1924–2009) to attend a January 3, 1974 meeting of the group's executive committee. Lotz, a former assistant Dade County manager, was an experienced charter-drafting consultant. She was an avid birder and a frequent visitor to J.N. "Ding" Darling National Wildlife Refuge. Although she didn't live here, she had a deep fondness for the island. Within a few days after this meeting, Aileen was requested to submit a proposal to draft a charter that would be applicable to a new city if the movement turned out to be successful. Her initial plan for the structure of a new city government was basic. It would consist of a five-member council who would be elected at large and initially on staggered terms (three four-year terms, two two-year terms), the council would choose the mayor annually from among its body and council members would be elected during a general election. It was further agreed that the municipality would have a city manager, a professional appointed by the council. Provisions for "initiative, referendum, and recall" were added to the formula typically found in "good government." Aileen Lotz was hired after agreeing to a $20,000 contractual fee, including secretarial costs. The offer mandated a very brief time for completion. The draft charter would have to be delivered to the Home Rule Study Group in just eleven days. And this was before the days of more efficient email.

The process wove its way through the political and public arenas of deliberation, and it was found during one public hearing that when three

choices for the island's future were offered, it was the pro-incorporation sentiment that beat out the other two. To pursue a vote by referendum on incorporation received 55 percent of the vote. Those that did not make the cut were pursuing an independent district status (6 percent) and continuing to work with Lee County (39 percent). With everything progressing smoothly and everyone on the self-rule team working toward hopes of incorporation, a member of the Florida legislature, a representative from Fort Myers, announced on local television that there were defects in the bill. He based his comments cloaked in his standing as a member of the Florida Bar. Many incorporation proponents thought that someone in the opposition had "gotten to him." He said he would not introduce the bill in the legislature, and in his view, the Sanibel incorporation issue was dead in the water. There was instant diplomacy on the part of Ralph Zeiss, now chairman of the Home Rule Study Group, as he took on the politician. His common-sense strategy worked, and the bill was finally introduced.

A Naples attorney who owned land on Sanibel Island had reached out to this state representative and muddied the water. The incorporation-bent Sanibelians won that round, but before the bill was sent up for a vote, the Naples lawyer filed a suit that claimed incorporation would in effect infringe on his constitutional rights as a Sanibel landowner. He argued that a referendum would violate the Equal Protection clause of the U.S. Constitution. His fellow lawyers who served in the legislature quickly nullified that charge—his allegations were preposterous. Despite all the legal maneuvering to kill it, the bill passed the House of Representatives unanimously. Next, it was on to the Florida Senate. On June 24, the Sanibel incorporation bill became law as Chapter 74-606 of the Florida Statutes. The citizens of Sanibel Island were off and running, headed for the banner in sight at the finish line. It read, *Preserve Paradise.*

The next phase of the incorporation drive was to develop a city charter. A new group sort of evolved from the citizenry on its own volition—almost automatic—and Sanibel Tomorrow became the name of the charter-drafting and pro-incorporation group. It was promptly incorporated as Sanibel Tomorrow Inc. and steamed ahead. There were additional attempts by developers to block the movement, and once again, in September the Naples attorney made a last-ditch legal move to stop the train. It did not work. The Lee County Commission became involved and promised islanders a greater share of surplus proceeds from causeway toll revenues if they did not incorporate. Nothing could dissuade those who wanted to see islanders take control of their own destiny.

The election was held on November 5, 1974, and the voter turnout amazed all concerned: 84.6 percent of eligible voters cast ballots. Broken down, this turned out to be 63.6 percent in favor and 36.3 percent against the measure. A city was born. Candidates for city council had to qualify by November 19. This was only fourteen days after the charter vote. Seventeen candidates came forward, and a special run-off election was held on December 3. Of the five winners, four met the criteria of being conservationists, while the fifth was best classified as an environmentalist. All were committed to lowering building densities and retaining an island character and quality of life. Land developers and contractors and businessmen had reached uncertain times. They did have a variety of reasons to be concerned about their future. It was no longer in the hands of disconnected county commissioners; the "crazy" Sanibelians were firmly in control.

One of the first orders of business for the new council was to name the new city. Following a brief discussion. the view of Councilman Francis P. Bailey Jr. (1921–2013) prevailed. It became the City of San-a-bull. This phonetic usage was Bailey's traditional and lifelong (ninety-two years) pronunciation for the name of the island. It is still used as the spoken word by a few living people who were raised on Sanibel Island beginning eighty years ago and their children. The City of Sanibel was off to a good start, but no one seated on that first council had a clue as to the overwhelming workload that was ahead of them.

Lest we forget, and as we have continually and explicitly implied in our text, for those who live or visit here: When walking the beaches or exploring Wildlife Drive you may be *in* the city of Sanibel but you are *on* Sanibel Island.

ISLAND CONSERVATION EFFORTS TODAY

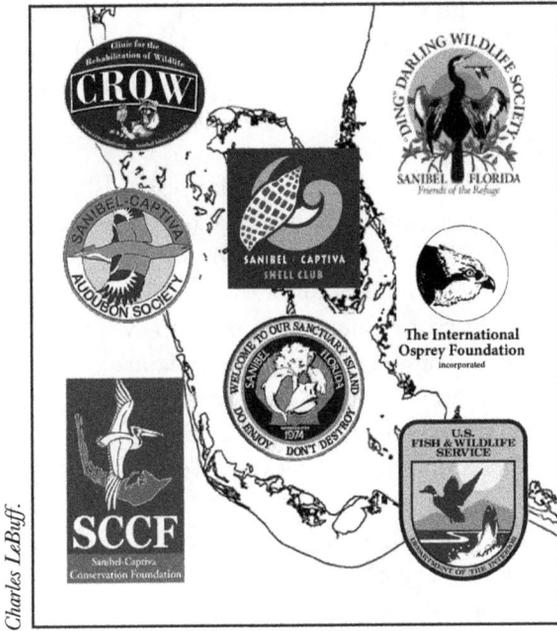

Charles LeBuff.

In this, our final chapter, we recognize the ongoing work of the federal and local governments and independent nonprofit conservation organizations that have helped Sanibel and Captiva Islands maintain their uniqueness and expand the conservation ethic so inherent in both communities. We asked several groups to convey their ambitions and goals for the future. The following sections consist of their words, and the photographs portray some of their important works.

These groups strive to protect the marine, estuarine, upland, flora, fauna and freshwater resources on or adjacent to the barrier islands. Other organizations on the islands address conservation issues from time to time, but their work is not in the broad spectrum of wildlife conservation as a whole. We felt the mission of conservationism should determine who to invite to share their aspirations. We hope we have chosen well.

J.N. "DING" DARLING NATIONAL WILDLIFE REFUGE

Paul Tritaik, U.S. Fish and Wildlife Service

J.N. "Ding" Darling National Wildlife Refuge is the oldest conservation entity on Sanibel Island, having begun in 1945. The refuge has grown to be the largest landowner on Sanibel Island, making up about 57 percent of the island's total area. The refuge is also the most visited attraction on Sanibel Island, after the beaches and the Sanibel Lighthouse, drawing over 900,000 visitors per year.

The significance of the refuge far exceeds those local distinctions. J.N. "Ding" Darling National Wildlife Refuge, as its name implies, is nationally significant as a haven for migratory birds and a mecca for birdwatchers. Visitors not only travel from all over the country, but from all over the world, to watch and photograph the charismatic avifauna.

The refuge is also nationally important for many threatened and endangered species, providing critical habitat for such species such as the piping plover, West Indian manatee, loggerhead sea turtle, smalltooth sawfish, and the aboriginal prickly apple, as well as improving habitat for state-listed species, like the endemic Sanibel Island rice rat. The protection of these areas and the species themselves not only help prevent extinction, but also aid in their recovery as well.

The refuge's importance is not confined to the diversity and splendor of its wildlife. The wildlife acts as a draw to the many people who visit the refuge, and to the hundreds of volunteers and refuge friends who support the refuge with their time, talent, and treasure. The refuge's friends group, the "Ding" Darling Wildlife Society, marshals support from around the community to greatly improve the refuge's role in serving the public. That contribution has helped the refuge accomplish so much more than it could by itself, from land acquisition, educational programs, and wildlife research to building boardwalks and a visitor center.

The building of the Visitor and Education Center and installing the interpretive exhibits, funded through private

The rare Sanibel Island rice rat is endemic to the island, and the refuge has implemented a plan to improve its Bailey Tract habitat. *U.S. Fish and Wildlife Service.*

philanthropy, is the milestone that greatly expanded the refuge's capacity to greet, orient, and educate hundreds of thousands of visitors each year. The Wildlife Education Boardwalk provides viewing opportunities of nesting birds and alligators for hundreds of Sanibel schoolchildren next door and thousands of schoolchildren from all over Lee County. The refuge also partners with a concessionaire, Tarpon Bay Explorers, to provide award-winning outdoor recreation like world-renowned fishing, sealife nature tours, tram tours, and exceptional wildlife viewing from kayaks, canoes, and paddle boards.

The refuge's success is also the result of a strong partnership with state and local governments and private conservation organizations. Working with Florida Fish and Wildlife Conservation Commission and Florida Forestry Service, Lee County, the City of Sanibel, and the Sanibel-Captiva Conservation Foundation, the refuge has been more effective in protecting, managing, and restoring habitat through land acquisition, invasive species removal, prescribed burning, hydrologic re-connection, and water quality monitoring and improvement.

The refuge's habitat restoration of mangrove forests and freshwater marsh, for example, not only benefits fish and wildlife long-term, but should also help improve the refuge's resilience in the face of climate change and sea level rise. The water quality monitoring and working with water managers is helping improve water conditions in our estuary. This is vitally important, because clean water is the lifeblood of a healthy ecosystem.

Like its namesake, J.N. "Ding" Darling National Wildlife Refuge has been, and continues to be, a leader in conservation, both locally and nationally. That is something Jay Norwood "Ding" Darling would be proud of.

For further information on this refuge please visit https://www.fws.gov/refuge/jn_ding_darling.

SANIBEL-CAPTIVA AUDUBON SOCIETY

Phyllis Gresham and James Griffith, SCAS

One of the oldest conservation organizations on Sanibel and Captiva Islands is the Sanibel-Captiva Audubon Society. For over 50 years, the group has contributed to the quality of human life and the environment and wildlife conservation on the barrier islands.

In the early 1950s, a naturalist and winter visitor to the Islands, B.K. Boyce, following the influence of "Ding" Darling, organized the Sanibel Captiva Audubon Society. During his four year tenure as president a summer bird count and two environmental reviews were sponsored by the chapter. Twenty years later, just prior to the City of Sanibel incorporation, SCAS became an official chapter of Florida Audubon.

A series of educational programs was established for winter visitors on topics ranging from water issues, habitat management, advocacy for wildlife, to specific issues relating to mammals and birds. There were also outings and classes taught by SCAS members, raising funds to donate to educational efforts on behalf

of wildlife and support of environmental conservation. Birds and bird ID have always been a focus of SCAS.

In 1960, the SCAS had its first Christmas Bird Count and it continues to this day among the highest number of participants of any Audubon Chapter in North America. At the same time, the chapter successfully lobbied for the protection of 1,900 acres of Sanibel wetland and the renaming of the Sanibel National Wildlife Refuge in honor of "Ding" Darling. Ten years later, SCAS provided the first group of regular volunteers to inform the public along Wildlife Drive at the refuge. This group evolved into the present DDWS. With Sanibel/Captiva Islands continued growth of seasonal visitors, SCAS members have expanded volunteer support to adjoining conservation and wildlife organizations.

SCA continues to be recognized for its advocacy for all conservation and legislative efforts relating to the environment. For more information and program schedules, visit: http://www.san-capaudubon.org.

A birder's trip sponsored by the Sanibel-Captiva Audubon Society to the nearby birding "hot spot" Bunche Beach on San Carlos Bay. This is among the best bird-watching sites in Southwest Florida. *Bill Jacobson.*

SANIBEL-CAPTIVA SHELL CLUB

Joyce Matthys and Linda Edinburg, SCSC

The Sanibel-Captiva Shell Club (**SCSC**) was created in 1961, incorporated as a 501(c)(3) not-for-profit organization in 1985, and has grown to over 340 members in 2018. It is open to anyone who is interested in working with shells as an art form or collecting and studying seashells and mollusks, the animals that create the shells. The members range from beachcombers with shells they have found on the beach to knowledgeable collectors with very valuable collections. They may be permanent residents from the surrounding area, seasonal residents, or simply visitors who want to support the club. Shell collecting can be a lifelong professional interest or a happy diversion for one's spare time.

The annual Sanibel Shell Show is the longest-running shell show in the United States, and it is considered the most prestigious competitive show in the country and quite possibly, the world. Exhibitors come from all over the United States and Canada, and as far away as the Caribbean and Japan to vie for awards in the Artistic Division and Scientific Division of competition. Winning an award at the Sanibel Shell Show means you have reached the pinnacle of excellence.

Each year all the profit from the club's annual Sanibel Shell Show is given out in the form of grants and scholarships. As the shell show has continued to grow and become more prosperous, the amount given away in grants has grown also. In the year 2000 our club gave away $8,000 in grants. In 2017, the club gave away $30,000 in grants. Some of the recipients of these grants and scholarships include The Bailey-Matthews National Shell Museum, Sanibel-Captiva Conservation Foundation, Mote Marine Laboratory, Florida Gulf Coast University Department of Marine and Ecological Science, Conchologists of America Scholarship Fund, Sanibel Community Association and the Florida Museum of Natural History. In 2018, a special onetime

The Sanibel Community House is filled to capacity during the annual three-day Shell Festival. *Sanibel-Captiva Shell Club*.

grant of $15,000 was given to the Bailey-Matthews National Shell Museum to help purchase a van for their new outreach program "Mollusks on the Move." This program brings the Shell Museum to schools, nursing homes and special events throughout Southwest Florida.

In addition to the grants and scholarships mentioned above, each year the club also awards the 'The Sanibel-Captiva Shell Club/Mary and Al Bridell Memorial Fellowship in Marine Science' to a graduate student at the University of South Florida. The club started supporting graduate students at the University in 1982. In 1992 they joined hands with club members Mary and Al Bridell to establish the Memorial Fellowship. The fellowship is now self-sustaining and the annual amount recently being awarded is $12,500.

Looking to the future, the SCSC will continue in its quest to further the objectives of the Club offering its members an opportunity for the exchange of information in the fields of conchology and malacology; fostering public education of these and related ecological resources; and encouraging and supporting studies and research activities in those fields. Visit our website, http://sanibelshellclub.com for further information on our activities and meetings.

SANIBEL-CAPTIVA CONSERVATION FOUNDATION

Kristie Seaman Anders, SCCF

The Sanibel Captiva Conservation Foundation stays true to its original mission in the twenty-first century. New lands are still being added to SCCF ownership. Research and wildlife monitoring expand and respond to the ever changing environment on and around the islands.

Violent storms in recent decades have created problems upstream in the greater Everglades watershed, and in particular Lake Okeechobee and the water course of the C-43 canal, which is known by residents as the Caloosahatchee. Massive amounts of brown, toxic water flows down this once vibrant river and surrounds the islands, fertilizer-rich water spawns algal growth in the river, Pine Island Sound, and off shore. Other alterations in the flow of water cause salinities to be either too high or too low, wreaking havoc on native estuarine and marine species.

One of SCCF's most encompassing projects came about as it has sought and continues to seek individual donors to maintain the River, Estuary and Coastal Observing Network or RECON. This very sophisticated array of equipment was deployed in 2008 and has collected data in key places 24/7 ever since. The data from RECON can help predict future events. Armed with sound science, SCCF created a Natural Resources Policy Director position, charged with being watchdog and communicator for issues that threatened the waters surrounding the islands. This requires SCCF's scope of work to reach off island to include issues of the entire greater Everglades watershed, from Orlando to the Florida Keys.

Working hand in hand with SCCF's scientists, the policy director informs over 100 decision makers, general public and elected officials of river and estuary conditions on a weekly basis, advocating for improving water quality that surrounds the islands. Residents have learned to depend upon SCCF's scientists to monitor and investigate radical changes. Policy decisions at SCCF are driven by honest science. SCCF

maintains a careful balance so as not to distort outcomes. Integrity of SCCF researchers is imperative for sound policy positions. There is constant scrutiny by peers within the scientific community assuring broad acceptance of results.

In an on-going restoration project, one bucket at a time, old shell is placed in the bay where historically living oyster reefs thrived. Oysters filter gallons of water each day feeding on microscopic plants and animals. Oyster spat are provided a place on which to settle. Crabs, brittle stars and other marine animals have moved into new craggy shelters along with oysters. Mangrove plantings restore habitat. Clam Bayou's mangroves were dying, closed off by shifting sands on the Gulf side and poor water exchange through outlets to Pine Island Sound. A new culvert under Sanibel-Captiva Road, helped refresh the water, and many community work days were invested in hand planting young mangroves to revive the system. Follow up studies there indicate new mangrove forest and associated flora and fauna are responding well.

Research needs will drive SCCF's future. The more that is known, the more questions arise and solutions are sought. Visit our Home Page at http://www.sccf.org.

Volunteers mobilize and plant native vegetation on the banks of newly created Devitt Pond at the Bailey Homestead, acquired by SCCF in 2010. *Sanibel-Captiva Conservation Foundation.*

CLINIC FOR THE REHABILITATION OF WILDLIFE

Linda E. Estep, CROW

The Clinic for the Rehabilitation of Wildlife (CROW) is a teaching hospital and visitor center dedicated to saving wildlife through state-of-the-art veterinary care, research, education, and conservation medicine.

CROW treats more than 4,000 wildlife patients annually and performs more than 300 soft tissue and orthopedic surgeries each year. Patient demographics for hospitalized wildlife include approximately 55% birds, 37% mammals, 7% reptiles and 1% amphibians.

Education is a core component of CROW's mission, making its student program an integral part of its success. CROW's reputation as a teaching hospital has attracted students from every veterinary school in the United States, as well as many international students. Students work long hours and are dedicated to learning how to care for the species that CROW sees as patients.

CROW works hard to advance the science of wildlife and conservation medicine. The Hospital staff has been working on a number of conservation and research projects including:

1. A novel treatment for brevetoxicosis in seabirds and sea turtles. Southwest Florida's coastal waters are home to harmful algal blooms known as red tide which causes brevetoxicosis, or red tide poisoning, in wildlife. A special treatment greatly reduces the amount of time needed for patients to recover.
2. Clear Your Gear is an ongoing collaboration of local organizations on Sanibel focused on educating anglers and providing easily accessible monofilament recycling bins on the beaches for hooks and lures. The project will help to reduce the number of hook and line injuries in Southwest Florida's wildlife.

The Visitor Education Center (VEC) offers specialty programs for enhanced visitor experience and education. Visitors learn

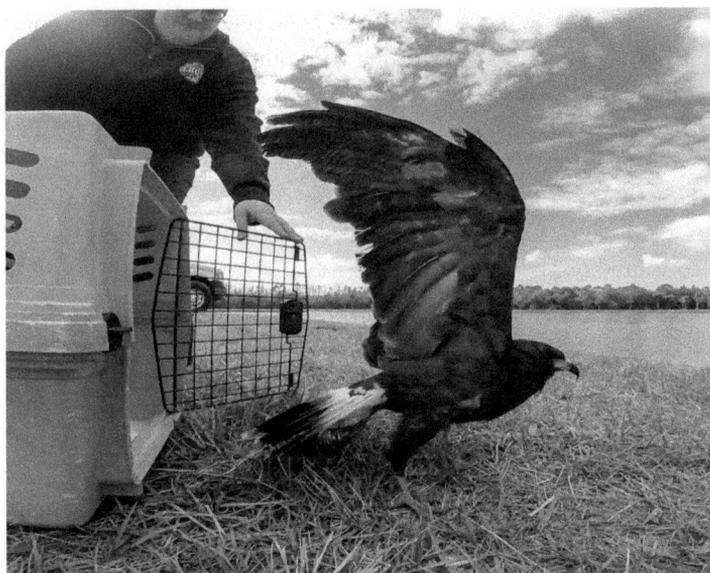

After treatment and rehabilitation at the CROW hospital, an endangered Everglade snail kite is released back into habitat on the mainland near the "River of Grass." *Clinic for the Rehabilitation of Wildlife.*

about the rescue, admission, treatment and release of CROW's wildlife patients. The Center's live animal exhibits compare and contrast invasive species found in Southwest Florida with native animals whose existence is being threatened by the presence of the invasive animals.

The Center features programs that cover a variety of topics and include a live Animal Ambassador along with special interactive displays for children, such as "Be the Vet" and "Children's Discovery" areas.

In 2018 CROW celebrates its 50th Anniversary with special events scheduled throughout the year. The major goal is to continue to focus on offering superior patient care and supporting collaborative research and interactions with partnering agencies and like-minded organizations. Equally important is the promotion of financial opportunities for supporting CROW. Recently, an Endowment Fund has been established to provide a self-sustaining source of funding for the ensuing years.

Our educational programs have been successful in promoting CROW's message of co-existing with our wildlife neighbors and sustaining wildlife for future generations. Never-the-less, CROW staff is committed to enhancing the educational offerings and exploring alternative methods of delivery of such programs.

CROW remains Passionate about Wildlife and Committed to Care and Education! To learn more visit: http://www.crowclinic.org.

CITY OF SANIBEL

Holly Milbrandt, COS

The preservation and conservation of resources was and remains a key component of the Sanibel Plan and its Vision Statement. The City of Sanibel's (COS) Natural Resources Department serves to coordinate, manage, and implement special conservation and environmental projects and tasks as directed by City Council; to ensure the city's native vegetation and wildlife habitat protection standards are adhered to; to oversee exotic plant control, habitat restoration, and land management programs for the city; and to monitor the island's water quality and actively participate in improving the quality of the coastal waters by addressing nutrient run-off, algae blooms, and freshwater discharges from Lake Okeechobee and the Caloosahatchee.

Since 1992, the department has received more than 150 grants totaling over $14.8 million to fund needed environmental restoration, hurricane recovery, and water quality projects on Sanibel. One of the most noteworthy projects was the acquisition of lands and restoration of the Sanibel Gardens Preserve in conjunction with the Sanibel-Captiva Conservation Foundation (SCCF), which ultimately eliminated more than 1,000 parcels from development. Also ambitious, and now nearing completion, was the city's Brazilian Pepper Eradication Program with the goal of eradicating the invasive exotic plant from the island. In the wake of Hurricane Charley in 2004, the

city undertook numerous projects to restore conservation lands and habitats impacted by fallen Australian pines. Additional habitat management activities, including exotic removal, prescribed burning, wildlife surveys, and native plant restoration and enhancement, are critical on-going components of the department's land management efforts.

Over the last decade, the department's focus has shifted to include a greater emphasis on protecting water quality, both on-island and off. Working with SCCF, the city recently completed a Comprehensive Nutrient Management Plan, identifying nutrient sources and nutrient reduction goals for the Sanibel Slough and priority projects to achieve those goals. Two projects identified by the Plan are already underway. The Jordan Marsh Water Quality Treatment Park, a 6.8-acre filter marsh designed to remove nutrients from the Sanibel Slough, is on schedule for completion in October 2018. Upgrades to the Donax Water Reclamation Facility will be completed within three to five years and will significantly reduce nitrogen and phosphorus in the city's reuse water. In 2017, the city also launched the Sanibel Communities for Clean Water Program, a science-based effort to document water quality conditions within neighborhood stormwater ponds and encourage residents of those neighborhoods to implement recommended best management practices to improve water quality.

Prescribed burn of Sanibel Gardens Preserve, June 2016. *San-Cap Aerial for City of Sanibel.*

With the city's leadership and strategy outlined in the Caloosahatchee Watershed Regional Water Management Issues white paper, tremendous progress has been made towards developing regional consensus on short and long-term strategies to address freshwater flows from Lake Okeechobee and the Caloosahatchee watershed. As we look to the future, it will be imperative that the city continues to work closely with its Sanibel partners as well as other local, state, and federal agencies and elected leaders to implement critical regional water storage and treatment projects to improve water quality and to reduce the ecological impacts in the Caloosahatchee estuary and Sanibel's coastal waters. Information on city-related conservation and environmental issues can be found online via http://www.mysanibel.com.

THE INTERNATIONAL OSPREY FOUNDATION

Phyllis Gresham and James Griffith, TIOF

The International Osprey Foundation was founded in 1981 by M.A. Westall, who began a ten year study of ospreys on Sanibel in 1979. At the time, there were just several ospreys on Sanibel and Captiva Islands. Worldwide, the osprey has been evolving for two to three million years. The species has played a pivotal role in the identification of DDT as a major threat to aquatic ecosystems.

The pesticide DDT which was outlawed in 1972 had been used to protect crops. It subsequently washed off the land and accumulated in fish fat, resulting in the thinning of egg shells and the endangerment of ospreys, bald eagles and other fish eating birds.

Although ospreys hatched on Sanibel and Captiva Islands will use mangrove canopy tops for nesting, they seem to prefer platforms. Nesting platforms provide an unrestricted view and increased safety from predators. Ospreys bring fish to the nest from both marine and freshwater habitats. They are usually tolerant of human disturbance.

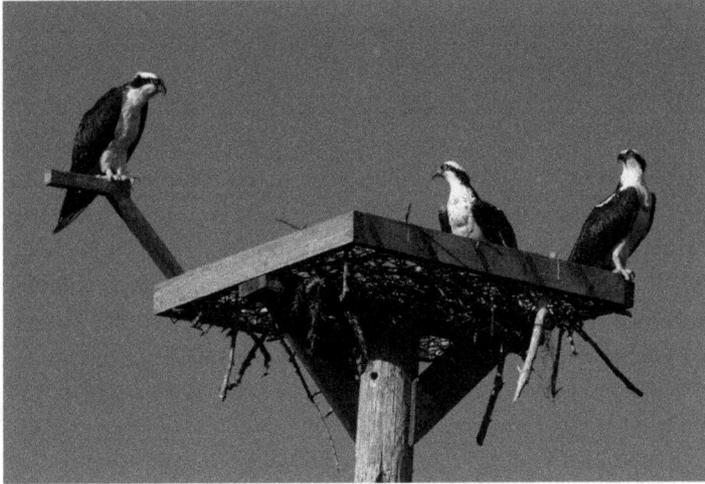

Ospreys inspect one of the many specialized platforms erected for them on the barrier islands. *Sally Thorburn.*

In 1974 the first TIOF osprey platform on Sanibel was built and installed by LCEC (Lee County Electric Cooperative) followed by six to eight more platforms. In 1979 there were 35 active nests and a possible 60 to 100 ospreys. The breeding population today is estimated at 200 ospreys. Ninety-seven birds fledged in 2017. On Sanibel, platforms are now built by James Griffith and are installed with the help of LCEC. Nest platforms are an important component in the re-establishment of ospreys in Southwest Florida. Long term survival is directly related to the health of the estuarine ecosystem threatened by water quality and the range of human development.

The International Osprey Foundation is dedicated to preservation and recovery of the osprey, and monitoring activities, using six teams of volunteers, for the accumulation of data specific to the osprey population on Sanibel and Captiva Islands. The organization also issues grants to researchers whose studies involve ospreys, other raptors, and environmental concerns worldwide. Information updates are available online via http://www.ospreys.com.

"DING" DARLING WILDLIFE SOCIETY: FRIENDS OF THE REFUGE

Chelle Koster Walton, DDWS

As the "Ding" Darling Wildlife Society (DDWS) looks forward to the seventy-fifth anniversary of the J.N. "Ding" Darling National Wildlife Refuge in the year 2020, it also looks back on nearly four decades of supporting conservation, wildlife, and environmental education on Sanibel and Captiva Islands and beyond. Since its inception in 1982, DDWS has become a shining model for friends groups across the 560-plus National Wildlife Refuge System.

In the past few decades alone, DDWS has expanded refuge boundaries, restored habitat, supported wildlife studies, created new educational exhibits, and hired interns and staff to fill voids created by severe federal budget cuts. In 1999, the friends group raised funds for the refuge's Visitor and Education Center, which it looks to expand in coming years. When 2004 brought the devastation of Hurricane Charley, DDWS stepped up to provide funds for cleanup on the refuge and the satellite refuge islands.

In Charley's wake, DDWS supported improvements to the Calusa Shell Mound Trail and Buck Key Paddling Trail, plus the creation of a first-of-its-kind iNature trail along Wildlife Drive with an interactive QR app to educate visitors. In 2012 and 2013, DDWS raised capital for new manatee, sea turtle, alligator, and other exhibits in the Visitor and Education Center; and the building of the Wildlife Education Boardwalk along Indigo Trail, complete with an educational Scat Trail.

Since 2013, the Society has worked with donors, property owners, and Lee County's Conservation 20/20 program to add nearly 24 acres to refuge holdings through three different acquisition campaigns. It continues efforts to expand along crucial wildlife habitat corridors.

Without the work of DDWS and the refuge, the landscape of Sanibel Island would look much different today. "Ding" Darling protects almost half the island, as well as much of the waters surrounding Sanibel—habitat for hundreds of species

of marine and land animals. Had it not been for the foresight of refuge namesake Jay Norwood Darling and, later, refuge administration and supporters, development would likely have taken over the island and decimated vital habitats.

Besides assisting in the expansion and protection of refuge lands, DDWS also works to educate visitors and cultivate the next generation of conservation stewards. In February 2017, the federal government permanently cut the refuge's Education Ranger position. Because education is a major part of its mission, DDWS made sure school and other programs could continue. With the help of generous donors, it funds a fulltime Conservation Educator. Every year, DDWS buses more than 5,000 school children, mostly from underprivileged communities, to the refuge to learn about the mangrove environment and the wildlife that call it home.

Looking to the future, DDWS recognizes a continued and possibly heightened need for strong refuge support. As it increases efforts to advocate for increased budgets and water quality issues at the government level, it works to cultivate

The renovated Alice O'Brien Tower is strategically located on Wildlife Drive. *"Ding" Darling Wildlife Society–Friends of the Refuge.*

endowment funding and encourage supporters to consider estate plan donations to ensure lasting support. Other projects on the horizon include another land acquisition, visitor center expansion, and intensified wildlife research studies. To become a part of the future of conservation on Sanibel Island and beyond, contact DDWS at 239-472-1100 extension 4 or dingdarlingsociety.org.

BIBLIOGRAPHY

Anholt, Betty. Chronicling Captiva's History. *Captiva Chronicle*. Various columns, 1999–2001.

———. *Sanibel's Story: Voices and Images from Calusa to Incorporation*. Virginia Beach, VA: Donning Company, 1998.

———. *The Trolley Guide to Sanibel and Captiva Islands*. Self-published, 1990.

Anholt, Betty, and Gwenda Hiett-Clements. *Sanibel-Captiva Conservation Foundation: A Natural Course*. Sanibel, FL: Sanibel-Captiva Conservation Foundation, 2004.

Anonymous. Obituary of Columbus G. MacLeod. *Bird Lore* magazine, January 1909.

Bailey, Francis. *My 92 Years on Sanibel*. Self-published, 2013.

Baker, Rick. *Beyond the Sunshine: A Timeline of Florida's Past*. Sarasota, FL: Pineapple Press, 2018.

Bancroft, Griffing, and George C. Tenney. *Helping to Save Paradise: The Story of the Sanibel-Captiva Conservation Foundation*. Sanibel, FL: Sanibel-Captiva Conservation Foundation, 1981.

Blanchard, Charles E. *New Words, Old Songs: Understanding the Lives of Ancient Peoples in Southwest Florida through Archaeology*. Gainesville: Institute of Archaeology and Paleoenvironmental Studies, University Press of Florida, 1995.

Blythe, R.W. *Wilderness on the Edge: A History of Everglades National Park*. Atlanta, GA: National Park Service, 2017.

Brown, Canter, Jr. "The International Ocean Telegraph." *Florida Historical Quarterly*, October 1989.

Buker, George E. *Swamp Sailors: Riverine Warfare in the Everglades 1835–1842*. Gainesville: University Press of Florida, 1975.

Campbell, George. *The Nature of Things on Sanibel*. Fort Myers, FL: Press Printing, 1978.

Clark, John. *The Sanibel Report, Formulation of a Comprehensive Plan Based on Natural Systems*. Washington, D.C.: Conservation Foundation, 1976.

Cushing, F.H. *Exploration of Ancient Key Dwellers' Remains on the Gulf Coast of Florida*. New York: AMS Press, 1973.

Dimock, A.W., and Julian Dimock. *Florida Enchantments*. New York: Outing Publishing Company, 1908.

Dormer, Elinore. *The Sea Shell Islands: A History of Sanibel and Captiva*. Tallahassee, FL: Rose Printing, 1987.

Edic, Robert F. *Fisherfolk of Charlotte Harbor, Florida*. Gainesville: Institute of Archaeology and Paleoenvironmental Studies, University Press of Florida, 1996.

Fontaneda, Do. *D'Escalante; Memoir of Do. D'Escalante Fontaneda Respecting Florida*. Translated by Buckingham Smith, annotated by David O. True. Coral Gable, FL: Glades House, 1944.

Fritz, Florence. *The Unknown Story of World Famous Sanibel and Captiva*. Parson, WV: McCain Printing, 1974.

Fuson, Robert H. *Juan Ponce de León and the Spanish Discovery of Puerto Rico and Florida*. Blacksburg, VA: McDonald & Woodward Publishing, 2000.

Gatewood, George. *On Florida's Coconut Coasts*. Punta Gorda: Punta Gorda Herald, 1944.

Gibson, Charles D. *Boca Grande, a Series of Historical Essays*. St. Petersburg, FL: Great Outdoors Publishing, 1982.

Haigh, K.R. *Cableships and Submarine Cables*. London: Standard Telephones and Cables Ltd., Submarine Systems Division, 1968.

Hambright, Tom. "Key West and Cuba become Link for International Communications, International Ocean Telegraph Co. in Key West." Monroe County Public Library, Key West, Florida, 1991.

Hammond, E.A., ed. "Dr. Strobel Reports on Southeast Florida 1836." *Tequesta* 21, 1961.

———. "Sketches of the Florida Keys 1829–1833." *Tequesta* 29, 1969.

Hann, John H, trans., ed. *Missions to the Calusa*. Gainesville: University Press of Florida, 1991.

Hine, Albert C., et al. *Sea Level Rise in Florida: Science, Impacts, and Options*. Gainesville: University Press of Florida, 2016.

Kolianos, P.E., and Brent R. Weisman, eds. *The Lost Florida Manuscript of Frank Hamilton Cushing.* Gainesville, University Press of Florida, 2005.

LeBuff, Charles. *J.N. "Ding" Darling National Wildlife Refuge.* Charleston, SC: Arcadia Publishing, 2011.

———. *The Loggerhead Turtle in the Eastern Gulf of Mexico.* Sanibel, FL: Caretta Research, 1990.

———. *The Sanibel Island Lighthouse.* Fort Myers, FL: Amber Publishing, 2017.

———. *Sanybel Light.* Fort Myers, FL: Amber Publishing, 1998.

Lendt, David L. *Ding: The Life of Jay Norwood Darling.* Ames: Iowa State University Press, 1979.

Lotz, Aileen R. *The Birth of a City, Sanibel.* Self-published, 1999.

Marquardt, William H. "Tracking the Calusa: A Retrospective." *Southeastern Archaeology,* no. 33 (Summer 2014): 1–24.

Marquardt, William H., ed. *The Archaeology of Useppa Island.* Gainesville: Monograph 3, Institute of Archaeology and Paleoenvironmental Studies, University Press of Florida, 1999.

Marquardt, William H., and Karen J. Walker, eds. *The Archaeology of Pineland: A Coastal Southwest Florida Site Complex, A.D. 50-1710,* Gainesville: Monograph 4, Institute of Archaeology and Paleoenvironmental Studies, University Press of Florida, 2013.

Menge, Conrad, Sr. *Early Dredging in the Lake Okeechobee Region.* Transcribed oral history, Dearborn, Michigan, June 1950. Southwest Florida Historical Society, Fort Myers, Florida.

Pratt, Theodore. "Shell Shock." *Saturday Evening Post,* February 22, 1941.

Saleem, Shihadah M. "Geomorphology of Submarine Spring West of Fort Myers, Florida." Master's thesis, University of South Florida, 2007. http://scholarcommons.usf.edu/etd/3836.

Twombly, Mark. "Stahlin Preferred Sanibel's 'Before Causeway' Era." *Island Reporter* (Sanibel, FL), 1980.

Viele, John. *Tales of Yesterday's Florida Keys.* Sarasota, FL: Pineapple Press, 2017.

Wilbanks, William. *Forgotten Heroes, Police Officers Killed in Early Florida, 1840–1925.* Paducah, KY: Turner Publishing Company, 1998.

Williams, John L. *The Territory of Florida: Or Sketches of the Topography, Civil and Natural History, of the Country, the Climate, and the Indian Tribes from the First Discovery to the Present Time, with a Map, Views, &c.* A facsimile reproduction of the 1837 edition with introduction by Herbert J. Doherty Jr. Gainesville: University Press of Florida, 1962.

Williams, Lindsey, and U.S. Cleveland. *Our Fascinating Past, Charlotte Harbor: The Early Years*. Punta Gorda, FL: Charlotte Harbor Area Historical Society, 1993.

Wilson, Charles J. *The Indian Presence: Archeology of Sanibel, Captiva and Adjacent Islands in Pine Island Sound*. A Barrier Island Nature Publication. Sanibel, FL: Sanibel-Captiva Conservation Foundation. Sanibel, 1982.

Workman, Richard W. *Growing Native: Native Plants for Landscape Use in Coastal South Florida*. Sanibel, FL: Sanibel-Captiva Conservation Foundation Inc., 1980.

INDEX

The authors, Betty Anholt and Charles LeBuff. *Cameron Anholt.*

ABOUT THE AUTHORS

BETTY ANHOLT is a long-term student of Florida's natural and social history and, in particular, that of Southwest Florida and the islands. She has published four books, including *Sanibel's Story: Voices and Images from Calusa to Incorporation*, numerous articles, columns and smaller pieces. She was awarded First Place statewide in Outdoor Writing in 1998 by the Florida Press Association in the Circulation Division of 5,000 to 11,999, published in the *Sanibel Captiva Islander*, for her monthly column On the River.

Born and raised in New Jersey, Betty traveled with her family throughout Florida as a child. After graduation from Rutgers University, Jim and Betty moved to Sanibel with their young family many years ago and owned/ operated two local businesses for much of that time. She has canoe-camped along several of Florida's rivers and streams, canoeing the Suwannee from the Okefenokee Swamp to the Gulf of Mexico at the Cedar Keys, and crossed the Everglades by paddle. Reading, exploring wild places and enjoying music are preferred pastimes. Volunteer opportunities have included City of Sanibel committees, local organizations and extensive work in archaeological work and research. Well-versed in island history and ecology, as of this writing, she works in reference and cataloguing at the Sanibel Public Library.

CHARLES LEBUFF was born in Massachusetts and moved to Bonita Springs, Florida, in 1952. He began a long federal career with the U.S. Fish and Wildlife Service in 1957 at the Red Tide Field Investigation Laboratory in

Naples. Then, in 1958, he was selected to fill the number two position at the Sanibel National Wildlife Refuge on Sanibel Island, Florida. He spent thirty-two years as a wildlife technician at this refuge, renamed J.N. "Ding" Darling National Wildlife Refuge in 1967. Charles retired from his position in 1990 but remained on Sanibel Island until 2005.

During his time on Sanibel Island, and in other than his official work capacity, he served as president of the Sanibel-Captiva Audubon Society, was a founding board member of the Sanibel-Captiva Conservation Foundation, was twice elected to the Sanibel City Council, serving his community from 1974 to 1980, and he founded and directed a loggerhead sea turtle conservation project, Caretta Research Inc., that has continued since 1992 under the auspices of the Sanibel-Captiva Conservation Foundation.

Today, Charles and his wife of more than sixty years, Jean, live near Fort Myers, Florida, where he lectures, writes, carves wood, builds World War II models, pursues an ongoing interest in wildlife photography, pilots his Phantom 4 drone, hunts Burmese pythons and is learning to master the acoustic guitar. He also self-administers his website, www.amber-publishing. com, and can be contacted there.

Visit us at
www.historypress.com

www.ingramcontent.com/pod-product-compliance
Lightning Source LLC
Chambersburg PA
CBHW060317100426
42812CB00003B/801